PLANETS ON TABLES

Planets on Tables

Poetry, Still Life, and the Turning World

Bonnie Costello

Cornell University Press

Ithaca and London

Copyright © 2008 by Cornell University

First published 2008 by Cornell University Press

Printed in the United States of America

Library of Congress Cataloging-in-Publication Data

Costello, Bonnie.
 Planets on tables : poetry, still life, and the turning world / Bonnie Costello.
 p. cm.
 Includes bibliographical references and index.
 ISBN 978-0-8014-4613-9 (cloth : alk. paper)
 1. American poetry—20th century—History and criticism. 2. Still-life in literature.
3. History, Modern, in literature. 4. Still-life in art. 5. History, Modern, in art.
I. Title.
 PS323.5.C67 2008
 813'.5409357—dc22

 2007033098

Cornell University Press strives to use environmentally responsible suppliers and
materials to the fullest extent possible in the publishing of its books. Such materials
include vegetable-based, low-VOC inks and acid-free papers that are recycled, totally
chlorine-free, or partly composed of nonwood fibers. For further information, visit
our website at www.cornellpress.cornell.edu.

Cloth printing 10 9 8 7 6 5 4 3 2 1

CONTENTS

ILLUSTRATIONS

APOLOGIES FOR POETRY

We are preoccupied with events, even when we do not observe them
closely. We have a sense of upheaval. We feel threatened. We look
from an uncertain present toward a more uncertain future. One feels
the desire to collect oneself against all this in poetry as well as in
politics.... Resistance is the opposite of escape. The poet who wishes
to contemplate the good in the midst of confusion is like the mystic
who wishes to contemplate God in the midst of evil. There can be
no thought of escape. Both the poet and the mystic may establish
themselves on herrings and apples. The painter may establish himself
on a guitar, a copy of *Figaro* and a dish of melons. These are fortifyings,
although irrational ones. The only possible resistance to the pressure of
the contemporaneous is a matter of herrings and apples or, to be less
definite, the contemporaneous itself. In poetry, to that extent, the subject
is not the contemporaneous, because that is only the nominal subject,
but the poetry of the contemporaneous. Resistance to the pressure of
ominous and destructive circumstance consists of its conversion, so far
as possible, into a different, an explicable, an amenable circumstance.

Wallace Stevens, "The Irrational Element in Poetry"

This book began many years ago as a formal and generic study, prompted by a museum seminar I gave called "Still Life Conversations." It was easy enough then to put aside matters of history and think about the poetry of the everyday, the metaphysics of the ephemeral, the textures and colors of domestic life, and the sympathy and rivalry between the arts. Still life, I assumed, was the opposite of history, which requires narrative and public imagery for its expression. But in some of the works I examined—still life paintings and collages, as well as poems that shared the quality and character of still life—history seemed to have entered the domestic setting, in the form of a map on a wall, a fragment of a newspaper, or more indirectly in the formal handling of the material. This was particularly true of works created in times of great public upheaval. The disposition of the works toward this intrusion of history varied. These intimate orders might convey empathy, shock, fascination, struggle, or resistance; a desire to transform or a desire to mend. As our own era became increasingly volatile and violent, I began to reflect more on the role of the arts, particularly the humble arts of lyric poetry and still life painting, in times of public disturbance. Were they a mere private indulgence, an escapist distraction? Or could these sensuous arts of the private, the everyday, the domestic, provide a medium by which individuals might encounter historical realities that were otherwise too distant, too vast, too mediated, too dangerous, or too impersonal to feel and comprehend? Of the many images that moved me during the destruction of the World Trade Center towers, one that stays with me is a still life—a bowl of fruit on a table, covered in ash (fig. 1).

My title derives from a late poem by Wallace Stevens, "The Planet on the Table." In that poem, Stevens contemplates his recently published *Collected Poems* (1952) and finds that it is good. "Ariel was glad he had written his poems" (Stevens 1997, 450). Appearing as it did at the beginning of the cold war, Stevens's volume might be seen to argue for art as a world apart, a protected sphere independent of history. Yet "The Planet on the Table" presents an argument for poetry quite opposite from the ideal of the autonomous object, the "globed fruit . . . / motionless in time" of Archibald MacLeish's "Ars Poetica" (MacLeish [1926] 2000, 331). Stevens writes that Ariel's "poems, although makings of his self, / Were no less makings of the sun." As Stevens looked at his *Collected Poems*, he valued it not as a total world

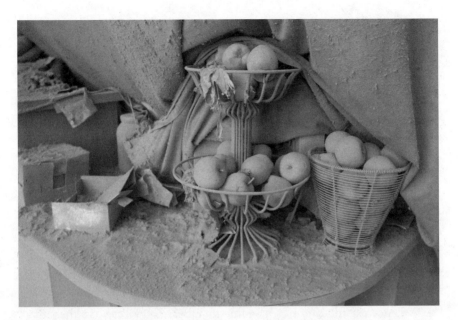

FIGURE I. Steve Wood, *Trade Fruit*, September 11, 2001. Inside the remains of one of the buildings in the World Trade Center complex. Reproduced with the permission of the photographer.

of art, but insofar as the poems "should bear / Some lineament or character, // . . . Of the planet of which they were part."[1] Stevens understood that the lyric connects itself to the world in a way very different from the novel. The lyric concerns itself not so much with the individual going out into the world as with the world entering into the life of the individual. "It is equal to living in a tragic land / To live in a tragic time," Stevens wrote (Stevens 1997, 183). "Not true," protested an Israeli listener when I read those lines at a conference. And yet there is validity in Stevens's words, at least a subjective validity, a lyric truth.

The history of poetry is a history of apologies, and over the past century, with its swelling catalogue of horrors, poetry has sometimes been blamed for turning its back on the suffering world. Its preoccupation with the self and its offering of private aesthetic pleasure has even seemed "barbaric" (Adorno [1949] 2002, 34). Few after World War I would be satisfied with the role for poetry that Arthur Davison Ficke set forth in the inaugural issue of *Poetry*: "It is a refuge from the stormy days, / . . . / Where beauty . . . / Enfolds the spirit in its silver

haze" (Ficke 1912, 1). Defenses of poetry have had to acknowledge the opposition. "There are things that are important / beyond all this fiddle," wrote Marianne Moore in 1919, strategically evoking an "interest" in, only after acknowledging a "contempt for," poetry (Moore 1981, 266). Yet when poetry takes to the streets or attempts to address a collective rather than an individual feeling, it sometimes loses its artistic vitality. Yeats, in "On Being Asked for a War Poem," declines the invitation to answer the demands of history, and there is more than an Irishman's distaste for English causes here:

> I think it better that in times like these
> A poet's mouth be silent, for in truth
> We have no gift to set a statesman right.
> (Yeats [1915] 1996, 66)

Are these the only roles for poetry in troubled times: escapism or silence on the one hand, or message-bearing politics on the other? "Poetry makes nothing happen: it survives," Auden famously writes in his memorial to Yeats (Auden [1939] 1976, 246). His essay "Writing" gives us an even more negative defense: "In so far as poetry, or any other of the arts, can be said to have an ulterior purpose, it is, by telling the truth, to disenchant and disintoxicate" (Auden 1962, 27). But is all enchantment dangerous? Auden also swore to defend to his death, as a political principle, "the right to frivolity" (Auden 1962, 89). Might the exercise of the imagination upon dishes of peaches and plates of fish, the exercise of the unreal on the sensation of the real, have some relevance to the struggles that we record as history?

In modern America, with its strongly pragmatic character, apologies for poetry have often attempted to explain its "usefulness." This has led to paradox and contradiction. Moore writes, equivocally, in "Poetry," "These things are important not because a / high sounding interpretation can be put upon them but because they are useful" (Moore 1981, 266–267). Never able to pin down this assertion, she deleted it from later versions of the poem. "Its uselessness may be its chief use," claims William Carlos Williams in his typically self-contradictory manner (Williams 1954, 179). By 1944 he is calling a poem a machine, an object created to be useful, but his emphasis in the analogy is on the economy of parts rather than the purpose for which the machine is designed. Machines are certainly useful in wartime. Are

poems? Even Wallace Stevens, a proponent of "pure poetry" well into the thirties, would admit in 1942 that the poem must be answerable to history. "It has to face the men of the time . . . / It has to think about war / And it has to find what will suffice" (Stevens 1997, 218–219). Yet Stevens's émigré audience at the 1943 Entretiens de Pontigny conference in exile must have been taken aback as he spoke of "The Figure of the Youth as Virile Poet." America was demonstrating its virility in the defense of Europe, but Stevens made no mention of the war when he spoke of the "radiant and productive atmosphere" of poetry (Stevens 1997, 679). Yet there was no need to mention what was on everyone's mind; the war was the conscious background and perhaps even the indirect referent in all Stevens argues concerning the "life apart from politics" (Stevens 1997, 678). So on this occasion he concerned himself explicitly with another war, the war that never ends between poetry and philosophy on the ground between art and politics.

Williams engaged in the same quarrel against the breaking up of life into rational categories and instrumental ideas. Ideologies impose static parts on the whole, leading to violent clashes in the public realm. Poetry takes the war inside and reconciles form with restless, boundless being; it takes the irreducible general culture into the particular, rather than generalizing from the particular. Art "closes up the ranks of understanding. It shows the world at one with itself. And it solves, it is the solvent—or can be—of old antagonisms. It is theoretical, as opposed to philosophy, most theoretical when it is most down on the ground, most sensual, most real," and most local. "A flower or bird in detail . . . becomes an abstract term of enlightenment" (Williams 1954, 198). Meaning for Williams inheres in the "radiant gist," a term he associates with Marie Curie (Williams 1992, 22, 173). Again we are in a radiant and productive atmosphere: "This paper is full of electricity," writes Williams. "I can hardly pick it up or lay it down" (Williams 1954, 198). For both Stevens and Williams, the artist's absorption in local, creative moments, which involve a certain withdrawal from public politics, can offer a "solvent" to a world fragmented by war and teach it how to be "at one with itself " in the lively integrity of its parts. In designing their planets on tables, these artists were certainly aware of another, hazardous model of the relation between art and politics, the one that treated the public realm as itself an aesthetic sphere, the state as a work of art, unified by a totalizing power.

Their local, intimate ordering of parts of a world offers a different way for the world to be one with itself, first one by one. In his diary, during the time he was working in a war plant, artist Joseph Cornell notes "allied control," and a few lines later "'unfolding experiences' as seeds—within itself so that the reader or audience may apply it to his own experiences" (Smithsonian, roll 1066.0571).

"Art is about beauty and politics is about just governance" is how Lydia Goehr has characterized (in order to interrogate) one version of the dichotomy (Goehr 2005, 472; see also Danto 1986, 1–21). The writers and artists who concern me here resist this sharp separation of powers even as they insist on their distinction. Certainly the pleasure principle is basic to the arts; they can bind us to the world by enhancing its delights, or draw us from the world into imaginary pleasures. The space of still life, with its absorbing textures, colors, and shapes, its play of light and reflection on surfaces transparent and solid, its dialectic of order and disorder, stasis and mutability, contains nothing that would seem to matter much in the affairs of the world. Some fruits or flowers, a broken dish, a light-drenched glass of water, the containers, utensils, consumables, and ornaments of the everyday, these subjects show off the skill and imagination of the artist, not his political or social insight. Such a disenfranchising of art from politics implies a harmonious division of labor, where the mind's synthetic impulses are restricted to the formal and imaginary realm, perhaps as compensation or consolation for a hostile and alienating reality, or perhaps as an arousal of the desire for harmony in other realms (Scarry 1999, 109). Here the ethics and politics of enchantment involve hope rather than agency. Another version, "art is about freedom and politics is about power," implies antagonism between the realms but still sees art as alternative, not just distinct (Goehr 2005, 472). "Freedom" here is more, presumably, than just freedom to "fiddle." In some versions of the argument it is a negative or silent freedom, imprinted on poetic form, which implies a protest against a distant and oppressive social condition. More optimistic arguments claim that art enlists the imagination in a construction of reality that is not only different from what is given but also capable of challenging it. Yet there is a gap in the logic which says that in resisting appropriation, art holds out as an enemy of the system. In the space between literature and politics, or between poetry and history, the possibilities for meaning and action are much less determinate and much richer than either construction allows. For unlike poli-

tics or philosophy, art offers what Stevens described as "an unofficial view of being" (Stevens 1997, 667). One might also call this an *individual* view or a *personal* view, but with the emphasis on a shared reality in which the official and the unofficial views communicate. These "unofficial" worlds made from local, intimate objects have a rhetorical power. One function of poetry might be to bring that reality out of the official (normative, collective, general, abstract) and into the unofficial (eccentric, individual, particular, sensate) view, then send it back again.

Threading any discussion of the relationship between art and politics is another discussion about one of the great organizing dichotomies of culture, that between the private and the public.[2] Current writing on this dichotomy has recognized how the two terms construct each other historically, and also how the referents can vary, leading to confusions and manipulations. Is the private/public divide a matter of economics? Of citizenship? Of social interaction? Is "the public realm" a space of impersonal statehood, technological and economic forces, and bureaucratic institutions? Or can there be a space of lively, free exchange of ideas and actions in contrast to these instrumental forces? Is "the private realm" a domain of bourgeois isolation and atomism, a repository of economic ownership, a domestic retreat? Or is it a space of intimate feeling, imagination, and personal freedom? Is the public space historical while the private space remains beneath or outside history? Or is the distinction a false one since "the personal is political" or since "privatization" is the trend of modern capitalism? The subjects of this study represent a range in the understanding and valuation of this dichotomy, as we shall see. For some, attention to intimate objects provides a discrete form of commentary and critique of the public world. For others, the aesthetic arrangement of the domestic world becomes a means of satisfying desire and awakening hope against the threatening forces of external reality. But the dichotomy is implicit in all their work, as is the desire to question both the extreme polarity of public and private, and the priority of one over the other. At the same time, each of these artists creates works for and about the life of the individual. If art must answer to history, they suggest, the art of poetry, like the art of still life, does so for the sake of the individual.

Whatever its choral roots, lyric poetry in modernity has been most often identified as part of the private realm, the feelings and environment of the individual. This has often been its defining generic characteristic, though it has also been confused with a preoccupation with

self, which is not the same as individual experience and feeling. (Nor is the individual's "unofficial view of reality" the same as solipsism.) Painting and collage, too, unlike statuary or architecture, have mostly belonged to this private realm, whether they hang on the walls of private residences or museum galleries. As vehicles for the expression of private experience, the arts of poetry and still life have sometimes been called upon to consider war or poverty or other public injustices, often from a great distance. But how can they do this without surrendering their allegiance to the life of the individual, the life felt in everyday moments or in metaphysical longings, not in the pageantry of public affairs? How does the artist bring news of distant events into the proximate realm—the realm of immediate perception and sensation?

At times poetry has certainly turned from its traditional commitment to the individual and focused instead on collective experiences, though a personal voice, often protesting a collective reality, remains. But it is also true that poetry may be most needed in its traditional function when the effect of great public upheaval is to undermine or destroy the feeling for individual life. In this case the role of poetry becomes to reawaken the sense of one's own life, not as an alternative to the world but as a "radiant and productive atmosphere" in which to confront that great pressure of reality. This bringing of the distant near, and this invigorating of agency within a proximate reality to meet the pressure of reality at large, precedes any political determination, though it may indeed refresh one's life as a citizen.

Poets might not agree with Hannah Arendt, who in *The Human Condition* argued that man is only really complete in his humanity in the public sphere, activating ideas in relations with others. Stevens, especially, preferred the contemplative life and the interior paramour, to any literal community. Yet even for him, as for many of his generation and after, poetry, made in the private realm, is nevertheless a kind of action and interaction in society. The woman in "The Idea of Order at Key West" is the maker of the world in which she walked, but the poet is not so solipsistic. He must turn "toward the town" and exercise his idea of order, his unofficial view of reality, in the social realm (Stevens 1997, 106). Yet he remains "an exponent of the imagination of that society" (Stevens 1997, 997). Arendt was one of many who decried the deterioration of the public sphere. The sense of crisis continues: we hear it in Jürgen Habermas, in Christopher Lasch, in Richard

Sennett. These thinkers express values that privilege the public realm of community and political action—of free exchange with others—as the apex of human existence. Personal life, for them, is a precondition or a remainder, but of little concern in its own right, and certainly not a moral or political priority.

This gives poetry a bad conscience, as a palliative at best or at worst an indirect agent of the crisis of community. Such a critique is unfair in part because so much modern poetry has been shaped to address it. But we might also consider that a crisis of the private realm is concurrent with the crisis in the public realm, that the life of the individual is besieged by the same forces that destroy community, and that the two realms should not compete, philosophically or practically, but support each other. (Indeed this is Arendt's view of the classical world.) Poetry has a role to play in creating a healthy congress between public and private, against the more restricting, even threatening tendencies of one to usurp or exclude the other. Yet if congress between worlds is the means, the end might still be, for poetry, the enrichment of the individual more than the citizen. Poetry, that is, can be a foyer, a place where the individual welcomes the world into his own domain and into his "unofficial view of being."

This book focuses on four American writers and one American artist. Since the wars of the past century have been "foreign wars," and since American culture was least inclined to threaten the freedom of the individual in his private sphere, the task of making history proximate has been especially challenging. What has the fascist bombing of Guernica got to do with the life of an obstetrician in New Jersey? Are everyday objects and sensations less important because so many lives are lost on an extraordinary day in Spain? The newspaper and radio brought distant crises and threatening, alien voices into American homes but left them abstract or disembodied. One task for poetry would be to register history within the emotional and sensate life of the individual. But how could the poet do this without displacing that life? Here a language of metaphor, symbol, and metonymy, engaging the particulars of everyday proximate reality, becomes more useful than reportage.

Aesthetically and spatially the relation between private and public is often one of scale as well as proximity, as Susan Stewart has shown. Power in the polis is often expressed in super-sized billboards, skyscrapers, and other monumentalities that create an effect of ubiquity

and impersonality. By the thirties many artists were beginning to recalibrate their sense of space, seeking an intimate, human scale of objects and relations in a world experienced as impersonal and chaotic, and against the outsized ambitions of the public realm. Modernity's expanded and fragmented space—its towers of glass and steel, its giant silver screens, the impersonal forces of capitalism and the state, the rise of totalitarianism—had not only undermined the participatory life of the polis but evacuated the realm of the personal as well. Many modernist movements sought to transform the physical and social environment in an all-embracing utopian methodology that dictated form to the last mechanical detail. A totalizing art, like a totalizing political power, imposes the part on the whole. Into this whole the individual vanishes. But the imagination can also use the part to evoke the whole, not extending out in solipsism but rather bringing multiplicity into the realm of the particular. Intimacy loves the miniature and the local, loves particularity. But intimacy need not be a closed chamber, poetry's world-in-itself. The bringing of parts of a world into the part reserved for the individual establishes a relation between world and self that is fluid and mutually supportive, the will fluently ordering in its small world the scattered or broken parts of a larger one.

So this remains a book about still life, about the poetry of the everyday, the aesthetic arrangement of domestic objects. The environment of still life is deliberately cropped off, squared off from the round turning world and the humans who make it—outside of politics, it would seem. Still life is shallow and artificial in presenting this world of domestic objects in stopped time. Its strategic, rarified light lifts the ordinary into the extraordinary and gives an eternal cast to the quotidian. Traditionally, still life is the art of the irrelevant—a form of pure poetry. Guy Davenport writes of it as a diversion: "Manet painting a bunch of asparagus is a man on holiday, like Rossini and Mozart having fun writing comic songs, or Picasso doodling on a tablecloth" (Davenport 1998, 9). But Manet's "holiday" was in fact an exile, and one might consider the public pressures that find their way into the intensity of this very intimate depiction. Perhaps his tender and honest rendering of a mean object was a way of pressing against the dangerous, hollow heroic rhetoric of his day. Still life's devotion to the material world can be a relief from the abstractions that erect false gods and

dangerously steer the public will. The contemporary Polish poet Adam Zagajewski makes a similar point in "A Defense of Ardor":

> The connections between high and low are complex. Let's take a look at one of Chardin's still lifes, perhaps his beautiful *Still Life with Plums*, which hangs in the Frick Collection in New York: what we'll see is apparently only a tumbler made of thick glass, some gleaming enamelware, a plate, and a bulging bottle. Through them, though, we'll come to love singular, specific things. Why? Because they exist, they're indifferent, that is to say, incorruptible. We'll learn to value objectivity, faithful depictions, accurate accounts—in an age so adept at exploiting falsehoods, particularly in Central Europe. (Zagajewski 2004, 10)

The connections between high and low are indeed complex, and it would be a mistake to read still life only as a relief from ideology, a utopia of pure objects. By drawing our attention to what is usually beneath our gaze, still life relieves us of our false abstractions; but it also gives a sense of importance to what is careless and entropic, and intertwines the low and ordinary with the high and heroic. Such transference is itself a potentially political act. It quietly reflects and critiques the public realm, and it offers amenable orders that awaken the desire for an amenable world grounded in reality. By engaging the senses so intensely, it ties the individual more powerfully to more remote realities. A defense of still life is a defense of lyric poetry, both offering a reality at once hypothetical and local. This book examines a number of American poets, and one visual artist, who have created intimate orders to express and enhance the sensuous and imaginative life of the individual. It finds in these works much evidence for an engagement with the world beyond the self, evidence that distant historical realities have become, through imagination, part of the life of the individual.

INTRODUCTION

CRUDE FOYERS

In the tonal quality of the French language, the *là* (there) is so forceful,
that to designate being (*l'être*) by *être-là* is to point an energetic forefinger
that might easily relegate intimate being to an exteriorized place....But
what a spiral man's being represents! And what a number of invertible
dynamisms there are in this spiral!

Gaston Bachelard, *The Poetics of Space*

Stephen Spender's comment in his autobiography, *World
Within World*, speaks for his generation: "By the end of the thirties pub-
lic events had swamped our personal lives and usurped our personal ex-
perience" (Spender 1951, 139). The same situation applied to American
artists and writers, politicized by the economic and social upheavals of
the Great Depression and alarmed by news of atrocities abroad. The
domestic life, not to mention the formal problems of the studio and of
pure poetry, hardly seemed appropriate content when people were be-
ing evicted from their homes, unable to pay the rent. The question be-
came not *whether* artists should concern themselves with politics but
how they should do so. The crisis of the depression led the majority of
artists and intellectuals to seek corrections in the social realm, and the
increasingly dire news from Europe sparked heated debates about
America's responsibilities to its allies. But the life of the individual, the
private life, the traditional subject of lyric, was not entirely evacuated.
In this book I feature the work of five artists who created intimate local
orders resounding with pressures from the public world but not

1

usurped by those pressures. In describing their achievement I hope to show how they responded to, rather than ignored, the imperatives of their time by reclaiming the space of the personal.

From Aesthetic to Social Imperatives

While the general trajectory of the thirties away from aesthetic and toward societal imperatives is familiar enough, a few examples bring out the character of art culture and provide a context for the poets and artists I discuss in depth. In place of new-art salons such as Alfred Stieglitz's 291 Gallery, artists organized in forums such as the John Reed Club of Writers and Artists, which inspired painters like Raphael Soyer, Ben Shahn, and William Gropper to abandon studio subjects for documentary ones. Journals such as *Art Front* (published by the Artists' Union and edited for a while by the painter Stuart Davis) and *The New Masses* (a revival of John Reed's magazine) combined art and poetry with political writings, and replaced earlier venues of aesthetic culture such as *The Dial* and *Camera Work*. The *Partisan Review* regularly published essays, letters, and journals from writers such as André Gide, Leon Trotsky, André Breton, Stephen Spender, and George Orwell who were reflecting on social revolutions in Europe and Russia and forging a new, political art to meet the demands of the age.[1] The American Artists' Congress and the American Writers' Congress (1936–1937) saw the artist as worker-citizen and discussed such issues as union organizing, welfare relief, credit reform, and war intervention. The WPA Federal Writers' Project and Federal Art Project were supporting artists and writers in their move toward the public sphere in making documentaries, murals, and anthologies of folksongs and stories. Surrealism, hosted in New York by the Julien Levy Gallery, offered an outlet for those who rejected populist and documentary styles, and was often condemned as decadent and self-indulgent. But it too responded to public urgencies, especially the nightmarish events in Europe described in the newspaper headlines. The surrealist painter André Masson spoke for many when he wrote:

> To wish not to recognize the concern of being in the world and of being part of the collective tragedy, to avow one's ignorance of the totality of existence, to take refuge in the practice of art for

art's sake, indifferent to the woes of the time, to exclude all representation of fear, violence, and of death . . . is nothing more than a derisive stance toward a world convulsed, prey to anguish and to war. The only justification of a work of art is to contribute to human development, to the transmission of values, to the denunciation of the dominant class, responsible for the imperialist war and fascist regression. (quoted in Sawin 1995, 54)

Those who resisted alliances with particular political groups, or believed, with Leon Trotsky, that "art can become a strong ally of revolution only insofar as it remains faithful to itself," nevertheless insisted that art must change its methods and its subject matter (Trotsky 1938, 19). Artists formed in the culture of modernism began to redefine their aims. Stuart Davis, for instance, who made the frontispiece to William Carlos Williams's avant-garde text of 1920, *Kora in Hell*, writes in "Why an Artists' Congress?":

In order to withstand the severe shock of the crisis, artists have had to seek a new grip on reality. Around the pros and cons of "social content," a dominant issue in discussions of present day American art, we are witnessing determined efforts by artists to find a meaningful direction. Increasing expression of social problems of the day in the new American art makes it clear that in times such as we are living in, few artists can honestly remain aloof, wrapt up in studio problems.

But the artist has not simply looked out of the window; he has had to step into the street. He has done things that would have been scarcely conceivable a few years back. (Davis 1936, 103)

Even those with more conservative politics responded to the pressure to address social inequities. Robert Frost's "Two Tramps in Mud-Time" (with its dialectic of love and need) and Marianne Moore's "The Jerboa" (with its division into "Too Much" and "Abundance") typify the widespread feeling that art must reconcile aesthetic impulses with economic realities.

For over a decade the realm of the personal, even for Americans, seemed doomed, or risky, or selfish. Modernist issues of consciousness, perception, and aesthetic autonomy were set aside by many younger poets for a style centered on witness and protest rather than

imaginative reinvention. In 1934 Kenneth Fearing published "American Rhapsody" in *The New Masses*, recording in lyrical rhythms the voice of the street struggling to survive:

> *She said did you get it, and he said did you get it,*
> *at the clinic, at the pawnshop, on the breadline, in jail,*
> *shoes and a roof and the rent and a cigarette and bread*
> *and a shirt and coffee and sleep—*
> (Fearing 1934, 96–97)

The incantatory listing functions as an anti–still life, presenting needs and wants rather than possessions. The imagery suggests the desperate effort to assemble the necessities of life, a stark contrast to bourgeois comforts. It shows little interest in private feeling or experience, let alone in the possibility of enjoying the object world aesthetically. We will see how Fearing's near contemporary Elizabeth Bishop managed to convey this sense of scarcity within an art that preserves sensuous beauty and an intimate dimension of reality. Fearing produces a litany of public shame.

The disturbances of the decade forced older poets to turn away from the personal lyric. Edna St. Vincent Millay had made her name in the twenties as a poet of love sonnets. But she took up the cause of Republican Spain, and then of subsequent nations falling to fascist forces. Indeed, her rallying poems became a regular feature of popular journalism. She records this pressure of news and its usurpation of personal happiness in "I Forgot for a Moment: July 1940": "I lived for a moment in a world where I was free to be / With the things and people that I love, and I was happy there" (Millay [1940] 2000, 330). This personal utopia is, the poem warns, a dangerous illusion, embattled by the terrors bruiting out of Holland, England, and France. Millay represents many writers in her readiness to put aside the pursuit of personal happiness. Indeed, this sense of disruption of the private life by the urgency of public events became a minor genre in the thirties and forties. Young poets like Muriel Rukeyser, a Vassar classmate of Elizabeth Bishop, made a deliberate choice to eschew the personal lyric in favor of political activism. "I lived in the first century of world wars," she writes in the retrospective "Poem," explaining her vocational awakening. The poet is stirred from the complacencies of her peignoir by the morning arrival of "the newspapers . . . with their careless stories." She finds her

voice in resistance to the hollow rhetoric of journalism and advertising which "attempts to sell products to the unseen." But this demographic "unseen" becomes her preferred subject. Remote, synthetic voices—the radio, the telephone—bring distant realities close and provoke the poet to "pen and paper." Such intrusions stirred in many writers a desire "to reach beyond ourselves" (Rukeyser [1968] 2000, 690).[2] Public priorities left little time in Rukeyser's generation for the delighted contemplation of texture, shape, color, and light in everyday objects.

The turn to social issues did not always lead to didactic or journalistic writing. Many of the rigors of modernist style, especially its impersonality and preference for the presentational over the descriptive, found new uses in poetry designed to encourage social cooperation. George Oppen preserves modernist economies of style but retains the Henry Jamesian close-up lens into private feeling—not his own but another's. This, he implies, is the first step into a view of the social and political world. He opens *Discrete Series* (1929–1933), a work prompted by the experience of the depression, with a portrait of a bourgeois individual, Maude Blessingbourne (a character from Henry James's "The Story in It"). In her comfortable privacy, she " 'approached the window as if to see / what was really going on.' "[3] Oppen's poem recognizes that political and social critique begins with the revelations of the isolated bourgeois individual, and with an opening of the domestic interior, even out of boredom, to knowledge of the world. The poem can be read as an allegory of this turn in the thirties:

> And saw rain falling, in the distance
> more slowly,
> The road clear from her past the window-
> glass—
> Of the world, weather-swept, with which
> one shares the century.
> (Oppen [1934] 2003, 5)

The poems that follow in *Discrete Series* encounter that "weather-swept" world. Oppen aimed to show us this knowledge out the window, beyond the "glass" of Maude's bourgeois encasement; indeed, he would obliterate the glass that separates her from "the century." But he suspended his poetic activity for many years. The demands of the lyric, with its tradition of individual feeling and solitary creation,

perhaps seemed at odds with this desire for sharing in the weather-swept public realm. Oppen became a union activist, returning only in the sixties to write *Of Being Numerous*.

Still Life Solutions

There was no going back to romantic inwardnesss or Victorian privacy. As W. H. Auden wrote before his emigration to America, "the glacier knocks at the cupboard . . . and the crack in the tea-cup opens / A lane to the land of the dead" (Auden 1976, 135). But if withdrawal into the personal, into bourgeois individualism, was unviable, another danger was arising in the very obliteration of the public/private dichotomy. The realm of the social, as Auden's friend Hannah Arendt pointed out, had overtaken the divide between polis and household and threatened to replace the lively congress of individuals with faceless collectivity and impersonal control. Her postwar concern was chiefly with the public realm—to rescue public discourse and action from the emptiness and loneliness produced by the totalitarian state in order to secure its power. But the recovery of the private realm, of individual feeling and creation, was similarly urgent, both for its own sake and to preserve lively association in the public realm. Against the impersonal forces that had usurped the public realm and diminished the private realm, the artists I discuss here sought to create tentative, partial spaces of order and beauty that might provide a conduit to the world without annihilating the personal.

The imagery and strategies of still life—those arrangements of quotidian objects in a shallow domestic space—provided a particularly productive focus for exploring the way the distant affairs of the world might reach into the life of the individual. Still life is a threshold genre which focuses on what is on the table, that private/public surface which we hardly notice but on which so much of life is centered. And it is often, throughout its tradition, combined with landscape, through a window that looks out, or a shape that suggests a wider topography. Still life is, then, one of many ways the arts find to bring the distant near and to relate to the world and public events within the private life. In the environment of still life the imagination can explore forces and contentions, whether formal or emblematic, which are elsewhere beyond the individual's reach, too abstract or too vast to be experienced

or confronted. This does not mean that the still life artist creates a miniature utopia. As Rosemary Lloyd notes: "It should perhaps be emphasized that a 'coherent whole' does not necessarily imply a sense of order. Often and increasingly so in modernist works, the still life objects convey a sense of messiness, of disorder, of chaos impinging on a world from which theological certainties were being eroded" (Lloyd 2006, xiii). We will see many instances of this impinging chaos in the works to follow. Nevertheless, as still life takes this chaos into its enclosed, personal space, it confirms our agency in the ordering of our lives.

Generically, I admit, still life stands at the opposite pole from an art of historical engagement. Indeed, in its association with the bourgeois individual it might even be considered an emblem of the enclosed world Miss Blessingbourne looks out from. Theodor Adorno certainly describes the bourgeois decorative interior of the nineteenth century as a form of still life; its objects are removed from use value but recovered for expressive and symbolic purposes, in an "arrangement" that held the trace of the dweller and his desires. Adorno critiques this practice because it is "historically illusory" and projects the fantasy of an "unchangeable nature."[4] Walter Benjamin, who celebrated the street, the loggia, and the arcade, clearly found nineteenth-century domesticity sepulchral. "To live in these interiors," he wrote, "was to have woven a dense fabric about oneself, to have secluded oneself within a spider's web, in whose toils world events hang loosely suspended like so many insect bodies sucked dry. From this cavern, one does not like to stir" (Benjamin 1999, 216). Like Adorno, he identified the nineteenth-century interior as an airless museum of still lifes. Benjamin's portrait of nineteenth-century dwelling is not without its nostalgic yearning, however, and the "porosity" and "transparency" of the modern world involved a loss.[5] Of course the diminished dwelling of his time was not just the consequence of modernist open-space architecture but eventually also of fascist confinements, displacements, and destruction: "for the living . . . hotel rooms; for the dead, . . . crematoriums" (Benjamin 1999, 221).

It was harder, in the twentieth century, to seal off the domestic interior and transfigure its objects into a merely private, nostalgic narrative. As Muriel Rukeyser testifies, the newspaper, the telephone, the radio, and later television, are all importing the distresses of the public world into the private realm and disturbing its timeless order. But

these devices bring impersonal voices describing remote realities that cannot be experienced directly. The artistic arrangements I describe in these twentieth-century works bring into the domestic and aesthetic sphere objects that absorb rather than shed history. The poems thus form aesthetic arrangements that register the pressure of the times and engage rather than escape the troubles of the turning world.

In their attention to small-scale, personal aesthetic orders and quotidian objects, these artists find new uses for still life, the lowest of the traditional genres.[6] Each of the artists I discuss is creatively engaged with his or her sister art and explores the wider possibilities of the relationship, both generic and local, between lyric and still life. Guy Davenport's *Objects on a Table: Harmonious Disarray in Art and Literature* and Rosemary Lloyd's *Shimmering in a Transformed Light: Writing the Still Life* survey various examples of literary still life, primarily from European prose. This book extends their discussion further into the realms of poetry and collage and locates these practices within a particular historical framework.

Still life is primarily associated with the emblematic tradition, with decorative impulses, or with formalist experimentation.[7] But as many scholars of still life have shown, the art form has always operated in a very immediate dialectical relationship with time and change, and its domestic arrangements have profound congress with the public world. It has, then, a philosophical and social dimension beyond conventional symbolism. Still lifes are not only synecdoches of the individual but also expressions of the individual's and the culture's relation to the wider world. In earlier centuries still life has sometimes been the vehicle for empire's self-reflection. Alexander Pope lightly mocks imperial display in "The Rape of the Lock" when he describes the "mystic order" of Belinda's vanity table, where "the various offerings of the world appear . . . / This basket *India's* glowing Gems unlocks, / And all *Arabia* breathes from yonder Box" (Pope [1714] 1996, 550). But by the 1930s the mock-priestly figure is Wallace Stevens's "man on the dump," a refugee sifting through the ruins of old cultural orders, finding empty containers, "the box / From Esthonia, the tiger chest for tea." Still life is now the work of the "janitor's poems / Of everyday" (Stevens 1997, 185). The still life and interior meditations I discuss in this study, both visual and verbal, tell a story less of mastery and appropriation than of imaginative and emotional connection

to a world from which they are apart but also a part; a world heterogeneous, dynamic, and perishable.

Still life concerns both objects and subjects—the social, personal, political meanings inherent in material culture; the desire to enhance, frame, and hold the sensuous life; and the simultaneous desire to transfigure the material, to locate a metaphysical or unconscious meaning. Of course the object itself had changed, particularly the object in art. It had been "cleansed" of association, objectified, made concrete. If late-nineteenth-century culture indulged in the invention and display of "things" (as Asa Briggs has catalogued in *Victorian Things* and Bill Brown has theorized in *The Sense of Things*), modernism preferred the illusion of "solid objects."[8] Particularly in America, objectivism—the "treatment of the thing and nothing but the thing"—would provide a cure for sentimentality and endow art with the precision and authority of science and the machine. Attention to "things" was a way of attaining knowledge. "There are things / We live among 'and to see them / Is to know ourselves,'" commented George Oppen (Oppen 2003, 163). To "know ourselves" in our social dimension, it seemed to Oppen and others, we must eradicate the personal. The poem itself becomes an object: "If it is perfect . . . you are not in it at all" (Oppen 1984, 16). But some artists, even William Carlos Williams, saw a limit to this momentum toward objectification. Although their work was profoundly influenced by the various image-centered poetics of the modernist movement, the artists I explore here are not objectivists, even when, as Williams writes, the artist "does not translate the sensuality of his materials into symbols but deals with them directly" (Williams 1954, 197). Williams explored "the poem as still life" not just to fix the object or reassemble it as an abstract design in the imagination, but to activate the individual life in its vigorous relation to environment and to "the weather" of the times. The poet reaches beyond his immediate environment paradoxically through an intense engagement with it: "From me where I stand to them where they stand in their here and now" (Williams 1954, 198). He says, "It is the life—but transmuted to another tighter form" (Williams 1954, 198). If Williams finds in still life the opportunity to be "not the breaker up but the compactor" (Williams 1954, 197) of life, Stevens uses the genre as a way to push back against the pressure of an external, historical reality. "The world about us would

be desolate except for the world within us," he writes. And the analogy he finds for this in the relation among the arts is reflected in his use of still life images. "There is the same interchange between these two worlds that there is between one art and another, migratory passings to and fro, quickenings—Promethean liberations and discoveries" (Stevens 1997, 747). Still life gave Bishop a way to think about foreignness, cultural difference, and inequality. It let Joseph Cornell place public events into private mythologies. It gave Richard Wilbur a model, and a recurring subject, in poems whose domestic ceremonies provide a precarious counterweight to violence and an assertion of peace against the memory of war.

A number of studies (e.g., Brown, Elkins, Erikson, Johnson, Mao) have brought "the modernist object" into critical focus. John Erikson's remark in *The Fate of the Object* is perhaps most pertinent to this book: " 'The concentration on the object in early modernism was a way of trying to fix the figure spatially against the ravages of time. But the object that proceeds from expressive labor out of the personal immediacy of perception newly emergent from the subjective depths of romanticism, finds only a tenuous existence as a thing-in-itself before it must encounter its ground in the social and in history" (Erikson 1995, 9). But the means of encounter are not a simple, linear travel between figure and ground. Few critics of poetry have addressed still life in particular as a medium for this encounter: the object in a specific tradition of aesthetic arrangement. More than portraiture or landscape, but often combined with these literally or metaphorically, it is a threshold genre, between nature and culture, morbidity and vitality. Still life ties us to our material existence, displays our cultural organization at its most elemental level, even as it may refer material objects to a symbolic associative or aesthetic plane. The stillness of objects, and their removal from scenes of production or use to a protected space of contemplation, has led some contemporary theorists, especially those following Adorno's lead, to view still life as a denial of time and history. Susan Stewart, in her suggestive study *On Longing: Narratives of the Miniature, the Gigantic, the Souvenir, the Collection*, has associated still life with the "disease of nostalgia." She writes: "Whereas still life speaks to the cultural organization of the material world, it does so by concealing history and temporality; it engages in an illusion of timelessness. The message of still life is that nothing changes; the instant described will remain as it is in the eye of the

beholder, the individual perceiving subject" (Stewart 1984, 29). An implicit warning against still life pervades her argument: still life collapses distance into proximity and past and future into present; it barters in false utopias of personal consumption and feeds the complacencies of the bourgeois subject. While Stewart's book opens up fascinating issues concerning the politics and poetics of scale and our life with objects, her conclusions seem overly burdened by reductive cultural critique, and frequently distort the actual instances of the imagination they purport to describe. Is it really true that still life conceals history and temporality? Doesn't it just as often in fact display them? Especially as we see poetry and art intertwining in these works, we will find that still life continually evokes narrative and history, just as accounts of narrative and history express yearnings for the suspensions and perfections of still life.

And one might question the supposition that illusion is inherently bad for us, that it necessarily causes us to forget reality, or even that nostalgia must always be understood as a sickness. (One thinks of the memorial function of objects in narratives of displacement by Walter Benjamin, Vladimir Nabokov, or W. G. Sebald.) But in terms of the artists who interest me here, my more important challenge is to read still life as a response to, rather than a withdrawal from, historical and geographic realities. To bring the world to the table is to touch the world and be touched by it. As Michael Taussig has argued, "The eye is an organ of tactility. . . . [C]opy and contact combine in mimesis" (Taussig 1993, 20). Like a parenthesis in a sentence, still life situates itself as a pause in a transitive reality. Like the cupping of a hand, it gathers and holds before us a small portion of the flux. It bespeaks the value of containment and framing which forestalls dissipation of radiance, small orders to satisfy for a time in a world that can sometimes seem overwhelming. Still life in the period after modernism becomes a means of relating to the dynamic world, with all its troubled history, on an individual, human scale.

My focus is not psychological, but the object relations theory of D. W. Winnicott in *The Location of Culture* does seem relevant. Antoinette Dauber has been especially convincing in applying his ideas to seventeenth-century poetry, and we might extend her notions to the work considered here. Winnicott writes of the "transitional phase" of development, in which the child, discovering his alienation from the world, forestalls this rude awakening by transferring his feelings of

at-oneness to a treasured object which symbolically restores the sense of wholeness. Winnicott often associated this process with a mature activity of making art. "But . . . seventeenth century poetry openly cultivated the intermediate space. . . . [T]he most salient feature of the lyric is the peculiar middleground it charts . . . somewhere between 'reality' and 'make-believe'" (Dauber 1993, 138, 146). Rather than replacing a lost wholeness, the poem as transitional object remains a lively threshold between imaginative order and the irreducible, turning world.

The most significant theoretical study of still life remains Norman Bryson's *Looking at the Overlooked*, a collection of essays that examines the social, economic, and spiritual meaning within these representations of "low plane reality." Like Stewart, Bryson sees still life as intransitive. Still life is "the world minus its narrative, or better, the world minus its capacity for generating narrative interest" (Bryson 1990, 60). As Guy Davenport and Rosemary Lloyd have shown, "writing the still life" is a perennial impulse in literature. But poetry's instinct in the face of still life composure is often to stir things up, to reinstate or expose narrative. Williams's 1944 volume *The Wedge* declares that "the war is the first and only thing in the world today" (Williams 1988, 53). He then turns to local, often domestic particulars, far from the theater of war—the "snake [waiting] under / his weed," "saxifrage . . . that splits / the rocks" (Williams 1988, 53). The stuff of still life, for Williams, is loaded with dynamic implication, and images and anecdotes of war constantly enter the still life environment. Even as still life draws us into its presence, into an illusion of perpetual gratification or an eternal moment of formal color and light, it often bespeaks the transience of the moment it captures and implies motion and change, violence and loss, in the disposition of the objects it represents.

In fact, as the literal history of still life objects is cropped out, the possibility for historical association is opened up at the metaphorical level. But the relation of still life to history is not passive or illustrative. Surrealist still life, for instance, with its "physical poetry" of radically juxtaposed objects, traverses the boundary marks of contingent reality and utilitarian meaning to exert pressure on reality from the unconscious. While the artists I discuss here were not surrealists, they all, in varying degrees, responded to the formal and thematic innovations of surrealism. The uncanny objects of surrealism—its fur cups

and lobster telephones—brought shock therapy to the domestic interior so that the violence within could interpret or overcome the violence without. Furthermore, still life develops affinities with the bi-directional art of collage, a medium that acknowledges irreconcilable origins and announces that its orders are not natural but fabricated out of the ruins of other orders. Collage makes an explicit link between personal, aesthetic orders and the fragments of history. Indeed it may be Picasso's first collage that Stevens evokes when he speaks of "a guitar, a copy of *Figaro* and a dish of melons." In 1912 Picasso did not paint a newspaper fragment; instead he tore and pasted it, a fragment that announced (with reference to the Balkans and here transposed to the art scene): "the battle is engaged."

The lyric imagination is drawn not only to the topoi of still life (flowers, tables, domestic and vocational objects) but to its aesthetic and symbolic arrangements as well, its metaphor and metonymy, its emphasis on the moment, and its interest in the intimate scale of experience, in the seasons and the senses. Lyric, like still life, explores the given and potential language of objects, their associative power, and their uncanny otherness, the way they evoke and refuse our subjectivity. Both offer us an oblique relation to the world, a space of reverie where time and materiality are altered. As Sharon Cameron, Jonathan Culler, Timothy Bahti, and many others have noted, lyric delights in playing on that word "still"; it shares painting's fascination with art's ability to capture ephemera and create a suspended present tense. At the same time, poetry shares still life's acute awareness of time and many of its symbols of mutability and mortality.

I do not attempt a survey in this book, but it is worth noting that the modern period, the focus of this book, has seen still life collaboration between Pierre Reverdy and Juan Gris, a tribute to Chardin by Francis Ponge, a book-length tribute to Joseph Cornell by Charles Simic, and a playful ecphrastic series by Howard Nemerov. Claes Oldenburg (who made poems as well as objects) "consider[s] visual art as poetry." For Richard Wilbur, "objects" attract the "devout intransitive eye" of painter and poet, but for Philip Larkin and Derek Mahon, this devotion of the senses yields to consumer culture's fetishistic displays. Not all writers are sympathetic to the spirit of still life. W. B. Yeats complained that the artists of his day were ignoring large ideas and powerful emotions in the human drama: "How many successful portrait-painters have given their sitters the same attention,

the same interest they have given to a ginger-beer bottle and an apple?" (Yeats 1961, 353). My argument will be (following Bryson) that while still life is the art of domestic detritus, these small gatherings evoke a larger, changing world.

In describing the search for a personal scale of order and meaning in a destructive and chaotic world, I take five primary examples. I begin with Wallace Stevens, who altered the ratio in his work between the orders of the individual and the orders of reality, especially under the "pressure of news." In the early *Harmonium* (1923) Stevens had eschewed the domestic "complacencies" of "late coffee and oranges" and (in "Anecdote of the Jar") made the planet his table ("I placed a jar in Tennessee") (Stevens 1997, 60). But in *Parts of a World* (1942) he suspects anyone who would take dominion; instead, he draws on still life motifs to reflect the violence and complexity of the world within a small, provisional order (Stevens 1997, 175). In chapter 1 I show how "the immense poetry of war" and the call to "heroic consciousness" enter into Stevens's still lifes without reconstituting the gigantic which troubles him (Stevens 1997, 251). William Carlos Williams, the subject of chapter 2, is explicitly associated with still life through his friendship with the painter Charles Demuth, his admiration of Juan Gris, and his constant attention to local, domestic objects. At the same time, Williams was well aware, through his medical practice, of the world beyond his "house in the suburbs" and "doctor's family" (Williams 1986, 218). A violence and turbulence characterize the poet's still life arrangements and connect private struggle to turmoil in the public world. My third example is Elizabeth Bishop, who would continue to bring the difficult world into a scale of intimacy. The city from her apartment window, for instance, becomes "a little chemical 'garden' in a jar" (Bishop 1983, 16). But since Bishop could not stay at home, her work increasingly moves out into lives of people and cultures less familiar. In this reciprocal movement she recognizes distance as well as proximity. Bishop "studies history" in the local arrangements of material culture—a whittled birdcage in Brazil, or the oily needlework on a porch table behind an American filling station. Like the photographer Walker Evans, she discovers aesthetic value in these spaces as well as social meaning, aware that these two impulses are not always ethically aligned. Within these objects reside stories of empire and migration, social aspiration and change

or stasis. While Stevens's imagination is primarily metaphoric, hers is metonymic. Throughout we see Bishop approaching cultural and domestic objects with an ethnographer's eye, which she ultimately turns on her own creative process. Her poems are full of souvenirs, and also the obsessive objects of trauma; ultimately, she reveals, the art of still life must yield to the art of losing.

With Joseph Cornell I move to a visual artist, albeit one obsessed with poetry. His work rewards the close reading more commonly brought to poems. He has been discussed as if he worked in a historical vacuum, interested only in ballerinas, movie stars, and penny arcades. But the economies of his art emerged at a time of economic and political crisis. In 1942 this "master of dreams" (Waldman 2002) placed a German-language map in a compass box, included in his Duchamp dossier a clipping about an air raid blackout, and built several "shooting galleries"; as the Allies bombed Naples, he memorialized the event in a cordial glass. Benjamin's description of the nineteenth-century interior might be a prescription for Cornell's art: "One might be reminded of the inside of a compass case, where the instrument with all its accessories lies embedded in deep, usually violet folds of velvet" (Benjamin 1999, 220). But Cornell's compass boxes, his "roses des vents," are tributes to exploration. Gaston Bachelard's *Poetics of Space* (which Cornell owned) could be an inventory of the artist's forms: "House and Universe," "Drawers, Chests, Wardrobes," "Nests," "Shells," "Corners," "Miniature," "Intimate Immensity," "The Dialectics of Outside and Inside," "The Phenomenology of Roundness." But history does not disappear inside Cornell's intimate spaces. His cabinets of Old World wonders contain the reverberations of a disturbing contemporary world. Cornell knew the hardships of the depression firsthand; he would have come into contact with the realities of European experience, at least through the émigré artists he was meeting. His collage "alchemy" of discarded and resurrected objects was deliberately incomplete, as it included not only personal souvenirs but scavenged relics of cultural memory too.

The work these artists produced during a period of extraordinary "pressure of news" set a direction they would pursue well into the more subdued postwar years. Although direct references to public crises recede, the sense of a fragile domestic peace, and a need for continuing contact with a disturbing world, prevail. Yet the desire to establish amenable local orders, and to mend the world shattered by

ruthless totalitarian orders, pervaded American culture. The power of that desire is most eloquent in the work of Richard Wilbur, whose poetry I discuss in chapter 5. While this is not strictly a chronological study, there is a sense in which Wilbur concludes the movement begun by American modernists facing the "pressure of news" in the thirties. His 1947 volume *The Beautiful Changes* moves between sights of desolation in contemporary Europe (he saw action as an infantry soldier in France, Italy, and Germany) and the abiding beauty to be found in nature, art, and domestic intimacy. The formal perfection for which Wilbur's work continues to be praised is a reflection of this desire of the whole culture for healing serenity after a period of destruction and chaos. Wilbur has been criticized as a "poet of suburbia" for turning out poems of pastoral pleasure and domestic ceremony. Wilbur's defenders, like Frost's, have emphasized the darkness surging within these poems, as if the expression of that darkness were the very purpose of writing. But as Wilbur himself has said, the desire to affirm and create intimate local orders is a profound human response to the waste and horror of war. If distant and proximate violence haunts the life of things, the poet's work is to cast a light on what can sustain us. The artist's instinct to "mend" a broken world, at least in the sphere of art, might be more than consoling, might be a way of resisting the violent orders that have shattered it.

Spirits in Foyers

In constructing intimate space and ordering objects to convey an imaginary relation to the world, these artists knew that the nineteenth-century mode of sealed-off privacy, whether desirable or not, real or only fantasized, was obsolete. Modernism had heralded in an antihumanist and antidomestic era of voids and transparencies, glass and steel; the International Style was more often about sublimity and power than intimacy, about bold public statement, not private ornament or eccentricity. Lewis Mumford was among the many public intellectuals beginning to question the thrust of modernist "technics" and the bureaucratization of modern life, asking, "Why has our inner life become so impoverished and empty, and why has our outer life become so exorbitant, and in its subjective satisfactions even more empty?" (Mumford 1952, vii). In "Technics and Civilization" he emphasized the need for

"personality" to reassert itself in symbols and illusions as a humanistic insurgence against instrumental technology and its consequences. (Orpheus, not Prometheus, was man's first teacher.) For Mumford, the individual is deeply tied to community, and his realization involves the engagement with a community he seeks to improve. In his emphasis on the life of the self needing to be tied profoundly to the collective experience, and in his warnings against mechanization and alienation, Mumford's utopianism is characteristic of the thirties. But the imagination requires a personal scale of illusions as well. As Walter Benjamin put it, revealing his ambivalence about the changes he observed, "The private individual who in the office has to deal with reality, needs the domestic interior to sustain himself in his illusions" (Benjamin 1999, 216). Noting the spread of modernist architecture, Benjamin continues, "Today this world has disappeared entirely, and dwelling has diminished" (Benjamin 1999, 221).

The old domestic interior lasted a little longer in suburban America, perhaps. Stevens, a generation older than Bishop or Cornell, came closest to experiencing this older world in Reading, Pennsylvania, and came closest to re-creating it in his own lifestyle in affluent, residential Hartford. In the 1950s he could write, "The house was quiet and the world was calm" (Stevens 1997, 311). But the troubling "cry of the peacock," and the more human cry of soldiers and hungry men, can be heard throughout his collected poems; coming from a world that is anything but calm, this cry enters his house and even his soul (Stevens 1997, 7). The humble, leaky dwellings Bishop describes stand in sharp contrast to the detested bourgeois interior of her Worcester relatives— but even there she is aware that "the war was on." The "*oh*" of global human pain enters her voice as well (Bishop 1983, 160–161). Joseph Cornell spent his childhood in a well-appointed bourgeois home in Nyack, New York. He treasured an early photograph that shows his genteel-era parents nestled before their elegant hearth and ornamented mantel; he would re-create this image in his *Paolo and Francesca* box collage. But the death of his father and the fortunes of the depression would send him, his mother, and his palsied brother to a less than utopian avenue in Flushing, Queens, near the "El," from which he would make his regular excursions to the Automats, flea markets, bookstores, and galleries of Manhattan. Cornell would draw on much of the paraphernalia of Victorian dwelling and encasement, but he would transform it to create a contemporary resonance.

Richard Wilbur's war experience took him into cities where the private life had been utterly shattered, where the conviviality of the table had been replaced by an occupied silence. The intimate, small-scale orders these artists create are not merely nostalgic retreats but conversions of ruins to creations; here the personal is not confessional or even biographical but rather a conduit between history and the theater of the mind.

While the solid objects of modernism were often isolated in an abstract space ("the thing and nothing but the thing"), still life gestures in the works I discuss here often evoke environments. In Williams's 1934 "Nantucket," the "white curtains" and "immaculate white bed" may evoke the page's blank space or the mind's purity, but they are first parts of an interior with "flowers through the window / lavender and yellow" and a "glass pitcher . . . turned down" next to a key, awaiting the next houseguest (Williams 1986, 372). Wallace Stevens begins "The Poems of Our Climate" with images that seem to transfer his poem from a summer to a winter scene: "Clear water in a brilliant bowl, / Pink and white carnations. The light / In the room more like a snowy air" (Stevens 1997, 178). In arranging and presenting things, those sundries of everyday living, as still life, these artists reclaimed a neglected private space. But the many anxieties of location arising within and after modernism—among them the collapse of distance, the violation and evacuation of the personal, the inhuman scale and power of the public realm—caused these artists to reconfigure intimate space even as they insisted on it. As they seek to retain or recuperate a sense of the personal, they define conditions of intimacy which connect them to external, even distant realities, making those realities themselves personal. The placid objects presented in "Nantucket" await the disturbance of human narrative. Stevens's "never resting mind" moves from still life to the world and back: "so that one would want to escape, come back / To what had been so long composed. / The imperfect is our paradise" (Stevens 1997, 179). While these porous environments forfeit the security and innocence of a purely transcendent interiority, they induce creative integration of proximity and distance, tying these artists to the world of ominous and disturbing circumstances even as they confirm an amenable personal, aesthetic space. I stress "aesthetic space" here because in representing certain intimate but permeable or liminal dimensions of

experience—foyers, desks, night tables, dining tables, alcoves, windows, open drawers, and chests—these artists are also configuring a space of representation, the scene of writing and the space of art. It is perhaps no coincidence that one particular object, the book, plays a strong role in many of these arrangements. Books bring this distance near, turn the world into a graspable object but without the pretense of domination. Indeed it is the mix of the real or physical with the make-believe or symbolic space, materiality and metaphor, that creates the conduit feeling I find so compelling in these works. Art is for them the place where we meet the other coming in as we leave our own chamber.

Wallace Stevens in 1942 expresses the pressure of reality bearing in on intimate dwelling:

> The way we live and the way we work alike cast us out on reality. If fifty private houses were to be built in New York this year, it would be a phenomenon. We no longer live in homes but in housing projects and this is so whether the project is literally a project or a club, a dormitory, a camp or an apartment in River House. It is not only that there are more of us and that we are actually close together. We are close together in every way. We lie in bed and listen to a broadcast from Cairo, and so on. There is no distance. We are intimate with people we have never seen and unhappily, they are intimate with us. (Stevens 1997, 653)

This transformation of dwelling was a matter not just of architecture but also of technology, such as "the broadcast from Cairo." Martin Heidegger, writing in the same period, saw radio technology in particular as a violation of ideal dwelling, another form of "enframing" that served instrumental reason and disrupted the essence of life to be reached by staying with "things themselves." As Carrie Noland writes in *Poetry at Stake*, "Radio is Heidegger's privileged figure for a false proximity, a technological eradication of the spatial . . . that only mimes proximity," as opposed to the poetic nearness of things (Noland 1999, 142). But the radio was a fact of American life as it was of European, even if the voices coming through it were less brutal and less authoritarian in America than abroad. Walter Susman, in his essay "The Culture of the Thirties," has emphasized the role the radio played in creating the "domestication of culture," a sense of a common

"voice." Roosevelt's "fireside chats" reinforced this sense of "from my living room to yours" (Susman 1973, 158–160). The radio appears in Bishop's work and Cornell's not as an interruption to authentic dwelling but as a link between the distant and the near reinforced by palpable objects. It is truly an object that speaks.

What Stevens presents in the quoted passage as a matter of distress becomes for him, and for other artists of his time, a source of creative possibility. Since modernity was producing a new experience of space, the artist must find a form of intimacy appropriate to such changes. As Victoria Rosner has shown in *Modernism and the Architecture of Private Life*, there is a direct link between the "interiority" of modernist consciousness and the nature of the spaces of domestic habitation. While poetry and painting may be associated with interior being, the very notion of interiority is itself subject to new definition, especially after modernism, holding in tension abstraction and materiality, metaphor and literality. "This definition is far broader and more permeable than the generally accepted critical view of modernist interiority, which emphasizes the mind's ability to craft an individual reality, to live in a world exclusively populated by personal associations and memories" (Rosner 2004, 11). To change a physical environment, then, was to change consciousness. Cognitive and psychological spaces—the metaphoric interior—are directly linked to physical interiors. In the period I examine here the physical interior registers the pressure of the public world; the dynamic of "home" responds to reverberations from affairs "abroad." And each of these artists shows, finally, that the polarities of inside and outside, private and public, here and there, are interwoven and dialectical in the human production of space. As Henri Lefebvre (a philosopher initially associated with surrealism) has shown in *The Production of Space*, the sense of a continuum from global, to intermediate, to private space is reproducible at every level of location. At the global level there are public buildings, but within them are the intermediate headquarters and the spaces reserved for an elite. At the intermediate level one finds avenues or squares, which lead to passageways, and on to houses. So in the private domain one moves from family rooms to thresholds to compartments for sleeping.

This sense of continuities between public and private habitation is heightened in the work of these artists as the divisions of the private space mirror and evoke (and not only metaphorically) the more global divisions. In these works the private space becomes a microcosm of the

world because the distance between planet and table is already collapsed by history. Stevens's meandering meditation on a glass of water turns into a town square in France; Cornell puts Italian street maps inside private alcoves; Bishop encounters an African village in a Worcester waiting room. For all three, the local space is a threshold at the same time that it has its own integrity as a location.

The foyer in particular, and similar intermediate spaces, become recurrent sites of this dialectical meditation, places where "here" and "there" meet and cross, and where the external and distant becomes the intimate and near. And we can take the foyer as a metonym for the inside/outside dialectic developed by all of these artists. A *locus amoenus*, the foyer is nevertheless open at both ends. Stevens uses the word "foyer" in only three poems, but it is central to each; the space might be seen as emblematic of more frequent instances of threshold phenomenology in his work. One can of course discuss the foyer entirely as a metaphor within the poet's phenomenology: the liminal condition between "imagination" and "reality," between ideality and experience. But these oppositions acquire social and historical implication for the poet writing in time of depression and war, a socially ambivalent poet drawn to an interior paramour but unable to shut out the clamor of news. So if the "foyer" in Stevens's poetry becomes a metaphor for the passage between imagination and reality, it retains its literal meaning as a passage between outside and inside, even between public and private space. In the foyer the distant other becomes the potential "interior paramour" (Stevens 1997, 444).

The term "foyer" carries an aural and semantic ambiguity which Stevens exploits as being akin to its liminal function. How should we pronounce the word? Is it French or English? In French its primary meaning is "hearth" or "nucleus," but in English, "entrance hall." Is it center or periphery? Most often the term is assigned to public places—theater or hotel lobbies, banks—but it later became associated with private houses, perhaps as people added a feeling of grandeur to private dwelling or had the luxury of an intermediate space. Stevens's house in Hartford has a very distinct front foyer protruding from the façade. But the architecture of the mind, as it greets the world, is less confident.

For example, the one-sentence poem "Crude Foyer" (in *Transport to Summer*, 1947) feels oxymoronic; its emotional and spatial reversals, its prepositional confusions, and its syntactic and semantic ambiguities

create a foyer-like form. But what is "a foyer of the spirit in a land-scape of the mind" (Stevens 1997, 270)? Is the spirit a foyer, does it create a foyer, or is the foyer an entrance to the spirit from a landscape of thought? And if there is a foyer in the landscape of the mind, must there not also be a mansion, or at least a dwelling beyond this public space, perhaps a "romantic tenement," to which this foyer is attached (Stevens 1997, 218)? The threshold thinking goes further as this foyer becomes a place where we are both king and comedian, where we pre side and critique, in which we "breathe the innocence of an absolute" but know this transcendental fiction as a falsehood. As "there" of regal (and tragic/historic) aspiration "turns out to be here" of the come-dian's ordinary world (the subhistorical world of still life and its detri-tus), as "sure to be able" returns to "incapable," we come back out of the foyer; but the foyer has become a place in itself, where happiness and falsehood, there and here, king and comedian, history and pri-vacy become entangled, even intimate.

Admittedly, Williams preferred attics to foyers, but the "happy ge-nius of [his] household" stopped dancing before the mirror early on and spent more time in the thirties looking out the window (Williams 1986, 86). In "Perpetuum Mobile: The City" he looks not alone but with his wife (Williams 1986, 430–435). Marianne Moore called this "an interior-exterior retrospect of life" (Moore 1986, 345), so we might think of it as functioning like a foyer, moving between recollec-tions of his marriage and domestic life and accounts of events in the distant urban reality they just glimpse from the window of their Rutherford, New Jersey, home. In the evening the city, which is invis-ible during the day, appears on the horizon as a flowerlike cluster of lights. Thus it becomes something intimate, like all Williams's flow-ers, yet also distant, like a star: a dream "of love and of desire." The poem acknowledges the artifice of this image, "more than a little false," and juxtaposes it to an everyday life of domestic objects: "we have figured up / our costs / we have bought / an old rug." Restive in such a quotidian environment the poet and his wife look with desire toward the urban lights, the "white northern flower." But the poet's mind turns abruptly from this dream to the coarse and even violent realities of the actual city, where desire is for "money!" and the scene is a robbery, or the desire is for food and the scene is sewage dump-ing. Between this dreamed ideal and this real the poet creates a "per-petual" foyer for the imagination.

We find similar threshold spaces throughout Bishop's and Cornell's work. If Stevens wished to overcome the feeling of being "a spirit without a foyer in a world without a foyer" by establishing a threshold in poetry, Bishop considered herself to be a spirit without a home. Her poems are full of cold parlors, abandoned nests, and leaky dwellings. Ideal houses are "perfect! But—impossible" (Bishop 1983, 180). Even in the most contracted spaces, the news of the world gets in. Inside always evokes outside, and windows predominate. While "In the Waiting Room" describes a semipublic space, its "arctics and overcoats, lamps and magazine" form a local still life (Bishop 1983, 159). Yet into this parochial space comes the world, through the window and through the *National Geographic*. The contagion of its images dissolves the boundaries of the book so that by the end of the poem, the waiting room is the center of a volcano.

Joseph Cornell's boxes would seem to offer the most extreme example of retreat into privacy and dream. Yet while the viewer is invited to linger before these displays, as before a store window, candy machine, or museum exhibition, he is not quite invited to retreat into privacy. The slot machine (which fascinated Bishop as well) designates a process of entry and exit, deposit and retrieval. *Penny Arcade Portrait of Lauren Bacall*, for instance, is generally treated as an instance of Cornell's romantic "star-gazing." But the box includes not only the famous studio image, surrounded by charming pictures of a preadolescent Bacall, but also several frames of the New York skyline, which move us back out from private to public space (whatever might be the skyscraper's potential as phallic symbol). It cannot be incidental, given Cornell's allusiveness, that this "penny" box is made in response to Bacall's first film, *To Have and Have Not* (1944), in which the foreground of romance is played against a background of historical crisis, economic and political. In this depression-era Hemingway story refitted as a World War II classic about a reluctant American hero (Bogart) in French Martinique, Bacall plays an adventure-loving, penniless girl who survives by stealing the occasional wallet, but who is essentially an innocent, especially as viewed against the backdrop of Nazi occupation and French resistance. Cornell kept a dossier he labeled "Working Model Based on 'To Have and Have Not,'" suggesting that the story itself, not just his personal obsession with this movie star, informs the assemblage. The city and the world form a background against which the individual portrait is drawn.

Richard Wilbur has been derided and praised as a poet of cold war restraints. He praises "things of this world," especially as they are drawn into the worlds of art and ceremony (Wilbur 2004, 307). Yet for Wilbur the negotiation of the proximate and the distant takes place in relation to the window, a structure he finds essential to the health of the imagination, and of the culture. Wilbur's still lifes and domestic interiors insist on the open window, the dialogue with the uncontainable world and with the reality beyond our fictive and personal orders. Shattered or darkened windows, drawn blinds, signify the dangers of both solipsism and totalitarianism; walls without windows threaten the death of culture.

For each of these artists the establishment of a space of "home," whether imaginary or experiential, is a central function of art as it negotiates between the private and the public. But others of Wilbur's generation and later would warn against the tendency to retreat into domestic complacency, where a partial world is mistaken for a whole world. Among these was George Oppen, driven to flee the country under McCarthyism. On his return to America and to poetry after a long hiatus, he brought a critique of the atomistic American dream ideology, "Solution." (The title, reinforced by the closing references to color, hints that this ideology is tainted by the same kind of exclusionism that led to Hitler's "final solution.") The world is in pieces, the poem reminds us, even if we assemble it into a pastoral fiction. This planet on the table is not a conduit to the world but an image with which we dangerously cover up reality:

> The puzzle assembled
> At last in the box lid showing a green
> Hillside, a house,
> A barn and man
> And wife and children,
> All of it polychrome,
> Lucid, backed by the blue
> Sky. The jigsaw of cracks
> Crazes the landscape but there is no gap,
> No actual edged hole
> Nowhere the wooden texture of the table top
> Glares out of scale in the picture,

Sordid as cellars, as bare foundations:
There is no piece missing. The puzzle is complete
Now in its red and green and brown.
(Oppen 2003, 45)

The task of postwar poets such as Plath, Ginsberg, Rich, and Simic and postwar artists such as Oldenburg, Johns, and Rauschenberg, would be to show us the sordid cellars, the primitive foundations, and the cultural waste on which we build the two-dimensional worlds we convince ourselves we live in. As objects are associated with social trauma, rage, anxiety, or cultural exhaustion, the uncanny resurfaces as a primary effect. In the conclusion to this book I examine some of these expressions of domestic disturbance. But in the work of the artists I describe here, the planet on the table serves to evoke, not to cover up, a broken, beautiful, unmasterable, heterogeneous reality. These artists, as Stevens says, "contemplate the good in the midst of confusion" and create orders that resist rather than escape the pressures of their times (Stevens 1997, 788).

ONE

WALLACE STEVENS

Local Objects and Distant Wars

The world about us would be desolate except for the world within
us. There is the same interchange between these two worlds that
there is between one art and another, migratory passings to and fro,
quickenings—Promethean liberations and discoveries.
 Wallace Stevens, "The Relations between Poetry and Painting"

Toward the end of his career Wallace Stevens had been think-
ing of George Santayana, that old philosopher in a hospital in Rome,
editing his manuscripts even on his deathbed, and perhaps he recalled
his teacher's definition of the poet's art, "the art of intensifying emo-
tions by assembling the scattered objects that naturally arouse [him]"
(quoted in Brown 2003, 14). That process of assembly, suggesting an
analogy with still life, is a labor Stevens describes throughout his
work, and at times he would draw explicitly on the art of still life to
stimulate and represent his poetry.

"The Poems of Our Climate" is probably the most famous of
Stevens's still life images. The opening of the poem captures the
enchanting world-unto-itself of impressionist light and color, a
"still" moment designed to "delight" a devotee of beauty such as
Santayana:

> Clear water in a brilliant bowl,
> Pink and white carnations. The light

In the room more like a snowy air,
Reflecting snow.
(Stevens 1997, 178)

As in all still life, the subject is not heroic or narrative but "low and round," yet quickly enough the grand tragic story of the Fall repeats itself through the agency of the "evilly compounded, vital I," and this "world of white" breaks open to human imperfection. A *paragone* arises between perfect images and "flawed words," between the presence of the carnations and the "never-resting-mind" that circulates around them, escaping and coming back, playing out its temporal destiny. If time and desire "compound" this scene, contemporary history seems utterly remote. Yet many of the other poems in *Parts of a World* can be easily linked to public events of the late thirties and early forties, when many "a violent order" was becoming "a disorder" (Stevens 1997, 194). Stevens is never journalistic, but history seeps into his meditations; he writes of Russia and Germany, of battleships and marching masses, of war and heroes, of "destructive force," ruins, and exile (Stevens 1997, 178). So among the many meanings of "the poems of our climate," it seems right to consider not only the heat of the inner life but also the compounded evil enflaming the times. This reciprocal movement—"escape, come back"—between a lighted room and a dark world is the logic I trace in Stevens's still life poems.

Stevens presents a curious case in the story of modernist obsessions with objects. While he proclaims his desire for "the thing itself," and while he kept up a lifelong poetic dialogue with Williams on the subject of ideas in things, he offers few metonyms, and little sensory description after *Harmonium* (Stevens 1997, 451). In the late poem "Local Objects" we are offered no samples of those things "more precious than the most precious objects of home" (Stevens 1997, 473–474). We know only that the retrospective speaker understood that he "was a spirit without a foyer" and that these objects are of "a world without a foyer." Perhaps this is why he does not describe them; though objects can through metaphor be transported to the room of the spirit, there is no common room in language between authentic spirit and the actual world. Yet these "few things / For which a fresh name always occurred" (never, then, merely denotative objects) are "the objects of insight" and thus, through the ambiguity in "of,"

issuing from world and from spirit. As such they create an image of "that serene he had always been approaching / As toward an absolute foyer beyond romance," where spirit and world might meet.

The late, retrospective "Local Objects" employs a language of domestic tranquillity that we might well associate with the art of still life. As in still life, the objects seem to be there "of their own accord, / Because he desired" (Stevens 1997, 474). But in the earlier "Man Carrying Thing" the activity is intense and exposed, far from the environment of still life (Stevens 1997, 306). The work obeys its opening dictum that "the poem must resist the intelligence / Almost successfully." The thing is obscure and the effort relentless. Man carrying thing is man making metaphor—poetry as transport, or at least transportation. (The poem was published in *Transport to Summer*.) In carrying something from here to there, in relating the "uncertain" parts of reality, man pursues the revelation of "the obvious whole." But the drama of the poem is in the snow "storm of secondary things" (manhandled, partial, obscure, ideological) that we must endure before the dawn of this "bright obvious" can stand motionless and unified before us.

That storm of secondary things dominates the volume *Parts of a World*, which Stevens wrote in the wake of the Great Depression and the onset of World War II. Then the whole was far from obvious; this was a period "of a storm we must endure all night, / . . . / A horror of thoughts that suddenly are real" (Stevens 1997, 306). I wish to consider Stevens's curious turn, in this stormy time, to the art of still life, and to suggest that this art is less (as one might expect) a retreat from the storm than a means of contemplating and resisting it. Contention is not, for Stevens, as it is for Williams, the end and animation of life. The conspicuous artifice of still life as a local human arrangement allowed Stevens the shelter of an order from which to feel remote disturbances and imagine, at least in moments of sudden rightness, harmonious alternatives. Yet the objects of still life are not described as things in themselves, in part because the poet refuses their utopian autonomy, reconnecting the figures of his private, imaginative experience to an uncertain, changing ground of actualities.

The study of Stevens's still life poems calls up complex issues of reference in the poet's work. That Stevens was never merely a "poet of the mind" but also always a poet of the world, "preoccupied by events," has been powerfully documented and analyzed by several

critics. James Longenbach in *Wallace Stevens: The Plain Sense of Things* reads the poems within the "pressure of reality" that helped to form them, and describes Stevens's reinvention of himself from a poet of formal experimentation to a poet of humanistic imperatives. In *Modernism from Right to Left: Wallace Stevens, the Thirties, and Literary Radicalism*, Alan Filreis traces shifts in Stevens's political sentiments through the thirties up to the onset of war. In *Wallace Stevens and the Actual World* he discusses Stevens's work and imagination within the context of American culture and politics in the war years and after.[1] Against the image of a poet working in the enclosed world of the poem, Filreis describes Stevens's attention to historical reality as an instance of the American isolationist tendency of the period to know facts at a distance and selectively, and with a mixture of disengagement and commitment. Filreis offers a nuanced and particular analysis of Stevens's development in these terms, moving toward a final postwar phase of "rhetorical power . . . that would at once reconstruct and contain the world" (Filreis 1991, 10). He portrays the poet as sometimes informed, sometimes willfully ignorant of, but always engaged with the historical reality in which he lived. Central to his argument is the poet's postwar correspondence with Barbara Church, in which he reveals a will to control and mediate his sense of the European reality, to sustain a "postcard-knowledge" (Filreis 1991, 227). This same image of the postcard has led Sarah Riggs, by contrast, to describe Stevens as a poet who practices "materialist-resistant methods" (Riggs 2002, 6). The verbal reality of the poem constitutes a "blacking out of indexical referents" just as the turning of a postcard to read its message blocks access to its photographic image. Stevens's "evocation of history and the actual world are a ruse, and what he is most after is a highly complex and sublimated poetic critique of the idea of reality *tout court*" (Riggs 2002, 6). An examination of Stevens's still life poems may suggest a stance distinct from either of these readings, materialist or autotelic. The fictional space of the still life is neither a means of protecting an idealized illustration of the actual world, nor a scene of resistance to indices of material reality, but rather a trope for that "foyer" in which imagination and world might meet.

A few of Stevens's still life poems of the late thirties and early forties are well known—for instance, the propositional "Study of Two Pears," which turns on cubist experiments in perspective (Stevens 1997, 180). In these poems the perfect "thing itself" eludes description

or fails to satisfy, and the poem becomes "compounded" with human desire and imperfection. Critics generally treat such still life poems in ahistorical terms of aesthetics and philosophy (Vendler, Bloom, Altieri). But Stevens wrote a number of other, lesser-known poems within this genre around the turn of the decade. Collectively and individually they capture his thinking about "the thing" in a public, as well as cognitive, "climate" of turmoil. I do not mean to suggest that the images of Stevens's still life are indices of the material world or allegories of the historical landscape. They are aesthetic objects suspended in an artificial space of contemplation, but they provide a starting point on the path between the private "climate" of meditation and the "climate" of the times. The connection is less substantive or referential than relational, as the energies of a disturbed world touch the field of artistic expression. In this way the still life poems reveal Stevens's thinking about the relationship of art to history.

Stevens's interest in his Dutch ancestry naturally drew him to the genre of still life, and this interest was further sparked, as Glen MacLeod has shown, by an exhibition in Hartford in 1938, which included a range of achievement in the genre. I agree with MacLeod, who follows the art critic Norman Bryson in associating still life with the value of the ordinary and the common, growing terms in Stevens's vocabulary as he sought a human scale. But "the common" has never functioned on a simple, metonymic plane in Stevens's work. And MacLeod is wrong, I think, to draw a distinction between Stevens's attraction to "the common" and his later concern with the heroic. As the pressure of reality enters the world of domestic arrangement, the imagination participates in the heroic.

This turn toward still life is a departure from Stevens's earlier work, in which he had continued the romantic preoccupation with landscape. Indeed, in "Sunday Morning" the poet is restive among bourgeois objects, within the "complacencies of the peignoir" and the breakfast still life of "late / Coffee and oranges" (Stevens 1997, 53). Where still life images do arise in *Harmonium*, as in "Anecdote of the Jar," they center and define a landscape rather than a domestic space (Stevens 1997, 60). Stevens's jar may signify the object as container rather than surface, a thing to put ideas in and also an ideational transparency around which things can be organized. (Stevens's jar in Tennessee is like Heidegger's jug in "Thing," a void constituted by the container, and a gathering of earth and sky.)[2] When the imperial speaker places his jar in Tennessee,

he makes the planet his table. Toward the end of his career Stevens would reverse this expansive logic, contemplating his *Collected Poems* as "the planet on the table" (Stevens 1997, 450). Late Stevens does not take dominion but expresses a feeling of intimacy and kinship between his words and "the planet of which they were part." In the mid-career work of *Parts of a World*, however, Stevens is still writing out the crisis of a fragmented world, the collapse of the sense of ordered reality that sustained such earlier landscape poems as "The Idea of Order at Key West." In *Parts* the landscape intimidates. In "The Dwarf" the subject is diminished by the pressure of the external world (Stevens 1997, 189); he describes "a weak mind in the mountains" (Stevens 1997, 192). So it is not surprising that the poet should turn to the shallower, smaller, more limited and private space of still life, and to the modest, aesthetic arrangement of domestic objects.

Stevens's turn toward still life in *Parts of a World* could easily have been a turn away from the world about him, a retreat into the personal, domestic aesthetic. Still life traditionally stands at the antipode of history painting, fixing an image most often beneath the concerns of history. Its depiction of everyday household objects, and its removal of these objects from human agency, satisfies a longing for decorative order and plenitude, a utopian image of material culture. For this reason still life has always been ranked lowest among the genres of painting. The genre was particularly appealing for modernist experimentation in the first decades of the twentieth century precisely because these objects are empty of historical significance and can be experienced as pure form; when the peripheral *parergon* (fruit, flowers, and ornamental objects) became the *ergon*, or central subject, formalism prevailed. But Stevens's turn to still life is not, as we shall see, a turn away from the world into petit-bourgeois concerns, or into formalism. The space of still life lies open to the world, which challenges the poet's quietude. These tentative, partial spaces of order and beauty provide a conduit to the world without annihilating the personal. These still life meditations tell a story less of mastery and appropriation than of imaginative and emotional connection to a world from which they are apart but also a part; a world heterogeneous, dynamic, and perishable.

Parts of a World ends with an unusual prose comment by Stevens that directly addresses the experience of scale, and of proximity and distance, in the pressure of a world at war. I quote just a few sentences

of this two-paragraph passage: "The immense poetry of war and the poetry of a work of the imagination are two different things. . . . [T]he poetry of war as a consciousness of the victories and defeats of nations, is a consciousness of fact, but of heroic fact, of fact on such a scale that the mere consciousness of it affects the scale of one's thinking and constitutes a participating in the heroic" (Stevens 1997, 251). Stevens goes on to acknowledge that "in recent times everything tends to become real, or, rather, that everything moves in the direction of reality." But the work of the imagination, in its "struggle with fact," is to come back to fact, and "not to what it was" but to "what we wanted fact to be." This distinction helps to explain why the poems in the volume to which this is a conclusion resist description or even sensory engagement. But it does *not* explain why so many of these poems (at least seven) are still lifes—meditations on small-scale decorative and domestic objects, on what art historians call "rhopography" or "low-plane reality."

One would expect a volume concerned with heroic fact to choose history or at least portraiture as its genre. What have these pink and white carnations, these bottles and pears and sundries of the table, to do with "the immense poetry of war"? The intimate scale of still life might suggest a poet nourishing himself on the sweets of art for art's sake while the world tears itself to pieces in the quest for bread. But "we are preoccupied with events even when we do not observe them closely" (Stevens 1997, 788). These poems do not isolate a purely aesthetic space, a mere poetry of the imagination. Nor do they approach the common objects of the table as peripheral, irrelevant matter in a world of heroic fact. I intend to show how "the immense poetry of war" and the call to "heroic consciousness" enter into Stevens's art of still life without reconstituting the gigantic that troubles him. In the language of the still life tradition, we might say that he intertwines "rhopography" and "megalography." More than landscape or portraiture, still life is a threshold genre, between nature and culture, vital and morbid, private and public worlds. Indeed, in choosing still life, Stevens insists on preserving an individual human scale of contemplation, a sense of the personal and the intimate with its accompanying desires; but he presents this as a struggle for tentative, partial experiences of order and beauty, always involved in a greater reality that gives them vitality and refuses them stability. In this way Stevens's still life brings the splintered planet to the table.

Attending more to the letters and prose writings than to the poems themselves, Filreis describes Stevens's development as "traveling a way outward toward wartime and postwar peripheries from a central, unmoving prewar identity" (Filreis 1991, xv). I want to suggest that this movement also describes the structure of many of his still life poems as they shift from the "here" of still life contemplation to the "there" of distant events. Stevens read two newspapers every day, and "the day's news" brought conflicts between capital and labor, "Japan brutalizing China; Italy invading Ethiopia; Falangist rebellion strangling Spain" (Filreis 1994, 25). Stevens's poems of the thirties are meditations, Filreis shows, on the artist's role in a disturbed society, part of a widespread debate in the literary and cultural community in which Stevens participated.

The poet's improvisations on still life objects feel this pressure of news. As the genre of the table and of the fruits of labor and economic exchange, still life becomes a site of reflections on hunger and poverty. As the genre of composure and peace, still life becomes a site of reflections on war and cultural transformation. Stevens does not employ social realism or any strictly indexical relation to history. Politically charged references become associated with philosophically charged themes. But their historical import is not thereby erased. Writing within a still life tradition, Stevens confronts contemporary challenges (from both popular and intellectual circles) to the aesthetic and to the personal, and brings the heroic and ethical into relation with these. Given the wide range of mood and disposition in his writing, it is striking that almost all of the still life poems introduce an element of violence. The violence from without threatens the security of the contemplative order; but by bringing that public violence into the personal, Stevens makes still life a field of action rather than a space of escape. The arrangements of still life are violently achieved and inevitably torn apart. And in *Parts of a World* this leaves Stevens vexed, uneasy.

As we saw, theorists of still life such as Susan Stewart and Norman Bryson tend to see these arrangements of everyday objects as antinarrative, as "the world minus its narrative, or better, the world minus its capacity for generating narrative interest" (Bryson 1990, 60). In one sense this is clearly the case for Stevens. Objects removed from use and mimetic context are set in a rarified space of the imagination. But Stevens's lyric poems reinscribe that narrative interest, not so

much in material histories of arranged objects (who grew or picked the pears we are studying?) as in dramas of disruption and assembly that represent the contingencies of form. Stevens is certainly tempted by the seductions of the still moment and its suspension of historical process, and his great subject is desire as it is aroused by the sensuous world he seeks to make personal; but by giving voice to the sensibility that yearns for this plenitude, he exposes the troubled, restless state that surrounds still life's orders.

In "A Dish of Peaches in Russia," for instance, he evokes a utopia of sensuous, erotic pleasure, the utopia of still life and its myth of presence (Stevens 1997, 206). The imagery seems in the spirit of one of Fantin-Latour's many paintings of peaches, which Stevens would have known. But before we are through the second line of the poem, this spell has been broken, and we enter a story of exile. The speaker who tastes, smells, and sees the peaches does not inhabit the space "where they are." Through the double reference to Russia, the exile of self-consciousness from integral being becomes linked to real exile under Stalinist terror, and the latter is not simply absorbed as metaphor. We might recall the real Russian exile who kept a shack near the Hartford dump within view of the Stevens's house, the likely model for the "man on the dump" who sifts through the ruins of his past (Stevens 1997, 184). The still life image here, the dish of peaches in Russia, evokes nostalgia in the I-as-Russian for a feudal utopia of "the colors of my village / And of fair weather, summer, dew and peace."

Like many modern American poets, Stevens believed that imagination was fundamentally nurtured by place and that the best art came from local soil. But he was in touch with émigrés in the art world, and the news coming out of Europe was all about invasion and displacement. One feels this historical pressure against the other examples of indigenous feeling in the poem. The "black Spaniard plays his guitar" against a background of civil war (and just a few years before, Lorca, poet of the Gypsy guitarists, had been murdered by Franco's henchmen); the Angevine absorbs Anjou (recalling "Study of Two Pears") as Germany advances on France. Into the window of reverie come the "ferocities" of modern class and national conflict; these are not just pressures from without: they become pressures from within that "tear one self from another." I am not suggesting that these poems are "about" specific historical phenomena; but neither can we see these historical references as a "ruse," as Riggs suggest, in the game of poetic

self-circulation (Riggs 2002, 6). Rather, the vibrations of history are transported into the meditative space, creating a relational rather than a substantive or referential connection between art and history. Still life evolves, paradoxically, into a scene of profound dynamism and instability for Stevens, in which temporality and history prevail. John Erikson's analysis in *The Fate of the Object* concerning the modernist relation of figure and ground is suggestive for this discussion of Stevens and still life: "The concentration on the object in early modernism was a way of trying to fix the figure spatially against the ravages of time. But the object that proceeds from expressive labor out of the personal immediacy of perception newly emergent from the subjective depth of romanticism, finds only a tenuous existence as a thing-in-itself before it must encounter its ground in the social and in history" (Erikson 1995, 9).

In "A Dish of Peaches in Russia," then, the speaker yearns for a consummation with sensuous objects, a being in his "whole body," which consciousness (and, I have argued, historical reality) denies him. But "The Glass of Water" defines the opposite move, from a purely transparent thing in metaphysical poise (still life's megalography or spiritual transfiguration) to opaque materiality and waste (still life's rhopography, its detritus) (Stevens 1997, 181–182). Shifting center to periphery, *ergon* to *parergon*, the poem moves from the "here" of lyric atmosphere to the "here" of locality and history, a move mediated by "ideas." The poem is difficult to follow, and this is deliberate; the language imitates this logic of increasing density and opacity.

What could arouse a fuller image of composure, purity, reflection and refreshment than a poem titled "The Glass of Water"? What could seem less "thingy" than this transparence? Yet Stevens is restive in such a place of ideality, a sphere of romance, as he says in "Local Objects," "with so few objects of its own" (Stevens 1997, 474). The poem explores violent refraction of the metaphysical and moves toward the formlessness and opacity of being. The center shifts from the metaphysical to the mental and textual, and then to the material. Coming directly after "Study of Two Pears" (in which "the pears are not seen as the observer wills"), this poem again creates a sense of tension between will and world, ideas and objects (Stevens 1997, 181). But from the outset it posits the physical and the metaphysical as indeterminate, metamorphic conditions, not only polar in relation to each other but also containing dynamic polarities within themselves. The poem begins in

a straightforward, demonstrative language, but one senses the anxiety behind this unstable identity of ideas and things; neither the glass of water nor its metaphysical type is a transparent center but only a swirl of parts that do not make a whole, a flux of states without equilibrium where container dissolves into the contained:

> That the glass would melt in heat,
> That the water would freeze in cold,
> Shows that this object is merely a state,
> One of many, between two poles. So,
> In the metaphysical, there are these poles.
> (Stevens 1997, 181)

The opening thought in this poem is stimulated by still life's formal play of surfaces and textures—liquid water against solid glass, and especially light coming in and distorting surfaces. Stevens also exploits the genre's iconographic potential. MacLeod reads the poem as an ecphrasis, claiming that the inventive line "Light / Is the lion that comes down to drink" derives from the lion image etched on a Netherlandish goblet Stevens saw reproduced in an art magazine. Whatever its source, the lion in Stevens is always a metaphor for natural energy that makes objects visible, and for poetic will, that "destructive force" which transforms objects, the light of the mind. Is there a foundational center to all this metamorphosis? "Here in the center stands the glass." "Here"—at the opening of stanza two, or in the metaphysical realm, or in a referential space? The imagery and the syntax (in this ten-line sentence) tell us we are not indigenes of any center. Violence breaks out as the metaphysical breaks down. The lion stirs the water: "Ruddy are his eyes and ruddy are his claws / When light comes down to wet his frothy jaws." The contemplative "pool" is obscured by "winding weeds" of reflection, and "the refractions, / The *metaphysica*, the plastic parts of poems / Crash in the mind."

Is this violence of *Parts of a World* a sign of the "heroic consciousness" that brings the imagination and the personal into relation with the "immense poetry of war"? As the weeds get thicker, the "here" shifts from the glass to "the center of our lives" (to the imagination of fact), but our lives are not centered in contemporary history; the center is moving. (And the center is also eventually shared, not a private

space any longer but a public space, a village.) The end of the poem confirms that the *"poles"* and *"states"* of physics and metaphysics referred to at the beginning take shape for the poet within the worldly struggle of *poli*tics and *state*hood.

The language of the last stanza moves us out of the still life environment and the mind's *metaphysica*. We enter a realm of contending ideologies and manipulations (or negligence?) of "politicians / Playing cards" on down to a condition of low-plane reality: opaque, disorganized, undifferentiated materiality and waste of "dogs and dung." But for Stevens this new centering is less a change of realms than a shift also from figure to ground, where center yields to periphery, here evoking there and there becoming here:

> . . . here in the centre, not the glass,
>
> But in the centre of our lives, this time, this day,
> It is a state, this spring among the politicians
> Playing cards. In a village of the indigenes,
> One would have still to discover. Among the dogs
> and dung,
> One would continue to contend with one's ideas.
> (Stevens 1997, 182)

Instead of a retreat from contention, still life offers an orientation to the crashing parts of the world. While there is nothing of the "heroic" in the peripheral world of dogs and dung, the last line is a mode of participation in the heroic in the very urge to move in the direction of reality but also of "what we want fact to be," a relation of center and periphery. Stevens has not chosen the path of modernist still life abstraction that, as Norman Bryson says, "takes mundane reality only as its starting point" (Bryson 1990, 86). The still life environment participates in the struggle that takes on meaning in history. Stevens, with America, was shifting away from an easy dichotomy in which "here" was a timeless realm of American stability and "there" a historical realm of European conflict (Filreis 1991, 10).

Stevens wrote "Martial Cadenza" in 1939, in explicit response to the invasion of Poland. The poet seeks the "evening star," as a "present realized" against the present struggles of "England . . . France / . . . [or] the German camps" (Stevens 1997, 217). That evening star may

represent the promise of art within the anguish of history. But this contrasts with another poem of the same year, "Man and Bottle," which shows Stevens resisting the retreat into "romantic tenements / Of rose and ice," instead describing "the mind" as "a man at the center of men," full of fury against "a grossness of peace," a complacent isolationism or aesthetic escapism (Stevens 1997, 218). We may observe here that the juxtaposition (and echo) of "man and bottle" is a familiar trope of modernist still life, such as we find in the work of Picasso or Juan Gris. The bottle is a figure for art, and it must stand alongside man as a center of tension rather than a spirit of consolation or evasive abstraction. So too the "glass of water" becomes a paperweight which Stevens shakes to meditate on the snowstorm of "secondary things," the world of contending ideologies.

In "Dry Loaf" we find a corollary to "The Glass of Water." This time the initiating focus is not on figure but on ground. MacLeod has persuasively associated the poem with a work by Miró, *The Old Shoe*, painted in 1937, during the Spanish civil war, and purchased by the Museum of Modern Art. It depicts a loaf pierced by a giant fork, and a single shoe looming in a stark, abstracted landscape of wavelike, luminous forms. Miró worked from a Spanish tradition (from Mendez to Picasso) which sets still life in landscape. Miró gives this juxtaposition a social and historical thrust by suggesting, in the eerie waves of color in the painting, the bloody upheavals of his native land. Stevens read about this painting in the *Partisan Review* in an article titled "Miró and the Spanish Civil War" by George L. K. Morris, written shortly after *The Old Shoe* was shown in Paris. The article reflects on the artist's struggle within the conditions of war that were affecting him personally as well as artistically. "The suave lyricism dries up before the new staccato rhythms," writes Morris. "He [Miró] fills other commissions for his government, and the resulting attempt at remaining impersonal becomes a strain on him. He must return to his natural beginnings if he is to stand securely, and so arranges into still-lives the household objects that dominated his first dry period" (Morris 1938, 33). The article ends with Miró's reflections on the collapse of the personal: "In the great epochs individual and community go along together; but today what do we have?" asks Miró, clearly lamenting the supremacy of the fascist and communist state, and the strain of the artist working within such pressures. The issues raised in the article—of lyricism drying up, of the individual responding to a

crisis in the community—inform Stevens's poem as much as the painting itself. It is tempting to read "Dry Loaf" as a defense of Miró, and of lyric, in desperate, arid times.

While Stevens does not live in the midst of these upheavals, his imagination does respond to the news everywhere of poverty and war, forces that starve out imagination and hope, and he attempts to work from these horrors toward "what we want reality to be":

> Regard now the sloping, mountainous rocks
> And the river that batters its way over stones,
> Regard the hovels of those that live in this land.
>
> That was what I painted behind the loaf.
> (Stevens 1997, 183)

Here, it would seem, still life conforms to "the violent reality of war" and its consequences (Stevens 1997, 251). Stevens designs an aesthetic not of Hartford and its middle-class comforts but of the "tragic time" in which he lives. Regardless of location, he suggests, we all stand before this bleak prospect. (No biblical transmogrifications here; the dry loaf will not feed the hungry multitude.) Yet this is not a poem in which the imagination, even as a dry loaf, merely succumbs to reality. Perhaps prompted by visual rhymes between landscape and still life in Miró's forms, Stevens moves from the foregrounded "dry loaf" to the mountain behind it. (He is remembering that New Englanders use the term "loaf"—Sugarloaf, Breadloaf—to describe such landscape forms.) The river over the stones becomes, as the poem undulates in clauses, a flock of birds; imaginations even of "the dry men blown / Brown as the bread" (reduced, perhaps, to material craving) awaken "because it was spring and the birds had to come." The birds suggest escape at first, but as "watery flocks" they (unlike still life) also promise transformation. The poet himself has a bird's-eye view. There are then two necessities, of arid rock and fluent river. Soldiers and birds become syntactically entwined here, both working together to move "in the direction of reality" transformed (Stevens 1997, 251). The soldier is a constant presence in Stevens's poems and often a challenge to the spirit of still life, but he is an ally to the poet who contends with his ideas. This "still life" is full of uncertain movement; it is "rolling, rolling, rolling." But if the poem takes the still life outdoors

and turns our attention to the movement in the landscape, the presentation of a fixed object in the foreground, the presentation of still life, provides us with an orientation, a sense of arrangement and form, and a local and individual connection to historical necessity.

Historical change becomes thematically central in "Cuisine Bourgeoise" (Stevens 1997, 209). The historical transition between one order and another is grotesque, and the poem conveys its horror. Here Stevens experiments with the *vanitas* mode of still life; skulls (or at least severed human heads) occupy the space of the table because we have turned in on ourselves; we have yet to harvest anything new:

> These days of disinheritance. . . .
>
>
>
> We feast on human heads, brought in on leaves,
> Crowned with the first, cold buds. On these we live,
> No longer on the ancient cake of seed,
> The almond and deep fruit.
> (Stevens 1997, 209)

War is a time of negations rather than beliefs, and a time of cultural self-consumption, when the "table [is] a mirror" (another *vanitas* image) and not yet a setting of "completely new objects" (Stevens 1997, 307); the "first cold buds" at this point simply add to the grotesquerie of this anti-pastoral. The cultural harvest has no fresh taste of reality. But to consume the "bitter meat" of failure is a preparation for the heroic, as the shift to third-person plural at the end of the poem suggests. "Who, then, are they, seated here? / Is the table a mirror in which they sit and look? / Are they men eating reflections of themselves?" The implication is that man cannot live on reflections alone; he needs a new knowledge of reality to nurture his soul.

Biblical story echoes in this poem not just as a lost coherence but for its analogies to modern times. The "ancient cake of seed" suggests the loss of ancestral (Judeo-Christian?) tradition. The poem was most likely inspired by Lucas Cranach's painting *The Feast of Herod*, which Chic Austin had recently acquired for the Hartford Atheneum in 1936 (fig. 2). Courtiers sit around a table set with plates and knives, ready to consume the head of John the Baptist, as servants bring in a plate full of grapes and other fruits and nuts. The line "The words are written, though not yet said" suggests the writing on the wall at Belshazzar's

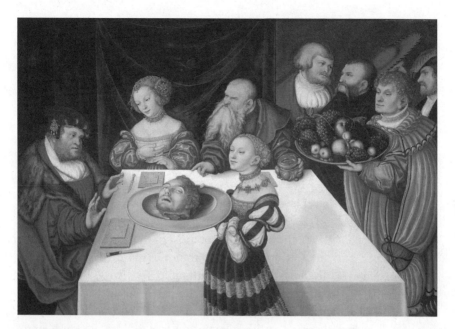

Figure 2. Lucas Cranach the Elder, The Feast of Herod, 1531. Wadsworth Atheneum Museum of Art, Hartford, Conn. The Ella Gallup Sumner and Mary Catlin Sumner Collection Fund.

Feast. These allusions hint that this modern crisis of the bougeoisie is a reverberation of earlier cultural transformations.

Who, then, are "they" seated at the table, in a poem that began with "we"? What is the proper voice of a still life poem? In each of the works we have considered, the isolated "I" of lyric and private space of still life have opened a foyer to the public, whether "the hungry that cried," "the soldiers that marched," the politicians who played cards, or all of us individually, "at the center of our lives," subject to the changes of history and cultural order. But this "we" at the end of "Cuisine Bourgeoise" must not solidify, must keep shedding into the "they" of past arrangements.

Fragmentation and disturbance are the conditions of the world as Stevens writes these poems in *Parts of a World*. These works offer neither comprehensive ideas of order nor contact with things in themselves. Ideology is for Stevens a scrim between us and reality dividing it into parts. We are "conceived in our conceits" and remain in a "prelude to objects." As Eleanor Cook has shown, Stevens here casts synecdoche in doubt. Part/whole relations are unresolved; the personal

seems broken from, or crushed by, external events. Still life's rhopography, imagery of the trivia of everyday material living, isn't so easily transfigured to megalography, the heroic or the numinous essence. Indeed, this volume also contains "The Man on the Dump," which subjects still life's personal arrangements and vain packagings (the "bouquet," "the box / From Esthonia: the tiger chest, for tea") to the law of entropy and the will to destruction (Stevens 1997, 184). Such rejected trash has always been recycled in the still life tradition. But if trash is still life's destiny for Stevens, it is not still life's only message. He responds to a world torn in pieces, and he struggles within the still life aesthetic to achieve heroic consciousness. He responds to fact but can imagine and therefore bring fact toward "what we want it to be."

As we have seen, the movement of most of these poems is negative; violence and uncertainty enter the tranquil space of still life. Dry loaves and skulls displace the abundant table. But *Parts of a World* also affirms: "After the final no there comes a yes / And on that yes the future world depends" (Stevens 1997, 224). "Woman Looking at a Vase of Flowers," despite the title's invitation to indolent pleasure, starts with the violence and thunder of a gigantic reality shattering into particulars (Stevens 1997, 223). While the poem makes no overt reference to contemporary history, "The crude / And jealous grandeurs of sun and sky / Scattered themselves" into the palpable forms of low-plane reality. But parts of the world do not leave winding weeds or dirty water this time. The storm of secondary things is a summer storm. And as things "escape" their "large abstraction" and enter material definition, they can be gathered into still life's "human conciliations." Here, for the woman looking, things "fell into place beside her." Stevens as a pragmatist offers an image of momentary conciliation in a time of worldly conflict and stress. The bouquet does not inspire a clairvoyance of original grandeurs (a transparent metaphysical center), but it does invite "a profounder reconciling" of "the crude and jealous formlessness" with the human need for intimate arrangement. In this way "Woman Looking at a Vase of Flowers" takes the floral still life as an emblem for the role and nature of lyric poetry with its "flowers of speech." Here I allude to the broader analogy that Stevens points to between still life and lyric—both arranging objects in sensuous and semantic orders, both celebrating the everyday. The woman looking has none of that Sunday morning complacency; her human arrangement of the flowers has the force of epiphany.[3]

Stevens largely abandons still life after *Parts of a World*. Indeed, in "Notes Toward a Supreme Fiction" he mocks the "President" who "ordains the bee to be / Immortal" (Stevens 1997, 337). He has "apples on the table" and "servants" who "adjust / The curtains to a metaphysical t," but he is displaced by the planter who works with seasonal change rather than against it. At the end of the poem what gives pleasure is motion:

> And we enjoy like men, the way a leaf
> Above the table spins its constant spin,
> so that we look at it with pleasure, look
>
> At it spinning its eccentric measure.
> (Stevens 1997, 350)

He is more focused on the expansion of the human imagination, the "gigantomachia" of human arrangement in relation to sky (Stevens 1997, 258). This enlarged scale continues through "Auroras of Autumn," which MacLeod has associated with still life's opposite, action painting (specifically with the work of Jackson Pollock). But the volume *The Auroras of Autumn* in fact closes with "Angel Surrounded by Paysans," a poem inspired by the Pierre Tal-Coat still life Stevens purchased from Paule Vidal (fig. 3). The poem gives no hint of its source (letters to Vidal tell the story); the Venetian glass bowl and humbler surrounding vessels appear as a "necessary angel" and human community (Stevens 1997, 423). But the still life stimulus for the poem suggests again for Stevens the planet on the table.[4] As a low genre, still life evokes the common spirit of the "paysan"; indeed, a "paysan" could have made the terrines and bottles or sat at the table Tal-Coat represents and Stevens carries over. The scene of hospitality, and the threshold experience suggested in the "welcome at the door," retain the mood, if not the substance, of still life. The necessary angel, the *numen* of Tal-Coat's simple pots and bowls, is surrounded by paysans and at the same time hovers at the welcoming door. She is a figure both of the center and of the periphery, the heroic and the common, megalography and rhopography.[5]

In *Parts of a World* we saw still life's "here" dispersing into "there" and often tearing one self from another in the process. Even in "Notes toward a Supreme Fiction" we can detect much skepticism toward the

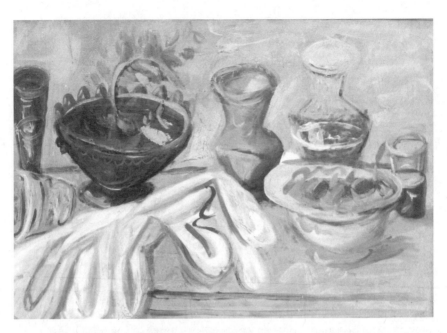

Figure 3. Pierre Tal-Coat, *Still Life*, copyright 1943. Courtesy of Peter R. Hanchak.

ambition of still life to master reality. "The President has apples on the table / And barefoot servants round him," but death lingers in "memory's dream." Yet in the late work still life brings a buzzing reality swarming and gathering to local objects. Instead of dissolving object into world as a spinning leaf, that is, he brings the world, contemplated as an object—an apple, pineapple, bouquet, book of poems—to the table. He finds ways to experience provisional order and plenitude under the motion and pressure of reality. Poems such as "Someone Puts a Pineapple Together" (explicitly still life in its constant reference to "an object on the table") acknowledge "the wholly artificial nature" of human arrangement (Stevens 1997, 693).[6] The object is seen not as a thing in itself, or as a machine made out of words, but as an individual human assemblage (variously metamorphosed into urn, owl, volcano, coconut, and cockerel in one, a table Alp, and numerous other objects). The object is inseparable from the erratic, metaphor-making will. Stevens likes the pineapple as an American symbol of hospitality, a local version of still life's *xenia*, or sign of social gathering. The poem invites the world (in fact "three planets: the sun / The moon and the imagination") into the domestic space,

"concourse of planetary originals, / Yet, as it seems, of human residence." The pineapple stands for a faceted, layered, and prismatic reality—the many in the one, "an object the sum of its complications, seen / And unseen." It retains its exoticism—a thing of the South, of the Americas, but not of the North, though exported to the North to be enjoyed in Connecticut households. It is precisely not the fascist bundle in which the individual, the particular, disappears into a totality. The poem returns, as Charles Altieri has said, to argue with the earlier poem "Study of Two Pears," with its longing for the thing itself. Reality must include all the perceptions of reality. But while Altieri reads this poem in the context of philosophical aesthetics and modernist abstraction, as a struggle within the faceted mind of the poet, we might also recall the historical struggle among parts of the world that had lately pressured Stevens's meditations. The object-as-earth is not just a simple thing of green nature but must admit "enlargings and pale arrondissements, / ... the furious roar in his capital." Stevens speaks here of the "scholar" or rational being whose thoughts divide and administer an intuitive reality; but the language of the polis is not merely metaphoric.

In the early poem "Anecdote of the Jar" Stevens lamented that the still life object "did not give of bird or bush" (Stevens 1997, 61). But the pineapple, by contrast, is a "fund." The perceptual order is performative rather than constative, and the performer is anonymous. Who is the "someone" who puts this assemblage together? Not just the artist but any beholder, or all beholders, each retaining his unique experience. The pineapple comes to symbolize the world both as an object beheld and as a community of individual beholders. The "ephemeras of the tangent swarm" in the still moment and give off the sense that "the truth was not the respect of one, / But always of many things" (Stevens 1997, 695). If the pineapple is the planet on the table, Stevens reminds himself nevertheless that "this is everybody's world," not an imperial possession. In this sense still life and its "wholly artificial nature" can bespeak "a total reality."

The "swarm" as a solution to the fragmentation of "parts" or the reduction of many to one emerges often in Stevens's late poems. The local gatherings of still life become models of human conciliation with "total reality" and human imagination. Just as this long poem "Someone Put a Pineapple Together" rewrites the brief "Study of Two Pears," so we can read the thirty-five-stanza poem "The Bouquet" as a

sequel to the shorter "Woman Looking at a Vase of Flowers." This poem flaunts its transfiguring powers; "things" become "para-things" and men become "meta-men" (Stevens 1997, 384). The bouquet is not one of these "choses of Provence growing / In glue," a static, nostalgic object, but a drama of perception akin to the work of a Cézanne or Van Gogh. The "eccentric twistings of the rapt (yet unwrapped) bouquet" are held in place by the red-and-white-checkered cloth, symbol for the poetic structure of this improvised meditation, and the structural objecthood underlying this "fund" of metaphor. As the poem pursues the enticing reds and blues of imagination and reality, we are finally transfixed by a "whole appearance that stands and is." But the final canto marks the end of the performance and reminds us that the world of meditation can never contain the historical world, even as a swarm. The violence within, the "lightning in an inner world," corresponds to an outer violence that has yet to subside. The "soldiers" of the poems of the 1930s, who were "Marching and marching in a tragic time" in "Dry Loaf" are apparently still on the move (Stevens 1997, 183). In brutally matter-of-fact, clipped syntax, utterly unlike the delightful tangents of meta-men and para-things that precede it, Stevens abandons the bouquet:

> A car drives up. A soldier, an officer,
> Steps out. He rings and knocks. The door is not locked.
> He enters the room and calls. No one is there.
>
> He bumps the table. The bouquet falls on its side.
> He walks through the house, looks round him and then leaves.
> The bouquet has slopped over the edge and lies on the floor.
> (Stevens 1997, 387)

From the beginning of the poem Stevens has reminded his reader that this space of still life has a door and is part of a larger world. The space is entered ("one enters, entering home, / The place of meta-men and para-things"), is looked out from ("Through the door one sees on the lake that the white duck swims"), and is implicitly exited. At the end of the poem the human perceiver, the being through whom things become para-things and funds of metaphor, vanishes. "No one is there." The performance is over. By leaving the door of this meditation unlocked, by displacing the poet with the soldier at

the end, Stevens relinquishes still life's myth of eternal present and disperses its swarm. But he will return repeatedly to gather "local objects," not "objects of home ("complacencies of the peignoir," totems of origin and indigenous being, or fetishes of the past), but things taken from their habitation in the changing world and made "objects of insight, the integrations / Of feeling" (Stevens 1997, 473). The space of still life is not the "absolute foyer beyond romance," but it may stand for it, stand for a meeting place of spirit and world, and thus stand for the poem.

TWO

William Carlos Williams

Contending in Still Life

A flower within a flower whose history / (within the mind) crouching /
among the ferny rocks, laughs at the names / by which they think to
trap it. Escapes! / Never by running but by lying still.

William Carlos Williams, *Paterson*

In the modernist dialectic of ideas and things William Carlos
Williams clearly weighted his energies toward things. Yet his work
supports Wallace Stevens's claim that "the subject matter of poetry is
not that 'collection of solid, static objects extended in space' but the
life that is lived in the scene that it composes" (Stevens 1997, 658). The
life Williams lived in that compositional scene was often tumultuous.
"Restlessness," its very "shape," characterizes his art (Williams 1986,
378). Marianne Moore saw this when she reviewed *Collected Poems,
1921–1931* for *Poetry*: "Struggle is the main force" (Moore 1986, 325).
At the same time, no poet has been more insistent than Williams on
the local or more ready to fix in the mind the ephemera of the every-
day, "things others never notice," "old things, shabby things, and
other things," as Moore also said of him (Moore 1986, 325, 145).
Williams's eye most often studies stationary objects—flowers, eye-
glasses, a plate of fish, a pitcher and key on a night table—and this has
led many to read "the [Williams] poem as still life" (Djikstra 1969,
163), and to associate his art with precisionist strategies for presenting
the object in space (Djikstra, Tashjian, Schmidt). Yet his poems reflect
futurism as they create a feeling of motion, turbulence, and conflict,

often in unexpected places: "petals radiant with transpiercing light / contending / above the leaves" (Williams 1986, 184). Reality itself seems in Williams to be infused with torsions forcing "acrobatic" motion: "each petal tortured / . . . each petal / by excess of tensions / in its own flesh / all rose" (Williams 1986, 424, 423). Still life is about Life for him, not *nature morte*, even when the object is inanimate. For Williams, every "poem as still life" is an image of the world's dynamic, contentious core, which escapes codifying abstraction, "never by running but by lying still" (Williams 1992, 22). In Stevens we saw still life as a contemplative space disturbed by the restless mind and the violent pressure of reality. In Williams the still life environment is itself a concentrated turbulence which the poet creates to quicken a static perception of reality. Deliberate assembly and disarray produce the poem's tense equilibrium. Such actions counter old regimens of thought that would impose a narrow order on the world. For Williams, then, a poem does not simply respond to its times; it presents a spatial compression of historical process, a "flower within a flower."

While Williams may naturalize struggle, it is useful to look for contemporary sources of this contention, even if it remains indeterminate. Is the struggle merely perceptual—the quickening of the mind and eye, darting among the visible forms? Is it the violence of literary modernity itself in the making of something new, contending against the aesthetic forms of the past? Or is all this strife amidst petals and leaves a parable of man's own restiveness within the confines of his domestic and workaday routines, the "hemmed-in male" trying to "quicken" a static situation (Williams 1986, 273)? Finally, do these dartings and piercings of light and color relate to a more public, historical struggle? The answer of course varies from poem to poem and along the trajectory of Williams's career. Longer poems, such as "The Crimson Cyclamen" or "Asphodel, That Greeny Flower," engage many of these sources of tension at once. But whether long poems or short, "the poem as still life" allows these forms of "contending"— aesthetic, perceptual, psychological, political; personal and public—to interact.

Wallace Stevens's introduction to Williams's *Collected Poems, 1921–1931* (published in 1934 by Objectivist Press) focuses on the struggle of the romantic poet against the lure of the unreal. Stevens read what he called Williams's "anti-poetic" as an antidote to sentimentality

(Stevens 1997, 768–771). Of course Stevens himself had entertained "the anti-poetic" in such poems as "Anecdote of the Jar." This introduction bears the history of a sometimes rancorous public conversation between the two writers, beginning in Williams's reference to "dear fat Stevens, thawing out so beautifully at forty" in the 1920 prologue to *Kora in Hell* (Williams 1970, 27). Indeed, Williams would "clash with Wallace Stevens" throughout his career (Williams 1970, 14). Among the sources of struggle in Williams's still life poems, his career-long dialogue with Stevens is not the least, as Stevens apparently perceived. "This Florida: 1924" (Williams 1986, 359–362) is indirectly addressed to Stevens (masked as "Hibiscus," as in Stevens's "Hibiscus on the Dreaming Shores") and anticipates his fellow poet's languorous, iambic southern muse. Williams asks:

> Shall I write in iambs?
> Cottages in a row
> all radioed and showerbathed?
> But I am sick of rime—
> (Williams 1986, 361)

Instead of describing the "rime" of Florida, Williams turns to the abstract visual rhymes of modern painting, emphasizing orange:

> orange
> of ale and lilies
>
> orange of topaz, orange of red hair
> orange of curaçoa
> orange of the Tiber.

Of course orange becomes here just a word, a word that famously has no rhyme. From this excursus on orange Williams returns to his everyday world of medical practice: "I shall do my pees—instead / boiling them in test tubes / holding them to the light." Surely this for Stevens would constitute an example of the "anti-poetic," and it seems explicitly hurled at the poet of the dreaming shores.

Stevens's observation of "the slightly tobaccoy odor of autumn" in *Collected Poems, 1921–1931* has itself a whiff of riposte. The poet whom

Stevens had accused of "beginnings and ever new beginnings" had settled into domestic quiet (Williams 1970, 26). "Williams is past fifty," Stevens baldly states (Stevens 1997, 768). Stevens himself was four years older. *Harmonium* had been reissued just three years earlier, to largely negative reviews. While Stevens knew that the epithet of the romantic "will horrify him," the preface is not without its sense of nobility in Williams's struggle. He is a prototype of the man on the dump. If the "anti-poetic" is in part an effort to bring attention to the everyday, it may also involve a larger project with wider cultural stakes: to resist the lure of unreality. "Williams looks a bit like that grand old plaster cast Lessing's Laocoön: the realist struggling to escape the serpents of the unreal" (Stevens 1997, 770).

The analogy deserves a bit of looking into. In alluding to Laocoön, Stevens might be thinking of the realist who warned against a Trojan horse, an unreal that led to real destruction. He might also remember that Laocoön was the rebel who entered into domestic life, fathering (like Williams) two sons, and breaking vows of celibacy and priestly devotion to Apollo, for which he was silenced by the serpents. The unreal, it would seem, surrounds the poet on all sides, just as the anti-poetic, the epiphany of "the real," turns out to be a neon sign for a carbonated drink, "soda" (Williams 1986, 325), or a billboard for "Snider's Catsup, Ivory Soap and Chevrolet Cars" (Stevens 1997, 771). The real is itself infused with the unreal even before the poet intervenes; it is a problem of contemporary culture, not just of the poet's romanticism. The struggle is within and without.

Finally, in referring specifically to "Lessing's Laocoön," Stevens also evokes the *paragone* between poetry and painting, explicated by Gotthold Ephraim Lessing. Lessing insisted that poetry's work was the representation of action through time, not the depiction of bodies in space, whereas Williams emphasized the common cause of the arts, as in "This Florida: 1924," where he writes of

the shades and textures
of a Cubist picture

the charm
of fish by Hartley.
(Williams 1986, 361)

Was Stevens, in citing Lessing, hinting to Williams that his imitation of painterly strategies was a doomed project?

Williams can hardly have been comforted by Stevens's effeminizing compliment "He writes of flowers exquisitely," yet it is precisely in such still life moments, with their sentimental and romantic associations, that Williams's Laocoön struggle is most dramatized. Indeed, Williams himself (in "Still Lifes," 1961) links the tense energies of a vase of flowers with a story of Greek heroic struggle, as if remembering Stevens's early portrait of Williams as a figure from the Trojan War. The poem can stand as a late-career summary of Williams's approach to still life:

> All poems can be represented by
> still lifes not to say
> water-colors, the violence of
> the Iliad lends itself to an arrangement
> of narcissi in a jar.
> The slaughter of Hector by Achilles
> can well be shown by them
> casually assembled yellow upon white
> radiantly making a circle
> sword strokes violently given
> in more or less haphazard disarray
> (Williams 1988, 378)

Are Williams's still lifes themselves a little like Trojan horses, bringing violence and heroic narrative into the domestic lyric? One can find in an arrangement of narcissi in a jar, and in the "narcissistic" private worlds of lyric, the trace of struggles of great public and cultural import, modern as well as mythical. Brian Bremen has articulated a connection when he writes of Williams's poems as defining a "diagnostic space" of culture's struggle to locate the real within the structures of human discourse: "His arrangement with the dialectic between history and the modern recalls the ways in which his poetic language—his 'language of flowers'—resists reduction to simple allegory by attempting to compress within the 'diagnostic space' of its writing a 'poetic reduction' that holds in tension both identity and difference" (Bremen 1993, 126). The violence in Williams's language

of flowers involves a struggle for embodiments of knowledge. Moore is correct:

> The poem often is about nothing that we wish to give our attention to, but if it is something he wishes our attention for, what is urgent for him becomes urgent for us. His uncompromising conscientiousness sometimes seems misplaced; he is at times almost insultingly specific, but there is in him—and this must be our consolation—that dissatisfied expanding energy, the emotion, the *ergo* of the medieval dialectician, the "therefore" which is the distinguishing mark of the artist. (Moore 1986, 327)

Williams's poetic "struggle," which charges his local particulars with heightened consciousness against the haze of custom, internalizes both personal and world struggle. It may be seen as the *ergo* of a force field of violence and counterviolence that extends out from the personal to the public, or into the personal from the public realm. He sees in the local arrangement of flowers in a jar an emblem of his own and the world's restless contention, and a place to enter the fray.

In attempting to understand the centripetal and centrifugal energies of the Williams still life, and the impression of "struggle" that constitutes the "main force" of the poems, we can look to certain analogies with the practice of collage, which influenced a number of modernist poets. At its inception, collage was an art associated with war, a tense, incongruous aesthetic order resonating with external violence. Picasso's introduction of newspaper fragments (from *Le Journal*) in the painting environment has been interpreted mostly in formalist terms, but while LA BATAILLE S'EST ENGAGÉ (The Battle Is Commenced) may declare war on traditional painting, it is pasted onto the canvas from an article on war in the Balkans and retains that original reference. Indeed, as Patricia Leighten has observed: "A close look at many of the newspaper clippings incorporated into the collages shows them to be not arbitrary bits of printed matter, nor mere signs designating themselves, but reports and accounts, meticulously cut and pasted to preserve their legibility, of the events that heralded the approach of World War I and the anarchist and socialist response to them" (Leighten 1985, 122).

Collage, like still life, is an art of assemblage, and the two were often combined, as in the work of Juan Gris, for a long time Williams's

favorite painter and the inspiration behind some of the poet's early work, most famously "The Rose" from *Spring and All*. In collage, semantic and textural tension remains heightened within the assembled visual order, as the fragmentation and heterogeneity of materials resist the formal unity of the work. Collage is at once an intimate art (using materials of everyday life and often using still life in its design) and the most public of art forms, drawing from the daily newspaper, advertising, and other mass-produced, "anti-poetic" sources. And in collage, more than any other art form identified with modernism, we find the everyday and the poetic, the real and the unreal fused and reversed. In "The Realism and Poetry of Assemblage" William Seitz describes this fusion: "Physical materials and their auras are transmuted into a new amalgam that both transcends and includes its parts. . . . [M]eaning and material merge" (Seitz [1961] ca. 1989, 81–82). Even if a poet does not employ collage in the literal sense, his pastiche effects, uniting fragments from various linguistic textures and sources and mimicking signs and billboards, form an analogy with collage.

Like the collage artist, Williams invests the most insignificant physical objects—broken glass, a paper bag—with associational power, while he gives numbers ("5") and letters ("SODA") graphic presence (Williams 1986, 174; 325). Seitz writes of collage: "As element is set beside element, the many qualities and auras of isolated fragments are compounded, fused, or contradicted so that—by their own confronted volitions as it were—physical matter becomes poetry" (Seitz [1961] ca. 1989, 83). Williams cuts and pastes (*coller*) objects from their habitual settings and recombines them in what Moore called his "chains of incontrovertibly logical apparent nonsequiturs" (Moore 1986, 325). Moore's description was likely prompted by a poem such as "April," part of the *Della Primavera Trasportata al Morale* section of *Collected Poems, 1921–1931*, in which a seasonal landscape with a tree is spliced with road signs, danger signs, hospital ward direction signs, sales signs, and an ice cream menu, not to mention bits of Latin, platform speeches, and conversational asides. The platform refrains "Moral" and "I believe," themselves drawn from public speeches, sew together the conventionally separate discourses of politics, nature, the human body, consumerism, and poetry.

For Williams, as for many American artists he admired, the explosion of advertising billboards across the landscape was evidence of the American imagination and deserved to be imitated and memorialized

in art. Matthew Josephson could be describing a painting by Charles Demuth or Stuart Davis when he writes:

> A stranger, nearing the port of New York for the first time and peering anxiously toward this fabulous city, would perceive, as the first indications of its culture and personality, gigantic incandescent messages shooting fitfully over the dark waters: COLGATES . . . HECKER'S FLOUR . . . AMERICAN SUGAR REFINERY . . . the language of modern poetry becomes thus enriched by the use of technical expressions and names which have attained significance in America. . . . If our younger writers tend to become more sensitive to the particular qualities in their material environment, one might well imagine their giving and taking fresh stimulus and novelty of the literature of the billposter. (Josephson [1922] 2001, 63)

Yet by the thirties Williams's response to this collage landscape of the unreal-real was more ambivalent. "Lovely Ad" contrasts reality to billboard, even as he sees the billboard as part of reality. We might recall the epiphany of "SODA" when we read of the woman on this "lovely ad": "All her charms / are bubbles" (Williams 1986, 455).

The objectives of collage seem to be parallel to Williams's poetic goals: to incorporate concrete particulars into a unified aesthetic work without usurping their identity, to resist the naturalizing of any one rhetoric or genre, to thwart hierarchies of value, to create an expressive transmutation of objects, to critique the overlap between the real and the unreal in consumer culture, and to close the gap between art and life. As in collage, the objects in Williams's assemblages retain the memory of their tearing.

Against the Weather

In relating Williams's art of still life to historical pressures and processes, it is helpful to consider briefly some different senses of and attitudes toward history that enter into his work. A distinction among three related categories will clarify how Williams's poetry concerns itself with history. First, history can be understood as the past. *In the American Grain* gives us such a narrative. But Williams also asserts

that the forms and figures of the past do not claim special authority over the present. As Williams writes in "Rome," "history is our possession—we are it. We own it—it is to use, they [the ancients] are our servants (quoted in Bremen 1993, 132). The imagery of decay in the poem "History," in which the speaker visits the recently opened Egyptian exhibit at the Metropolitan Museum of Art, locates the past in its body and separates it from the body of the present (Williams 1986, 81). Second, he understands history laterally, as contemporaneous. While he maintains an aesthetic of the local, his choice of particulars reflects the events and forces at work in the modern world. He does not generalize from his particular experience, imposing his narrow perspective on the broader culture. Rather he opens his vision to the historical particularity of others. Third, "history" for Williams means historical dynamics, which he understands as dialectic between the past and modernity, between old codes and new experiences, and which he seeks to draw into the unit of the poem, where it can be willed and enjoyed rather than simply suffered. History, then, is past, present, and process.

Williams's democratic style and subject matter, his portrayal of hard-pressed communities in northern New Jersey, and his struggle against hierarchical forms in art and culture coincided with populist movements of the thirties and made him a natural candidate for literary spokesman of the left. But Williams is not a populist; his cause was to quicken the life of the individual.[1] To see this we need only recall his warnings within his praise of "the crowd at the ball game" (Williams 1986, 233). He insisted on a distinction between poetry and politics, protecting his "integrity as an artist" from prescriptive ideology, collectivism, and "Proletarian writing": "All I want to do is to state that poetry, in its sources, body, spirit, in its form, in short, is related to poetry and not to socialism, communism or anything else that tries to swallow it." At the same time he saw his art as fully engaged with its historical reality: "to reconcile [his independent art] with the equally important fact that it deals with reality, the actuality of every day, by virtue of its use of language. Doing so, naturally it reflects its time" (Williams 1984, 131). How can the poet resist the current climate without merely withdrawing from history? For Williams, this meant bringing the "black winds" of the times into that independent, unyielding space of contemplation, not to displace it but to stir it up (Williams 1986, 189).

Cultural systems and poetic forms for Williams both grow in history and reflect it, but "freedom" depends on structures that "quicken" in the historical present rather than impose the patterns of History as it is embodied in past forms. As Williams walks through the Rotunda in the U.S. Capitol building, contemplating the painted depictions of historic events and figures that shaped America, he is aware of both their heroic and their archaic aspects. Democracy, he reflects, is a "living coral," a vital, multiplying organism, more process than substance, dwelling atop the dead embodiments of the past but never determined by them (Williams 1986, 255). This spatial metaphor allows Williams a rhetorical triumph over historical determinism which is not transcendental.

This concern with history may seem remote from "the poem as still life." But his image of the Capitol, and the nation itself by implication, as a coral island, itself a kind of still life, recalls the structural principle behind many of his local images, in which the general is embedded in the particular, and stasis and change are reconciled. Still life poetry in this context becomes another instance of "living coral," more performative than substantive, and an image of American democracy itself.

How the historical pressures of the general culture might be reflected in the arrangement of local details was of critical concern to Williams in the thirties. Robert Von Hallberg analyzes the poet's struggle to produce an art independent of any fixed ideology but not indifferent to politics. He identifies in Williams's work of the time a negotiation between "description and explanation": "Williams was trying in this book [*An Early Martyr*] to reconcile the political demands of a disruptive decade with the kinds of descriptive and often delicate poetry he was then accustomed to writing" (Von Hallberg 1978, 131). We see the same issues arise in *Adam and Eve and the City*, where the domestic world of a modern "Adam and Eve" must answer to the pressures of "the City" and its impersonal institutions. Von Hallberg argues that Williams selects objects for their emblematic force but treats them in flat, documentary fashion, and we can certainly recognize this in "View of a Lake" or "To a Poor Old Woman," where objects are "locatable in terms of class" even as they are given descriptive immediacy without reference to such sorting. Von Hallberg writes: "The major problem for a democratic poet was to keep a hold on the facts of his world without being pinned to the level ground by those chiefly ordinary facts" (Von Hallberg 1978, 136). For

Williams, it is structure rather than discourse that liberates particulars into uncodified generality.

Some of Williams's greatest poems were written in this negotiation between explanation and description, between documentation and abstract design. "Between Walls" describes not an interior but broken glass in the narrow alley between hospital buildings. With its *intermural* space and broken containers, the poem can be read as an inside-out or anti–still life, an image for the destructiveness and homelessness of the decade. Williams achieves "emblematic" force through lineation that highlights signifying terms ("nothing," "broken," "cinders," and so on). Such structural maneuvers allow the poet to introduce his intentional focus without any deterioration of the self-identity of things. As Von Hallberg reads the poem, it merely reflects the fragmentation and misery around it. Yet an aspiration to correction can also be read in the poem's structural choices. The end words of the longer lines struggle against the desolate climate of the times: "wings," "shine," and "green" complete the dialectic between the world and the poet's will. These are figures not of mere restoration or mending but of transfiguration. The poet is again a "composing antagonist" who not only reflects reality but also imagines its regeneration (Williams 1986, 186). He is "against the weather," creating order where there is disorder and flight where there is stasis. Unlike the bottles or the rooms that once contained them, this impersonal space is "filled" with what it cannot contain: entropy, death, and waste. But the poet's subjective imagination, seeing green in the midden, challenges the culture to renew itself.

If "explanation" rises out of "description" here, so also does metaphor, specifically the metaphor of the phoenix, hinted at in the "cinders," "wings," and "shine." The anti-poetic still life becomes a poetic trope. Like the metaphor of "a living coral," the phoenix offers continuity in change, but in a more self-consuming figure. "The natural corrective," writes Williams, "is the salutary mutation in the expression of all truths, the continual change without which no symbol remains permanent. It must change; it must reappear in another form, to remain permanent. It is the image of the Phoenix" (Williams 1954, 208). Only the artist's imagination finds in these "green" bits of glass the pattern of rebirth in an emergent order. The poems of the thirties often see the world as "an empty, windswept place" and yet find "among / the flashes and booms of war" a "source of poetry"

(Williams 1986, 458–459). An order, while it does not exist in the historical world, presents itself as potential rather than merely imaginary.

To be "Against the Weather" in Williams's "study of the artist" of 1939 was not to retreat into decorative escapism or relinquish the power of imagination to a documentary function. Rather the poet struggles toward the creation of a "new world that is always 'real'" (Williams 1954, 96). More assertion than argument, this essay nevertheless provides important keys to Williams's work and helps us understand how "the poem as still life" might have relevance to "the whole" even in times of inclement weather, even in times of "bombardment" (Williams 1954, 196–197).

Several principles in the essay converge to suggest the poetic and political values behind Williams's way of contending in still life. The essay begins with an image of the poet removed from the fray, struggling alone within his art: "He might well be working at it during a bombardment, for the bombardment will stop. After a while they will run out of bombs. Then they will need something to fall back on: today." Yet what he creates is not a system or generalization or philosophy, not any codification of reality. Instead he finds a "solvent" for the "old antagonisms" by intense engagement with the local. Art is "most theoretical when it is most down on the ground, most sensual, most real. Picking a flower or a bird in detail that becomes an abstract term of enlightenment." The focus here is on the performance ("picking . . . becomes"). The "abstract term" derives not from discursive "explanation" but rather from "structure" in the poem, where "life" is "transmuted to another tighter form." The tightness of poetic form optimizes contention: "The structure shows this struggle between the artist and his material, to wrestle his content out of the narrow into the greater meaning." The almost incantatory emphasis on structure in this essay reminds us that for Williams, abstraction inheres more in design than in proposition: "In the structure the artist speaks as an artist purely. There he cannot lie." He is a "man of action" rather than a mere bearer of other men's messages. "Content" is "merely useful."

Yet as the essay proceeds, the artist's actions are again connected to the political "weather" of the time, especially the oppressive orders imposed on the public realm. Williams seems to propose an ideal of art that is anti-ideological, or at least restless in its historical forms and longing for a condition of language that might escape historical determination: "We live under attack by various parties against the whole.

And all in the name of order! But never an order discovered in its living character of today, always an order imposed in the senseless image of yesterday—for a purpose of denial. Parties exist to impose such governments. The result is inevitably to cut off and discard that part of the whole which does not come within the order they affect." Against these "fix[ed] orders from without" the artist creates aesthetic structures in restless contention; his "timeless" as opposed to topical art abides not in inventing symbols of eternity or unchanging forms but in his very commitment to multiplicity, mutation, and indeterminacy. Williams spatializes historical process. His recurrent figure for this concentration of contending shapes is a still life: the multifoliate flower.

Vocational Still Life

For Williams, attention to the local sometimes meant a focus on the scene of writing, and an inventory of the objects on his desk. Like words themselves, the instruments of a writer's life can be distanced from his intentions and seen as things. By suspending the functions of objects, Williams creates a still life portrait of the artist. This severance from function allows new connections: it links his writer's life to the immediate, physical world that his intentionality abstracts, and at the same time opens up noncontingent associations with the wider world. In "The Eyeglasses" from *Spring and All*, Williams works to avoid identification of reality with its frames. The "universality of things" pulls him not toward Shelley's abstract "white dome of eternity" but toward the concrete objects under his nose—eyeglasses, typewriter, and paper—which the poet now treats as things rather than instruments of perception and composition (Williams 1986, 204). He gathers these things "without accent" that might impose interpretive order. The frames "made of tortoiseshell" contain lenses that can "favorably distort," but their technology is suspended: "they lie there with the gold / earpieces folded down." As Williams turns toward the typewriter, containing a letter that is "made of linen," the complex nature of the verbal sign—its visual presence, its aural potential, and its referential extension—stirs in the image. All the objects he enumerates (glasses, letters, and so on) are connected with the ability to close distances of sight and communication. While Williams suspends this function at the level of metonymy, he reactivates it at the level of

metaphor. These things lie "tranquilly Titicaca." Perhaps this final, vast lake image was provoked by sound alone (the ear cued by the description of the glasses), or by the association of Peru with gold, as in the "gold earpieces." One is struck by the disjunction in scale and context introduced in this line, a move that seems designed to connect the solid local image to a limitless, reflective surface, modeling the "universality" of the particular. Suddenly the world is on the table, but with none of the turmoil of history to disturb it. In this poem the link between proximity and distance is imaginary.

In the prose leading up to "The Eyeglasses," Williams recalls his vocational anxiety: "Oh yes, you are a writer! A phrase that has often damned me, to myself" (Williams 1986, 203). He overcomes it, of course: "I find that I was somewhat mistaken—ungenerous." In the twenties the radiant atmosphere of experimentation seemed self-justifying. But Williams's struggle to understand the place of poetry in his vocational life intensifies in the thirties. "You have pissed yur life," Ezra Pound wrote to him, and Williams defiantly echoes the words back in the concluding poem of *An Early Martyr* (Williams 1986, 401–402). Even as the "ineffectual fool / butting his head" becomes the "brilliant—focusing" performer, the sense of futility remains. "Any way you walk," he writes back to Pound, "you have pissed your life." In the thirties, then, there seems to be more turmoil than tranquillity on Williams's desk as he seeks to connect his writing to the world. He is more troubled, too, about the nature of the sign. Within the formula "no ideas but in things" he now enfolds not just things in texts but textual things and the text as thing.

Williams's desk in the thirties was cluttered with signs of bureaucratization and co-optation. It was a doctor's desk, not a writer's, in an office, not a garret. His workspace was now inside a bank, and though he worked in the bank, not for it, "Simplex Sigilum Veri: A Catalogue" (more collage than catalogue in its erratic assembly) struggles with this context in a number of ways. Instead of folded glasses with gold earpieces and letters from literary editors, his pen and pencil are now laid alongside a bank matchbook, an ornamental ashtray, a telephone book, and an advertising calendar for the medical profession. Again small proximate objects express larger, remote phenomena, but economic and political terms intervene in the transaction. How do these "printed characters" relate in motive and method to his poetic composition? Williams wrote the first version of "Simplex

Sigilum Veri" in the same year as "Question and Answer," which was published in *The New Masses*: "What's wrong with American literature? / You ask me? How much do I get?" (Williams 1986, 321). By the fall of 1929, when "Simplex" appeared in *Blues*, that question and answer had a powerful new resonance. On a more playful level, in 1934 we see Williams weighting the economy of art against the money economy, and perhaps folk culture against mainstream culture, in a little still life poem, "To a Mexican Pig-Bank." Here he describes a colorful ornament on his mantel, given to him by the artist Marsden Hartley, along with some miniature sheep gathered in haphazard disregard around a toy shepherd. But inside the bank, in "Simplex Sigilum Veri," the poet requires a more severe distancing strategy (Williams 1986, 382–383). Throughout "Simplex" what is real and what is unreal, proximate and distant, inside and outside, genuine and counterfeit, collide in a network of images of wealth and power.

On the one hand, across the poet's desk are the emblems of his various worldly constraints. On the other hand, Williams's creative investment in and his subversive restructuring of this "catalogue" begin to liberate objects from the various reductive views of being to which he is subject: economic, social, and political. Overriding semantic and syntactic distinctions, the catalogue is less metonymic (indexed to worldly realities) than metaphoric and metamorphic (capable of realigning those realities). Again Williams shifts attention from the iconic to the material character of the objects in order to liberate their significance. Critics seldom comment on this poem, included in revised form in the politically inflected volume *An Early Martyr*, perhaps because the "catalogue" scatters the poem's argument. But within this inventory Williams works to free his consciousness from the imperial orders that oppress him.

A "sigil" is a statuette or an embossed seal or ring used in imperial transactions. Here, until the end of the poem, with its image of the golf club–wielding Prince of Wales, various bureaucracies (bank, industry, medicine, government) stand in for imperial power. Here humanity is neatly classified in numbers, or alphabetical entries, or days of the month. Against such filing systems Williams asserts his individuality. Through strategic line breaks and formal associations he cuts across these reductive classifications and discovers an "all" at once simple and complex. The junk on his desk, this "truncated pyramid" and memorial to "all that we have lost," takes on the momentum of a new world.

If the objects in "The Eyeglasses" lie "tranquilly Titicaca," the inert pile of bureaucratic paper in "Simplex Sigilum Veri" is about to catch fire.

The incendiary dimension of Williams's imagination at this time is latent in the "American papermatch packet" which is the first object of his attention. It is "closed, gilt with a panel insert," but if there is no fire in this poem, there is certainly smoke and ash and eventually a cigarette at the end of the fourth stanza. The smoke belongs not to cigarettes but to "puffs of / white cloud" in the "blue sky." While the lineation of the poem leaves the location of this sky ambiguous, the logic of images puts it on the match packet insert. Against this pictorial sky is "the bank, a narrow building / black" with "small windows in perspective." Presumably this image is advertising the same bank in which Williams is situated as he beholds these objects. While the depicted scene sends us out of the immediate moment into the illusionary scale, the catalogue pulls us back to the desk, where we now find

> a sixinch metal tray, polished
> bronze, holding a blue pencil
>
> hexagonal, a bright gilt metal
> butt catching the window light.

Our attention is drawn to the actual window of the bank, seen from the inside, rather than the represented window from the outside, depicted on the matchbook cover scene. The play of light dissolves the distinction between inside and outside. The poem also offers a series of inversions that undermine the economic and social distinctions embedded in the images. The other repeated word besides "window" is "gilt," and it ricochets off the matchbook cover onto the pencil. ("Gilt" would be revised later to "brassy bright," as if to distinguish the shine of art from the gilt of wealth.) The "cheap" penholder belies the gold-ringed saucer under the flowerless primrose plant. Clearly in this poem the nature of the "sign" or "seal" is not so simple, let alone the "truth" it signifies, since the poem is riddled with images of fake surfaces. The syntax and lineation remove objects and attributes into a cascade of words in which the poet must find a sustaining structure.

At one level, then, we might see this still life of the poet-doctor's desk as a "sign" of the various versions of constraint he feels, and as a formal struggle to resist such containment. In questioning surfaces

(the gilded and brassy monuments in miniature on his desk), he opens the poem to a realignment of values. And by violating orders of scale and confusing inside and outside, he refuses the fragmentation of reality that restricts the whole. The poem may also be read as an exploration of the sign itself, especially the relationship between literary signs, cultural signs, and advertising signs. The poem's catalogue includes images of writing and of the writing process (worn eraser, stained blotter) and other "surfaces of all sorts / bearing printed characters, bottles, / words." Are words themselves like bottles, containing reality? To "words printed on backs of two telephone directories" Williams would add "titles for poems." What is the relationship between poetic and other, more public uses of words? Do titles stand over poems as the titled stand over the unentitled—doctors or princes over the masses in the phonebook? The poem raises more questions than it answers about how we sort and represent reality.

Amidst this dump of images he includes "The Advertising Biographical Calendar of Medicine," where exemplary figures are immortalized but lives are subsumed in the passage of days to form a "portrait / of all that which we have lost." Williams's line break segues from the looseleaf calendar, with its "various shades sticking out / from under others," to another hierarchical "truncated pyramid," the pyramid-shaped "bronzed metal ("probably the surface / only") of the inkstand on which is mounted "the Prince of Wales" swinging a golf club. In this anti-hierarchical poem Williams may express irony toward this Old World figure on a pedestal, this false monarch (still idolized on the American scene), the sport-loving, abdicating Edward VIII. But his posture also suggests the poet's own teeing off. In this pyramid of unreal real things, with its foreign slogans in American scenes and simulacra of banks, of abdicating royals, and advertised lives, Williams searches for the uncontainable real.

Contending in a Sea

Perhaps because Williams's attention to "things" and to "the local" is so emphatic, his constant return to the image of the sea has drawn little comment. It is difficult to think of the sea as a "thing," and it is even harder to localize it. It might have had resonance for Williams with his island-born parents and expatriate friends, and later with his

son Paul serving on a Navy destroyer during World War II. The opposite of still life, the sea is a flux which overwhelms human purposes. In "Asphodel, That Greeny Flower," Williams reminds himself that his local orders must submit to a reality beyond his or anyone else's powers: "The whole world / became my garden!" he boasts, but then checks his ambition: "But the sea / which no one tends / is also a garden" (Williams 1988, 313):

> Always
> when I think of the sea
> there comes to mind
> the *Iliad*
> (Williams 1988, 315)

Yet "Asphodel" is stalwart in its gaze at the sea, and in its determination to see every storm as another flower in the garden of the expansive will. As he would later write, "The violence of the Iliad lends itself to an arrangement / of narcissi in a jar" (Williams 1986, 378). So it is not surprising to find still life and the sea often brought together in Williams's poems. Williams is ambivalent: the sea is sometimes felt as a threat to manmade structures, at other times as a sign of freedom from the constraints of those structures. By bringing the sea into the still life environment he negotiates between turbulence and order, as well as epic and lyric forms.

The Great Depression was a time of upheaval for the nation and a test of Williams's optimism about American democracy. It was also a time of crisis in his personal life. As Paul Mariani notes, Williams lost considerable investments in the stock market crash. And a year later his brother-in-law Paul Herman committed suicide, following the example of Paul Herman Sr. ten years before (Mariani 1981, 304). The proximity to chaos which Williams had advocated in his early experimental work now had an actual, not just an imaginary, force. After a visit to the Herman family in Monroe, New Jersey, helping to console them and secure their future, Williams traveled to Gloucester, Massachusetts, to visit his friend (and fellow artist) Richard Johns (Mariani 1981, 307). Perhaps this turn from a place associated with death and disaster to a place associated with life and creativity helped Williams carry on in this dark time. Perhaps also the proximity of the sea, so powerful against the craggy Gloucester rocks, formed for him an

image of the chaos of reality against which and within which the artistic creation must be forged. Williams was certainly not the only poet in the thirties drawn to the image of the sea and as a figure for contemporary dangers. Stevens's grinding and gasping ocean in "The Idea of Order at Key West" reminds us how the human rage for order is a pressing-back against the chaos of the veritable ocean; Marianne Moore's stranded whales in "The Steeple Jack" remind us that "danger" is not far in the "sweet sea air" of the coast (Moore 1981, 5). For Williams, as for his fellow modernist poets, the proximity of the sea becomes a prompt not only "to see" clearly but also to create forms which can contend with that chaos beheld.

The most famous of Williams's poems from the thirties is "The Yachts." The boats "contend in a sea which the land barely encloses" (Williams 1986, 388–389). The descriptive exuberance reveals a point of view, a "happy eye, live with the grace / of all that in the mind is fleckless, free and / naturally to be desired." The poet projects a voice caught up in the heroism and glamour of technology. Williams may well have had in mind his friend Charles Sheeler's *Yachts and Yachting* of 1922, with its precisionist grace and ardor for industrial forms. But Williams, a thirties sensibility attuned to hard-pressed humanity, contends with the allure of the yachts. The speaker turns away from the rapturous opening scene into a Dantesque allegory of suffering, "the whole sea become an entanglement of watery bodies" and the yachts perhaps now symbols of industrial power's disregard for human labor. There are no safe harbors for the laboring or out-of-work multitude.

Williams had anticipated this grim vision a few years earlier when he imagined a *vanitas* still life in the sea, "a severed cod- // head between two / green stones—lifting and falling" (Williams 1986, 357). And in "The Sadness of the Sea," Williams used some of the same vocabulary— "waves like words, all broken— / a sameness of lifting and falling mood"—to suggest a terrible background of inhuman flux. But within this desolation the artist's hope takes shape: "a coral / island slowly forming / to wait for birds to drop / the seeds will make it habitable" (Williams 1986, 383). In *Spring and All* Williams had evoked the sea to mock Eliot's Prufrockian despair, setting Eliot's images of drowning against the birth of a new Venus who will "assume the new—marruu" (Williams 1986, 223). But in later poems the sea seems wider, something that not only separates America and Europe but also threatens America's own shores, a voracious circus "sea elephant" that wants to

consume the whole world (Williams 1986, 341). Similarly, in the 1938 poem "Advent of Today" (after a Marguerite Zorach painting), the sky itself seems full of "torn spume" (Williams 1986, 443).

If Williams often turns to the sea as an image of overwhelming forces threatening human agency, he also creates an imaginative counterpoint so that "the sea is circled and sways / peacefully upon its plantlike stem" (Williams 1986, 378). "Flowers by the Sea" exemplifies the reciprocity created in art between the intimate still life order and the greater flux embodied in the sea. The poem seems anomalous in the politically inflected *An Early Martyr*, until we recognize in its particulars the "abstract terms" of dialectic between freedom and constraint, chaos and order. The poem enacts a trajectory in which thought detaches from one object into an abstract and emotional space, and then reattaches into a newly formed reality. The revisions of this poem are instructive, for they reveal not only the work of economy and realignment but also a major shift of sensibility and focus, from "quietness" to "restlessness," and from passive thought to active imagining. In the reciprocal transfer of tenor and vehicle, Williams makes the poem a parable for freedom in "ties." A conventional scene becomes unconventional when the perspective is transferred to the objects seen. The title is suggestive at many levels. It connotes flowers as the sea might conceive them. It also places the poem among those tributes to folk aesthetics that were common in the thirties. "Flowers by the Sea" could be the title of a decorative painting in an ordinary household. "Nantucket" is another example of this aesthetic. But like "Flowers by the Sea," its humble subject matter and laconic description conceal turbulence. Williams only hints at the sea in "Nantucket"; chaos lies well beyond the flowers at the window of this empty guesthouse room, its flux suspended or held in erotic potential in the "immaculate white bed."

A lovely and critically neglected still life poem, "Sea Trout and Butterfish," brings the sea directly into the table environment through a tumultuous handling that quickens the static image:

> The contours and the shine
> hold the eye—caught and lying
>
> orange-finned and the two
> half its size, pout-mouthed

beside it on the white dish—
Silver scales, the weight

quick tails
whipping the streams aslant—

The eye comes down eagerly
unravelled of the sea

separates this from that
and the fine fins' sharp spines
(Williams 1986, 353)

Williams struggled with the structure of this poem and published it variously in a two- and three-line stanza unit. In both versions we find the lively contending of forms and associations. Ambiguities abound amidst the precise details. Are we looking at a painting—something Marsden Hartley might have done, for instance—or at an actual object on a table, such as Richard Johns might have served in his Gloucester home? The "white dish" implies a canvas. "The contours and the shine / hold the eye" either way in a dialectic of form and freedom. Is the eye or the image "caught and lying" here? The fish anyway are more raw than cooked. The poem becomes a kind of fulcrum for perception and its object, for reality and its image, for form and flux. The fish on the plate or on the canvas or in the mind may be "caught," but their image is alive in a sea of associations and is ready to be caught again in the moment of perception, "quick tails / whipping the streams aslant" and their "weight" under "silver scales" impossible to gauge. Words are tense with multiplicity and metaphor: scales associated with weight and weight associated with the waiting time and quickening of the still object. The fish separates itself out "unraveled of the sea" so the eye can see (and the ear can hear) "fine fins' sharp spines."

It would be hard to say what "use" such a poem has; it offers little of "explanation" and seems entirely a work of descriptive delicacy. It bears no semantic relation to public realities. But as Jay Cantor has said in *The Space between Literature and Politics*, "a still life is the general critique applied to a particular fruit. . . . There is no work of art where the universal does not show forth in the particular configurations,

actions, sufferings" (Cantor 1981, 133). Indeed, Williams serves as Cantor's paradigm of a continuous transformation that art models for society. Still life is not a space of retreat from the chaos of the world but rather a way of thinking with the materials at hand. In the partial enclosure or harbor of art, the imagination can contend with a sea, invoking its breadth and flux without succumbing to the sad rise and fall of the world.

"Is Gentleness the Core?"

Williams's poetics, as we have seen in several contexts, involve a violent struggle. As he wrote to Marianne Moore in 1921: "Each must free himself from the bonds of banality as best he can; you or another may turn into a lively field of intelligent activity quite easily, but I, being perhaps more timid or unstable at heart, must free myself by more violent methods" (Williams 1984, 52). But his essays and poems view violent struggle as a necessary part of history and culture as well, his inner war but part of a warlike whole. For Williams, the greatest failure of art, and of life, is stagnation, the retention of past forms in the contemplation of present realities. Life for this doctor entails constant transformation; creative destruction preserves the health of society. The poet's exuberant evocation of violence is sometimes hard to align with the delicate art of poetry. As Brian A. Bremen has put it, "The valorization of violence forms the rhetorical grounds for Williams's ideas, about history and culture, as it plays an integral part in Williams's poetics" (Bremen 1993, 6).

But what exactly is the relationship between the artist's violence, its aesthetic rigor that resists the "banality" of convention, and violence in the historical realm? A process poet like Williams resists the distinction between means and ends, but in a world at war it is hard to accept violence as a permanent state; indeed, that is the ideology of the fascist enemy. Is violence the core of art and the driving force of modernity, as the futurists believed? Or "is / gentleness the core" (Williams 1988, 72)? And if the latter is truer, how is this core of gentleness to be discovered within the violence of forms? And what is the relationship between, on the one hand, the exercise of violent imagination upon quotidian objects and, on the other, a reflection on an extraordinary violence in the historical world, where interests

and ideologies have collided into war? Williams's wartime volume *The Wedge* can be read as an examination of these questions. The variety of poetry in the volume, poems of dance and poems of battle, those that depict flowers and those that depict weaponry, pastorals and anti-pastorals, all operate within a paradox of violence that protects gentleness at the core. To protect "gentleness," it seems, its image must constantly be "transformed," thus making violence and gentleness an inextricable pair. If poetry is "a different sector of the field" in time of war, it works toward a core vision of vital, transformational peace. The gendered contract between violence and gentleness may be less persuasive to us than it was to the generation of World War II. Williams presents the paradox that violence and gentleness are both opposites and allies, but his attempts to represent their pairing reveal its instability.

Stevens spoke for his generation when he wrote that the modern poet must "think about war and find what will suffice" (Stevens 1997, 219). Williams had been thinking about "the flashes and booms of war" and the artist's response for some time when he gathered poems into *The Wedge* in 1944. (Williams 1986, 458). He had been thinking about the Spanish civil war, and about the encroaching Nazi threat, in translating poems by Nicolas Calas, Yvan Goll, and others who explored the grotesque realities of their time in the language of surrealism (Williams 1988, 29–40). Williams had been thinking about Martha Graham, who met ferocity with ferocity in her powerful evocation of "war, the destroyer" (Williams 1988, 43). In "Against the Weather" it is clear that Williams is no pacifist: "To stop the flames that destroy the old nest prevents the rebirth of the bird itself" (Williams 1954, 208). But while "An Exultation" may see England's agony as somehow necessary, the country's survival is fervently wished for and its suffering recognized (Williams 1988, 42). Now America had joined the war, with Williams's own family affected. The urgency to enlist one's talents in the cause must have been strong. "The war is the first and only thing in the world today," he writes. "The arts generally are not, nor is this writing a diversion from that for relief, a turning away. It *is* the war or part of it, merely a different sector of the field" (Williams 1988, 53).

How does the artist contribute to the struggle in his particular sector of the field? The poem itself must be understood, he argues, as a "machine made out of words" (Williams 1988, 54). Perhaps he

remembered Marianne Moore's words about him in a review of 1936: "The welded ease of his compositions resembles the linked self-propelled momentum of sprocket and chain" (Moore 1986, 345). Is he also still defending himself to Stevens when he insists, "There is nothing sentimental about a machine"? Williams renews the battle-ground of the "anti-poetic" in this volume. "Compose. (No ideas / but in things) Invent!" is the rallying cry (Williams 1988, 55). Free-dom of the individual against the forces of tyranny or the pressure of the herd requires, as he says in "Writer's Prologue to a Play in Verse," the constant "transformations from the common / to the undis-closed" (Williams 1988, 60). Williams's opening salvos in *The Wedge* do not prepare us for gentleness, yet he could be describing a still life when he writes, "He takes words as he finds them interrelated about him and composes them—without distortion which would mar their exact significances—into an intense expression of his perceptions and ardors that they may constitute a revelation in the speech that he uses" (Williams 1988, 54). The function of the poem-machine, then, seems to be the classic one for lyric, even if its structure adopts mod-ern efficiencies. And that classic function of individual expression must address itself to the intense pressures coming from the public realm.

The many apologies for poetry included in these wartime poems show Williams attempting to define the role of the arts and reveal his anxiety about artistic "turning away." Such anxiety led to overstate-ment, as in "Writer's Prologue": "Would it disturb you if I said / you have no other speech than poetry? / You, yourself, I mean" (Williams 1988, 60). Of course Williams himself was exploring other kinds of speech—the novel, the short story, drama, journalism, advertising. But what he finds in poetry is some access to an ideal of individual truth against "outward forms" (Williams 1988, 61). "Fury and counter fury," Williams declares in "Catastrophic Birth," "violence alone opens the shell of the nut." "Raleigh was Right," he tells us, in his anti-pastoral sentiment: "we cannot go to the country / for the coun-try will give us no peace." So "What can the small violets / tell us that grow on furry stems / in the long grass among / lance-shaped leaves," he asks, implicitly answering his own question with the metaphor of weaponry: the violets tell us that delicate beauty, that of art or that of nature, is no retreat from the fray, but wields its lance violently against what would crush or constrain it (Williams 1988, 88). "Saxifrage is my

flower that splits / the rocks" (Williams 1988, 55). In Williams, the rhetoric of inventive composition and reconciling metaphor ("to reconcile / the people with the stones") draws from the theater of war. But the alliance is not an easy one for Williams. Despite its emphatic assertions, an uncertainty lingers in *The Wedge* about how to reconcile gentleness and violence, art and war.

In the most famous poem of *The Wedge*, "Burning the Christmas Greens," the poet hurls the season's decorations, "their time past," into the hearth (Williams 1988, 62–65). But the language of war is everywhere in the account of this yearly ritual, so that its larger referent is never in doubt. The Christmas greens arranged to ornament the mantel are "a promise of peace, a fort / against the cold." The poem initially works with such dichotomies of inside and outside. The family brings the outside in and arranges this display in opposition to "the unseeing bullets of / the storm." Yet art, which invents new forms "against the snow's / hard shell," might bracket itself off, create a new dimension to challenge claims of an established reality, but it must also burn its own orders and find light in the flames. It cannot cling to old ceremony. The decorative solace of still life may be rejected in "Burning the Christmas Greens"—"their time past, pulled down [from the mantel] / cracked and flung to the fire" of an immediate war and its "unseeing bullets." But a new kind of still life, full of terrible implication, emerges in the phoenix-flames as an image of gentleness and peace: "an infant landscape of shimmering / ash and flame." Williams's anticlerical sentiments began early and persist as part of his general abhorrence of dogma and the herd mentality. Yet he uses the rhetoric of incarnation and nativity in this crèche, where the season's hope lost in flames becomes the world's hope found in flames. In the blazing hearth where the wreaths have been, we find "ourselves refreshed among / the shining fauna of that fire." At the end of the poem violence and gentleness, outside and inside, red and green are not alternates but occupy the same local space.

Williams explores this paradox further in "The Rose," which again juxtaposes the impulses of art to the realities of history (Williams 1988, 74–75). The rose was obsolete in *Spring and All* but also infinitely renewable. Its faceted, multifoliate form implicitly becomes, for Williams, a symbol for an idea of beauty abiding in constant transformation. Again Williams's image arises in an implicit dialogue with

Stevens. Stevens may have been thinking of Williams when he wrote, in "Esthetique du Mal" (1942),

> that Spaniard of the rose, itself
> Hot-hooded and dark-blooded, rescued the rose
> From nature, each time he saw it, making it,
> As he saw it, exist in his own especial eye.
> (Stevens 1997, 279)

Stevens, extrapolating from conventional war elegy, had brought that rose into the world of war: "How red the rose that is the soldier's wound" (Stevens 1997, 281). When Williams takes up the image in *The Wedge*, he may be responding, in turn, to Stevens: "the stillness of the rose / in time of war" signifies both suffering and transcendence, mortality as in the soldier's wound, and immortality, as in the endurance of art, where stillness is not finality (Williams 1988, 74).

Early Williams fought the impulse to symbolize, cleaving instead to the edge of the image. For him the poem as still life was a formal and sensuous more than an emblematic and symbolic arrangement. But in *The Wedge*, Williams employs symbolism freely as a vehicle for paradox. The rose is *"nature morte"* in the form of a sparrow on the pavement, "the long sleep just begun" (Williams 1988, 74). But as an emblem of art it is also *Stilleben*, a figure for "some breathless book when / stillness was an eternity / long since begun" (Williams 1988, 75). Even as still life draws us into its presence, into an illusion of perpetual gratification or an eternal moment of color and light, it often bespeaks the transience of the moment it captures and implies motion and change in the disposition of the objects it represents. Williams captures this still life dichotomy in the double symbolism of the rose and sets it within the intensities of wartime violence and loss.

Wightman Williams, the artist who designed the cover of the Cummington Press edition of *The Wedge*, understood well the central paradoxes and dichotomies of the volume. A triangle with point down, "the wedge" becomes a kite by way of a perpendicular drawn inside it (this iconic cross perhaps also suggesting "Burning the Christmas Greens" and "The Semblables," with their links between war and redemption). Assembled awry within this grid are the key figures of "To All Gentleness," a stylized rose with thorned, winding stem (also suggesting the volume's images of serpent and barbed

wire), and a cylindrical pole resembling both an architectural column and a missile capsule. Williams's words offer a challenge:

> The lion
> according to old paintings will
> lie down with the lamb. But what is meant
> has not been precisely enough stated:
> missed or—postponed.
> (Williams 1988, 68–69)

Williams's project will be to state it anew, where the violent energies of the imagination are not suppressed or disarmed for a peaceable kingdom but rather form an alliance with "gentleness," the flower of that creativity, a constantly transforming sense of reality. But this is a complex, even troubling alliance that requires Williams to employ some strained sexual similes:

> Like a cylindrical tank fresh silvered
> upended on the sidewalk to advertise
> some plumber's shop, a profusion
> of pink roses bending ragged in the rain—
> speaks to me of all gentleness and its
> enduring.
> (Williams 1988, 68)

Presumably Williams has found these local objects in proximity—but how is a profusion of pink roses like a fresh silvered tank? We are accustomed to radical comparisons in Williams; in *Spring and All* we have copper roses, steel roses. But metaphor in *The Wedge* works differently, often creating analogical relations out of contingent relations (as in the church beside the munitions factory in "The Semblables"), thus giving metaphoric unity to a world that appears to be incoherent at the level of experience. The opening of "To All Gentleness" does not transpose the object to the imagination but keeps us near the sidewalk. The cylindrical tank is more than an industrial image, of course. The plumber, in time of war, may appropriate this blank missile to advertise his patriotism. The volume's context and subsequent stanzas do link this "cylindrical tank" to war, but here it is upended, unthreatening, while the blooms of the roses are bending ragged under the deluge. The

bidirectional pull of the image—an odd assembly of unlike things—spatially defines a cycle of destruction and renewal in which Williams wishes to locate "all gentleness and its / enduring."

The second stanza attempts to lock the two images, rose and missile, together with metaphoric inversions rather than simile. Instead of the metal cylinder we have "a column of tears borne up by the heavy flowers." The poem acknowledges the difficulty of the figure: "the new and the unlikely, bound / indissolubly together in one mastery" (Williams 1988, 68). In the third stanza the "heavy emphasis" is now not the rain but human love of the flower, which threatens to destroy it by entombing it in elite classical forms. With this Williams launches his defense against Stevens's critique of the "anti-poetic." The very division of the world into poetic and anti-poetic subjects simply highlights the violence of a mind that leaves "half the world ignored." For Williams the stakes are absolute: in addressing "gentleness" he addresses "all." In its rigorous dialectic Williams will not settle on a structure of priority or teleology. As it progresses, the poem works to define a relation for this "valid juxtaposition" (Williams 1988, 68). If the new image of reality is the sought-for gentleness, the obstetrician recognizes violence as a condition of birth and the female as a figure for "that gentleness that harbors all violence." In this case, then, violence is the core and "gentleness" the protection, reversing the dynamic posed elsewhere in the poem. Williams returns to these paired male and female images at the conclusion, where he once more insists on their juxtaposition: "one / by the other, alternates, the cosine, the / cylinder and the rose" (Williams 1988, 72). What he predicted in *Spring and All* is fulfilled in a new way: "to engage roses / becomes a geometry" (Williams 1986, 195).

"To All Gentleness" begins and ends with a spatial juxtaposition, but as description gives way to narrative, Williams's dialectic enters a sequential alternation. The poem follows an arrow, a figure of both aspiration and destruction, its target the moment of creative truth. Within the narrative structure Williams forms a parallel between the artist's quest and the soldier's. The arrow becomes a combat plane shot down, "knocked into the sea." Again we have the rise and fall of that force of fate, "the wash and swing" of the sea. Does the violence of a tumultuous ocean occasion the heroic emergence of order, or is it the other way around? "Copernicus, / Shostakovich. Is it the occasion / or the man?" (Williams 1988, 70). These creative minds are caught in the tumult of the times, but finding within themselves an aspiration

for radical new order, they also partake in the destruction of the past. The logical and generative relation between "the cylinder and the rose" and between violence and gentleness is never firmly established in "To All Gentleness." Williams produces images and scenarios in search of this logic and returns to the emblematic pair as an assertion of what logic cannot sort out. Is the violence of art addressed "to all gentleness"? "Is gentleness the core"? Or is the constant cycle of creation and destruction a "fury and counter fury" without end?

Williams recalls this emblematic pair of rose and missile in the retrospective "Asphodel, That Greeny Flower," but in this postwar poem gentleness comes to the foreground, defended against the death-obsessed culture of the cold war world. The bomb itself, that pervasive image mushrooming into popular culture, becomes a flower, but a flower of hell, from which a return to love arises. If Williams "writes of flowers exquisitely," as Stevens said, he has also taken into the flower what another mind might view as its antithesis: "I am reminded / that the bomb / also / is a flower / dedicated / howbeit / to our destruction" (Williams 1988, 321). Adam and Eve (William and Flossie), now grown old in their domestic dream life, must acknowledge more than the historical city and all its violence, as they do in "Perpetuum Mobile: The City." Now before them lie both personal mortality and worldly annihilation. Michael Davidson in an essay on cold war poetry indicates how the public world enters into the private life and the lyric imagination. In reference to "Asphodel's" evocation of the bomb he writes:

> What is so prescient about these lines is Williams's emphasis on the *picture* of the bomb, for it was as a representation that the threat of nuclear annihilation came into American households. . . . But if a picture held us captive, to adapt Wittgenstein, it did not lie solely in "our" language but in a language being enlisted in a process of cultural hegemony. The age of the bomb created what Alan Nadel has called a "nuclear gaze" through which "actions with ambiguous motives" or indeterminate causes could be seen—and contained." (Davidson 1998, 287)

The bomb not only entered into Williams's private domestic space but also symbolized and perpetuated a society's internalized fear. We can read "Asphodel" in part as Williams's attempt to resist that fear to

"press back," to use Stevens's terms, against the pressure of reality. "The bomb / has entered our lives / to destroy us," but the poet speaks back to the bomb, of all gentleness. "Only the imagination is real!" he declaims, bringing even the force of annihilation into its flowerlike folds:

> The mere picture
> > of the exploding bomb
> fascinates us
> > so that we cannot wait
> > > to prostrate ourselves
> before it. We do not believe
> > that love
> > > can so wreck our lives.
> The end
> > will come
> > > in its time.
> Meanwhile
> > we are sick to death
> > > of the bomb
> and its childlike
> > insistence.
> > > (Williams 1988, 321–322)

At times this late poem seems to turn its back on history, as if it could choose, against "the bomb's work" and "the fire at the Jockey Club in Buenos Aires," to live instead according to the intimate pleasures of love and art:

> You know how we treasured
> > the few paintings
> we still cling to
> > especially the one
> > > by the dead
> Charlie Demuth.
> > With your smiles
> > > and other trivia of the sort
> my secret life
> > has been made up,
> > > (Williams 1988, 324)

The mind when it turns to these things of "love" and "eternity" "gelds the bomb" (Williams 1988, 335). Here Williams evokes the world described by still life and lyric against the violence that is pervasive in history. "Waste / dominates the world" (Williams 1988, 324). In art and memory, the very things that count as "waste" in the world, Williams finds some reprieve from the dominion of the bomb. "Love and imagination" aim "to avoid destruction" (Williams 1988, 334). This rhetoric is a long way from early Williams in *Kora in Hell*, where "it is in the continual and violent refreshing of the idea that love and good writing have their security" (Williams 1970, 22). Throughout "Asphodel" Williams abhors violence, seeking peace in the spirit of still life. Yet even in this gentleness Williams's restless struggle and movement in place continue: "The light / for all time shall outspeed / the thunder crack." At the end of the poem he focuses on that central element of still life, the language of light which seems motionless as it surrounds the objects of ordinary life but is unstoppable "in its struggle with darkness" (Williams 1988, 335).

Stevens never traveled much aside from his occasional sojourns to the American South. Instead, he was a collector, experiencing the distant world imaginatively, through letters and other exchanges, and through the objects that carried some of its savor. Williams stormed within the walls of his New Jersey home and medical practice, bringing the universal into the local. But as we turn to the poetry of Elizabeth Bishop we find an opposite situation: the poet as foreigner, in the midst of vibrant yet distressed cultures that are not her own. For Bishop still life becomes a way to understand cultural difference and inequality, to imagine the life of the other without surrendering her own.

THREE

Elizabeth Bishop's Ethnographic Eye

If Wallace Stevens struggled to overcome the feeling of a
"spirit without a foyer," Elizabeth Bishop often felt herself a spirit
without a home. All her local spaces are transitional ones—barren
apartments, cheap hotels, cold parlors, leaky kitchens, waiting rooms,
bedlams, mirrors in which the troubling world enters and flees. Yet as
readers have long noticed, she was absorbed throughout her career
with the idea of home, whether those "narrow provinces / of fish and
bread and tea" she remembered from her Nova Scotia childhood or
those "gray wasps' nest[s] / of chewed-up paper / glued with spit" that
make up the primitive dwellings of her subjects to the south (Bishop
1983, 169, 34). As Bishop examines these dwellings, she is often on the
outside looking in, or at least looking on, whether through use of the
third person, through the adoption of a persona, or as a visitor or
tourist. Her own alien presence becomes a part of the picture, creat-
ing intimacy and distance at once. It is often by way of quotidian do-
mestic objects and their arrangement in intimate space that she
conveys this sense of dwelling and distance. Bishop inherited from
Marianne Moore and William Carlos Williams a penchant for close
observation of particulars, and she turned often to the senses and the
sheer otherness of the object world as a relief from human abstraction

and rhetoric. But things are not things-in-themselves. Objects accrue and provoke human feeling, though sometimes a feeling of the uncanny. As objects speak in Bishop, some of them quite literally, they convey history, ethnicity, and traumatic experience. More than the otherness of objects, Bishop concerns herself with the objects of others, things as they are interpretable within alien social and cultural settings. Yet within this inhuman field of objects, Bishop locates a common human feeling. Through the language of still life, she charts a variegated cultural landscape where distinctive local orders express a human desire to dwell.

The World Is Not Flat

An exclamatory "Look!" runs throughout the poetry of Elizabeth Bishop, but the close-up, intimate looking for which she is famous developed over time. Some of the early poems hold the world at bay, imagining it from a perspectiveless height where the landscape is flattened and generalized into symbol. Bishop's first "planet on the table" is a map. Yet even in these early poems Bishop checks this tendency to abstraction with local details and intimate gestures that bring the world into relief. The case through which she gazes at the world in "The Map" reminds her of an aquarium or glass "cage" (Bishop 1983, 3). Yet she refuses to submit to the rational abstraction of the map or to be bound by the rules of the diagram. Her imagination runs free within this "cage" and releases parts of the world into an indeterminate, fluid, and sensuous whole. Her haptic connection to the map (the "bays" can be "stroked" like the backs of horses; "the peninsulas take the water between thumb and finger / like women feeling for the smoothness of yard-goods") is one of care, affection, and creativity rather than cognitive or political mastery. A pictorial and fabulous rather than a rational, diagrammatic reading of the map brings the world closer in scale and feeling even as it undermines the map as a document of knowledge about reality. Yet she seems aware that this is not how maps are used, and that in history their function is more instrumental than playful.

How different Bishop's speaker in "The Map" is from the warmongers she describes in "Roosters," "marking out maps like Rand McNally's" with their "glass-headed pins," creatures who would cut the

fabric of the world to a narrow rule (Bishop 1983, 35). Bishop's contemporary model was W. H. Auden, and one can hear his warning voice, his wariness of maps and projected landscapes, throughout her work of this period. Like Auden, she used disjunctions of scale and perspective to critique the expansionist ethos of fascism and nationalism: "The language of size / Spreading to China along the trade-routes" (Auden 1979, 51). In contrast to such an impulse to dominate, to see the world only from the distance of one's own intentions, or the distance of one's own security, Bishop gives voice to local lives stabbed by each glittering pin,

> each one an active
> displacement in perspective;
> each screaming, "This is where I live!"
> (Bishop 1983, 36)

Bishop moves out from the dream-world of the map to explore the historian's colors, but with the poet's empathic and imaginative embrace rather than the positivist's or romanticist's distance. (Bishop did not have Auden's direct experience of war, but like Stevens she spent time in Key West just when military maneuvers were intensifying there, and like him she comments on this presence in her letters. As Camille Roman points out, the military presence was indeed in her backyard.) Bishop was a great traveler, in Walter Benjamin's sense: "the person who passes through cities and countries with anamnesis [memory of the past]; and because everything seems closer to everything else, and hence to him, since he is in their midst; all his senses respond to every nuance as truth" (Benjamin 1999, 248).

We see this move from schematic and remote to dispersed and localized image as a pattern in several of Bishop's early poems. In "Over 2,000 Illustrations and a Complete Concordance" the "heavy book," the illustrated Bible, wants to hold the world in its engravings, "complete" in its cross-referencing concordance. But as the poet gazes at the Bible's pages, they yield to a fluent, dynamic series of experiential memories (Bishop 1983, 57–59). Like the Rand-McNally map, the "heavy book" is a kind of planet on a table that distorts the living planet stretching beyond its "grim lunette." Bishop condemns Ezra Pound for similar distortion in "Visits to St. Elizabeth's," where his "house of Bedlam" is a consequence of his walled-off, distanced view,

his fascist vision which has flattened a world (Bishop 1983, 133–135). The poem moves out, across roads, across the sea, to a world that was once round but is now flat because of war.

But Bishop, like Robert Frost, remained ambivalent about "walls," which become a recurrent trope in her work. If walls separate and fragment or constrain the world, they also provide shelter. In an unfinished poem, "The walls went on for years & years," she associates the walls not only with various dwellings she has lived in and lost but with poetry as well, "holding up those words / as something actually important" (Bishop 2006, 61). The difference is between walls that would enclose the world and walls within the world that would shelter and order the individual life or community. If some early poems reveal Bishop's suspicion of those who would flatten the planet with diagrams, other poems show her affection for the human impulse toward local aesthetic orders which produce a sense of "home" in a disturbing, fragmented, and chaotic universe. Again in the unpublished poem, as in others, the world's "sad view" comes "to the window to look in" and then darkens (Bishop 1983, 62). As Bishop stands on both sides of the window, her gaze is not disinterested; she gives us a sense of her own presence amidst the scenes she observes. Her proximity is not transparent. Like the modern ethnographer, she knows she is involved in what she sees.

Bishop's localizing gaze seeks and creates textured orders in a chaotic world rather than flattening it into a grim lunette. Against the expansions of the public realm, Bishop's poems often struggle to find a human scale of value. Issues of proximity and distance, and the related issues of scale, appear throughout her work, as many readers have noted. From early in her career Bishop's attention to excesses of scale, and her preference for a more intimate scale, seem to have something to do with urban experience and with modernity in general, its deracinating, dehumanizing force. "The whole shadow of Man is only as big as his hat," though the "man-moth" spirit "nervously begins to scale the faces of the building" (Bishop 1983, 14).

Bishop began her poetic career just after an era of ecstasy over the magnitude of human technological achievement, just when the Great Depression awoke the world with a jolt from its materialist dream. "From the Country to the City" imagines the landscape as one continuous harlequin body, a suffering body tortured by the foolish dream-life of the city's demonic "brain" and its insatiable, corrupt

"heart" (Bishop 1983, 13). As Susan Stewart has pointed out in *On Longing*, the giant body often figures the public realm, whether of the state or of technology, while miniaturization figures the personal interior (Stewart 1993, xii). Bishop's early city poems suggest a fragile human dimension beneath the vast façades of steel and cement, a fragility of the private world under the outsized ambitions of the public realm. The window is a central vehicle for this reflection. It becomes a constant in Bishop's work, framing a threshold between inside and outside, offering at once containment and extension. In "Love Lies Sleeping," a poem influenced by T. S. Eliot and Hart Crane, she manages to feel tenderness toward the "immense" city of New York by miniaturizing and animating the scene within her apartment window, her personal space (Bishop 1983, 16). The city becomes "a little chemical garden in a jar," which "trembles and stands again, pale blue, blue-green, and brick" (Bishop 1983, 16). But like Williams's glittering city starflower in "Perpetuum Mobile: The City," Bishop's window vision is "a little false," a pastoral fantasy (Williams 1986, 430). As Stewart observes: "Once we engage in the mode of consciousness offered by existence *within* the city, distance is collapsed into partiality, and perception becomes fragmentary and above all temporal. Inside or outside, the typical view of the city is through the window—a view within a definite frame and limited perspective, mediated and refracted through the glass of the city's abstraction of experience" (Stewart 1993, 79). As her imagination moves out from this miniature to imagine a populace waking up, Bishop actively displaces her perspective, reminding us that her image is only part of a prismatic whole.

Bishop often subverts, even reverses, the human tendency to align size with a scale of value. She may be intrigued with the "large bad picture" suspended between "commerce and contemplation," but she is enamored of the little Nova Scotia painting in "Poem," "a sketch for a larger one," "about the size of a dollar bill," which tenders memories of Great Village (Bishop 1983, 11, 176). Nature's size can sometimes remind us of the limits of human mastery and power, as in "Brazil, January 1, 1502," where the invading Portuguese and modern North American tourists are shrunken and absorbed, "tiny as nails," into the "giant web" of the jungle (Bishop 1983, 91–92). The poor know best what is true of all of us, that we are "specklike" squatters in the vast mansion of rain (Bishop 1983, 95). But if nature can be a corrective to

the outsized ambitions of human mastery, there remains the problem of defining a scale of order and arrangement that satisfies us individually, and this is where Bishop often turns to still life.

Bishop and the Art of Still Life

When Elizabeth Bishop took out her watercolors and inks, as she tended to do throughout her itinerant life, it was often to capture some small-scale arrangement of objects: a liver-spotted croton leaf, a star cactus, a simple but graceful wildflower cluster, wreaths in a cemetery. Often the subject was a domestic interior, not home but a hotel room, a ship's cabin, a hearth with no walls around it. Bishop's eye was drawn to anything on a table—an oil lamp, a candelabra, tea laid for one, a scraggly bouquet of daisies in a paint bucket. This attention to proximate objects is hardly surprising in a poet who values useless concentration, and the emphasis on domestic interiors reflects her long meditation on "home." In her simple ink drawings and watercolor sketches, often unfinished but always enchanting, one can find the style and matter of her poetry. A richly colored image of pansies beside a pile of books on a checkered tablecloth conveys her instinctive association of word and image (fig. 4). Bishop's words become visible in odd angles of vision, the play with scale, the emotional language of colors, the affection for the humble.

As with her poetry, her paintings sometimes represent a world, and a point of view, anomalous to the viewer, and yet intimate. *Red Stove and Flowers*, for instance, is a marvelous bit of folk art in which the "Magic"-brand stove topped with pots of black beans and white rice is placed on the same visual plane and in the same scale alongside white and red flowers bursting from a crude pitcher (fig. 5). Presumably in this deliberately "naïve" image the flowers are meant to be in the foreground, sized to indicate their relative proximity in comparison to the background stove. But without the perspective lines the effect tips toward a psychological and emotional equivalence: aesthetic delight holds its place beside necessity. As if by "magic"—and painted in a Brazilian environment that favored the occult—norms of proportion and scale disappear, and the stove and flowers fit equally on the picture plane and in the mind. The black background (common in Dutch and Spanish still life), which is hardly even a wall, establishes closeness; we

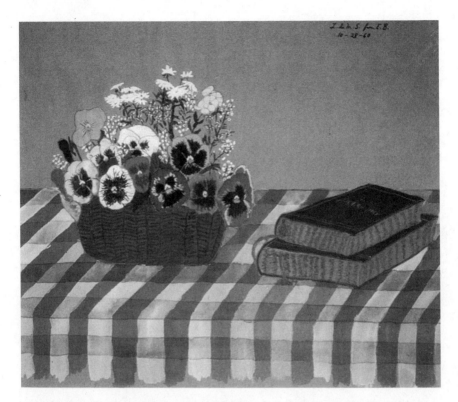

Figure 4. Elizabeth Bishop, *Pansies*, 1960. From *Exchanging Hats: Paintings* by Elizabeth Bishop, copyright 1996 by Alice Helen Methfessel; reprinted by permission of Farrar, Straus and Giroux, LLC.

cannot distance ourselves from this space, strange as it is. The wooden floor becomes a wooden table, and the two items become intimate gifts offered to the addressee: "May the future's happy hours bring you beans and rice and flowers" (Bishop 1996, 67). Like the painting, the syntax of the greeting puts the objects in parity, and we adjust our perception.

The Brazilian domestic scene, with its element of "magic," transforms the quotidian. The picture stands in contrast to earlier images of stoves in Bishop's poems and drawings, where the "magic" has a sinister effect. In a small ink drawing of a paneled room lined with clocks and stoves, the brands "Fancy" and "Ideal" compete with "Regulator" to produce more anxiety than charm (Bishop 2006, 64). In an unfinished, discarded poem associated with this drawing, "Stoves & Clocks," the mood is profoundly dark. The poem seems to compress

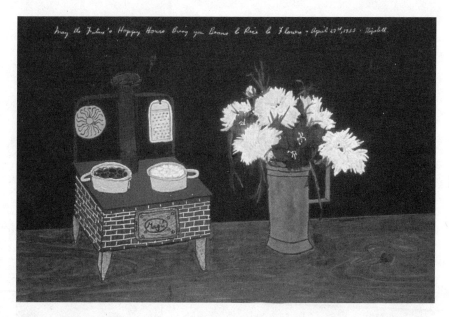

Figure 5. Elizabeth Bishop, *Red Stove and Flowers*, 1955. From *Exchanging Hats: Paintings* by Elizabeth Bishop, copyright 1996 by Alice Helen Methfessel; reprinted by permission of Farrar, Straus and Giroux, LLC.

time into space and cosmic and global space with all the "fixtures of the world" into a cold, silent room: "Extinct and terrible the world" (Bishop 2006, 65). Perhaps it is Bishop's allegiance to George Herbert, and his command to be "new, tender, quick," that would not allow her to finish such an awful, cheerless meditation. Even the "Marvelous Stove" in "Sestina" generates more warmth (Bishop 1983, 123).

Bishop is certainly an inheritor of the American modernist obsession with ideas in things. But she is less driven than either Stevens or Williams to isolate the object from its world and fix it in an aesthetic space. As we have seen, Williams selects and arranges objects to bring out fresh associative, even personal value, but in order to do this he wages war on conventional narrative and scenic values. While Bishop learned from the localism of John Dewey and shared modern poetry's resistance to the intentional subject, her poetics of detachment did not involve Williams's "unpairing of people and things" (Brown 2003, 125). Instead she tended to study people, and herself, through their things, removing her gaze from human purpose and labor to the objects in which they leave their trace. Narrative, both cultural and

personal, is not purged, but lurks in all her descriptions. Rather than isolating the object in poetic space, Bishop often presents objects arranged in shallow, intimate spaces redolent with memory and emotion. For her, still life is the art not of things in themselves or in the mind but of things as we order them for our uses and displays.

Bishop's penchant for the domestic still life and the culture of the table gives her an affinity with the Dutch tradition, but while Dutch still life attends to the surfaces of things, Bishop's poetry probes objects for the cultural and psychological knowledge they might contain. Her eye traced wild cliffs and coasts, of course, but she returned repeatedly to more local, habitable orders of "fish and bread and tea" (Bishop 1983, 169). And while she often treats domestic objects with familiar nearness and even myopic detail, she conveys at the same time the sense of an outsider, even an ethnographer. Bishop does not take up the subject matter of still life directly as a matter for formal experimentation, as does Wallace Stevens, William Carlos Williams, or Marianne Moore, studying pears, animating a pot of flowers, emblematizing a dish of nectarines. But one finds within Bishop's portraits, domestic scenes, and travel narratives still life moments in which objects are arranged and scrutinized for their aesthetic and sensuous pleasure and their silent cultural significance.

In a manner characteristic of still life, Bishop frequently foregrounds objects, suspending human activity. A begonia set on a doily, a scarlet fish in a frying pan, a wasp's nest on a pharmacy shelf, an iron teakettle on a stove: these images belong to stories and even, indirectly, to History. But Bishop removes these structures and narratives to the background and lets objects speak in the language of material culture. Norman Bryson identifies the matter of still life as "the life of the table, of the household interior, of the basic creaturely acts of eating and drinking, of the artifacts which surround the subject in her or his domestic space, of the everyday world of routine and repetition, at a level of existence where events are not at all the large-scale, momentous events of History, but the small-scale, trivial, forgettable acts of bodily survival and self-maintenance" (Bryson 1990, 14). But Bishop's imagery, the peripheral stuff that she brings into focus, tells us something important that we could never see full-face. The hand-hewn clogs in "Questions of Travel" are the trace of Dutch presence in Brazil; the "arctics and overcoats, lamps and magazines" of "In the Waiting Room" are things absent from the world depicted in the

National Geographic, but they seem, in a gaze estranged from the familiar, just as "unlikely" (Bishop 1983, 159–160). This is the trivial, ephemeral, entropic stuff of still life, and Bishop's eye lights on it not only in order to elevate the ordinary but also to read the everyday as the domain in which the purposes of culture (such as economics, sexuality, or politics) are conveyed or resisted.

Like Williams, Bishop knows that while we may want materiality to precede culture, to be the ground of ideas and the anchor of identity, we inevitably experience things within culture, its semiotic and ideological structures. But still life often suppresses the work of culture as it displays the goods of culture. These arrangements seem given rather than made. And indeed, while things are never things in themselves, yet they are never fully of us either. The table is the primary site of material culture for the art of still life: even more than the hearth, it is the sign of home, the site of conversion from nature to culture, raw to cooked. The table is the sign, too, of consumption and display, the two sides of cultural desire, the shelf being a related, prior site. In these relatively shallow spaces (compared to the landscapes Bishop describes), local orders become defined in relation to material flux. Things bespeak the culture that produces them, its relationship to nature, and the place of individuals within that culture. But they retain an alien aspect, an otherness. Bishop, much more than other poets enchanted by objects, selects things that bespeak our life of nurture and shelter, ornamentation and display.

In the seventeenth-century Dutch world, many still lifes celebrated an affluent, bourgeois existence and the national confidence of a productive culture able to import goods from distant places, proud of its secular learning but, as Simon Schama has shown, anxious about its spiritual health. Bishop greatly admired and imitated the Dutch art of describing, but the cultures she represents are very different. And unlike the Dutch, Bishop often looks, as Adrienne Rich long ago pointed out, as an outsider, at cultural positions different from her own. More than Williams or Stevens, Bishop reflects, implicitly, on the ethics and politics of this outsider gaze. Still life in her poems thus offers a refracted mirror, in which we see ourselves reflected, as well as the very different world to which these displays bear witness.

At the time Bishop was developing as a writer, America was becoming more interested in its regions and developing a complex sense of "American culture" that would be spatial rather than developmental.

The Federal Arts Project and Federal Writers' Project were encouraging the investigation and recording of regional cultures. A new emphasis on American folk traditions was challenging the bifurcation of American culture into high and low. This regionalist emphasis tended also to offer an antidote to the growing anxiety about industrialization and totalitarianism (Hegeman 1999, 130). While Bishop's career is often viewed as a diversion from the main path of American poetry, her early fascination with folk traditions in America and abroad can be seen as part of this trend. But for Bishop the celebration of rural traditions was not simply an antidote to political and economic crises. She uses folk images to identify the stresses within a culture's peripheral vision.

When Bishop's poetry represents worlds very different in class and region from those of her audience, a tension arises between the insights of social justice and aesthetic pleasure. Bishop's imagination is drawn to the aesthetic impulse within poor and working-class life; she discovers the affective power of the minimal or tattered object. Indeed, their poverty is part of the beauty of these arrangements for her, a relief from the excesses of first world affluence. In this she recalls Williams, who declared, "it's the anarchy of the poverty / delights me" (Williams 1986, 452). At the same time, one is moved to pity the hardship these inhabitants endure and to see their arrangements in terms of the broader political and social environment, more a matter of destiny than choice. Some of her descriptions recall American trompe l'oeil artists of the nineteenth century, especially John Peto, whose rack painting *Poor Man's Store* (in faded reds, greens, and blues) anticipates the beautiful melancholy of her Key West images. Bishop's prose description of the Key West barbershop window in which she first saw a painting by the Cuban folk artist Gregorio Valdes is itself a kind of rack painting: "The picture leaned against a cardboard advertisement for Eagle Whiskey, among other window decorations of red-and-green crepe-paper rosettes and streamers left over from Christmas and the announcement of an operetta at the Cuban school—all covered with dust and fly spots and littered with termites' wings" (Bishop 1984, 51).

Do the ornaments and luxuries of culture here evoke a *vanitas*, the still life tradition that reminds us, through symbols of time and erosion, of our mortality? This society has little for sale and can afford even less. But the colorful barbershop window frames a culture that

refuses to be defined by necessity—that may escape into drink ("Eagle Whiskey"), but may also embellish its dark world with rosettes and operettas. It is less pathetic than the house of the more affluent white woman in "Faustina, or Rock Roses" (Bishop 1983, 72–74), whose visitor, the narrator of the poem, is embarrassed "not by nakedness, though perhaps by its reverse," not by proximity to nature but by the effort to deny it in the all-white still life exhibit of "talcum powder, the pills, the cans of 'cream' " that promise to ward off mortality. But we are reminded even more of the vanity of human wishes by her pathetic display, her "clutter of trophies." An unambiguous *vanitas*, the poem reminds us of the entropy to which all culture is subject, even for those socially designated masters, like the white woman who employs Faustina. Clearly this little study in white is racially as well as psychologically inscribed, set as it is in chiaroscuro with a "black coincident conundrum." (The poem becomes for a moment a grotesque parody of Manet's *Olympia* as the black maid "exhibits" the objects to the reclining white figure, proffering pills now, Manet's bouquet transferred by Bishop to the speaking guest with her rock roses.) There is no sense of home or hospitality in that morbid environment, tense with race and class hierarchies trumped by mortality.

Bishop's still lifes can display, then, poverty amidst riches or riches amidst poverty. It is a difficult ethical balance that she would struggle with throughout her work. How can "pity" (think how often the word arises in "Questions of Travel" and how ambiguous its referent) combine with pleasure (Bishop 1983, 93–94)? As Margaret Preston has observed, there are "so many tables of still life in modern paintings . . . because they are really laboratory tables on which aesthetic problems can be isolated" (quoted in Lloyd 2005, 6). But for Bishop these are also ethical problems. How can we appreciate the aesthetic of the primitive without sentimentalizing the minimal, and limited, conditions in which this aesthetic arises? How can we recognize distinctive regional traditions without stereotyping their exemplars? Bishop represented a broader trend in American culture of the thirties when she turned her attention to rural and folk cultures in contrast to the sterile excesses of urban and dominant cultures.[1] Yet many readers criticize Bishop's early poetry, and even some of her Brazil portraits, for falling into stereotypes despite their appreciation of regional cultures. Camille Roman, for instance, remarks: "In poems like 'Jerónimo's House' and 'Cootchie' she represents the complex multicultural

race- and class-oppressed local cultures of Key West and in this respect refuses to follow the dominant cultural tendency of the era to ignore the existence of difference. However, she also domesticates and/or primitivizes racial difference and 'otherness,' reifying her own privilege and reproducing the era's stereotypes" (Roman 2001, 51). By examining Bishop's descriptions of domestic objects within these regional cultures, we can see how she negotiates this problem of cultural difference and aesthetic attraction. Walter Benjamin associated folk art with kitsch: "Art teaches us to look into objects. Folk art and kitsch allow us to look outward from within objects" (Benjamin 1999, 279). Bishop's artful poetry incorporates folk art and so allows us to look both ways, avoiding kitsch.

"Jerónimo's House" (Bishop 1983, 34) was inspired by Bishop's observations of the Cuban émigrés in Key West. Her letters suggest a particular model: "Down the street is a very small cottage I can look right into, and the only furniture it contains beside a bed and chair is an enormous French horn, painted silver, leaning against the wall, and hanging over it a pith helmet, also painted silver" (Bishop 1994, 68). The poem is similarly an inventory of Jerónimo's belongings—almost like a John Peto or William Harnet rack painting. Bishop brings the distant near in this small, shallow space through references to the radio and to the émigré's cultural and political past—with the suggestion here of an aspiration lost to the ravages not just of hurricanes but of political history itself. But under the artifice of Jerónimo's voice one hears Bishop both universalizing his condition (we are all living in frail shelters from the hurricane) and identifying with it personally (she likes this minimal aesthetic; she shares the desire for display). In particular, Bishop exposes the scene of writing so that his near distances become her own. In "Jerónimo's House" the shallow, primitive space of the Cuban's dwelling becomes intercepted with "writing paper lines of light," and the window through which she gazes into his home becomes a mirror, his center table her desk. The "wasp nest" home of chewed-up paper glued with spit recurs in "Santarém" as a figure for the poem. One might criticize this move as a metaphoric appropriation of Jerónimo's actual historical suffering. But the poem manages to retain Jerónimo's particularity while inhabiting his abode. The result is a linking of the poet and her subject which neither subverts nor presumes full knowledge of the Other.

The mixture of festivity and *vanitas* further complicates our reading

of "Jerónimo's House." He celebrates life even in the poorest conditions, and finds aesthetic abundance within spare circumstances. But as the poem delights in visual display and vibrant color, it highlights the precariousness and transience of this domestic order, the proximity of luxury to necessity, thus adding a note of melancholy. What complex relationship to this display does Bishop create for her relatively affluent, Northern audience? What role does the still life of the minimal play in a culture marked by excesses of number and scale? Does the scene in Jerónimo's house claim an imaginary, spiritual economy within a spare material economy? Does the poem therefore objectify Jerónimo and his household, making them available for the metaphorical and aesthetic contemplation of the better-endowed reader? Yet for Bishop the material economy is never forgotten.

We do not see Jerónimo, who creates this order—but we hear him (or, rather, his voice is constructed by the poet), and his contemplation of the order he has created is different from our own. The Roman word for still life, *xenia*, means both "host" and "guest," and he is both host and guest of this scene—audience, that is, to his own theater. But we are also his guests, audience, through Bishop, to his performance. We are aware immediately of the vibrant color—scarlets, pinks, greens, blues, aluminum—and the baroque variety of shape as well: ferns, French horns, looping Christmas decorations, woven wicker, and latticework on the veranda (an aural echo in the flamenco music). As so often in the still life tradition, all the senses are suggested within the visual field—smell and taste from the food, sound from the radio—adding to the feeling of abundance.

Jerónimo's rhetoric denotes his pride and pleasure in the order he has created: his "fairy palace" "endowed" with spiritual worth by himself as ruler, though materially poor and minute. Miniaturization makes this whole house, not just its contents, part of a still life—with its "little center table." This ornate and vibrant variety, addressed to the imagination, does not dispel the material poverty of the "perishable clapboards," or the general impermanence of the paper materials, which mark the thin border between this home and the chaos of the weather, the hurricane. The attention to number throughout the poem contrasts this domestic scene to an aesthetic of abundance. How many of us can enumerate our belongings? Here four chairs, ten beads, two palm leaf fans, four pink tissue paper roses, one fried fish. (A fish for how large a family, one wonders; since he mentions only

the "smallest baby," we infer several others in this three-room house.) These are spare numbers against the "lottery numbers" and their dream of quick affluence (the same force of chance, in contrast to feeble manmade order, that brings the more likely hurricane).

The lineation of the poem reinforces the insubstantiality of the scene but at the same time allows the eye to register each item, connected by "and . . . and . . . and." Why did Bishop choose to set this poem in double columns (as she did not, say, for "Night City," which also has very short lines)? The single page seems important to the sense of a finite space. The poem stresses the proximity of the culture of the table to the disorganized and even threatening presence of nature—the sense of the raw strong here within the cooked. The house, as Jerónimo tells us, is a kind of "wasp nest," an ad hoc "affair" of "chewed up paper glued with spit." The decorations retain their origin in nature—the ferns planted in sponges, the palm leaf fans. The little allowance for decoration at Christmas becomes the ornament that must sustain the occupants throughout the year. Jerónimo makes a space at Christmas for the aesthetic, but not for the Christ child; the real child, the baby, is the important one. Yet even here, display and aesthetic pleasure, not just necessity and use value, order the objects.

How are we to feel about this display? John Peto's rack paintings sometimes include a sign: "Important information inside." What kind of information is this poem alluding to with its display of objects? Certainly the objects are marked in an ethnic sense. The vibrant coloring and love of ornament seem to be part of a Southern baroque style that Bishop, like Stevens, contrasts to a more muted (grays and greens), colder Northern culture. Like many still lifes, this one evokes music, first with "an old French horn" repainted with aluminum paint, then with "flamencos" coming from the radio. The flavors evoked in the images again provide a contrast to the familiar diet of the Northern poet. Here we find a "scarlet sauce" for the classic still life fish—it has been dressed, most likely, in red chili sauce. Jerónimo's house is clearly that of an émigré, his possessions registering his frail tie to his origins. Objects are not universal or objective; they are ethnically coded, and Bishop celebrates this ethnic distinction even as distinctions of class and political oppression mark the difficult conditions of Jerónimo's dwelling. We can read these images for their political pathos.

Here is poor Jerónimo, barely getting by in Key West, pathetically celebrating the Cuban struggle against Spain in the parade for José

Martí. "The apostle of Cuba," Marti was a poet and statesman banished from his native country for activities in protest against Spanish colonialism. Cuba was one of those glass pins in Spain's colonial map. Martí cried out, "this is where I live!" (Bishop 1983, 36), and was jailed and exiled for it. While he was devoted to Cuba's freedom, he roamed the United States, Europe, and Latin America seeking support for his cause. Indeed, in 1892 he gathered Key West's fragmented Cuban exile community into the Cuban Revolutionary Party, the movement that led to the establishment of a free Cuba in 1902, just seven years after his death. He died on Cuban soil only minutes after his first ride into battle. His collected writings in seventy-three volumes commenced publication in 1936, just when Bishop was living in Key West.

Martí is a symbol not only of Cuba but of exile and of poetry as well. And Jerónimo is his heir. How liberated is this heir? He will be moving soon (unable to pay the rent?). Yet Bishop is clearly attracted to this ad hoc, primitive aesthetic with its proximity to nature. She is attracted not as an insider but as an outsider—coming from the world of excess in New York City and its hubristic "fantastic triumph" over nature (Bishop 1983, 13). Bishop seems to align her art with Jerónimo's. But in doing so she acknowledges the limit of her knowledge, turning the poem away from ethnic description and toward metaphor. Just as still life often announces its artifice, the poem draws attention to its own making in relation to the order Jerónimo has made. The "writing paper lines of light" remind us that all of this display rests upon the poem itself, ephemeral as the chewed-up paper house. Poetry, like still life art, is an ad hoc arrangement, a papier-mâché of the past. But if one direction of the poem is toward "rhopography"— the display of the stuff of life, what is ephemeral, trashy, and everyday—another is clearly toward "megalography," the conversion of poor materials to numinous riches. The poem seems to hover between these impulses, between rhopography and megalography, between economics and imagination, between Jerónimo's world and Bishop's own, between the shabbiness of John Peto and the elegance of Joseph Cornell.

The paternal Jerónimo presides over his own private world (emasculated though he may be within the economic and colonial structure of the wider culture). But still life, as Bryson argues, belongs to what is culturally defined as feminine space (Bryson 1990, 136–178). It belongs to the realm of the domestic, of nurture, of the table, of rest, of

nature converted to culture, as opposed to the masculine realm of the road, the outdoors, of work and war, movement and stress, of animal impulse. "Filling Station" (Bishop 1983, 127–128) pursues the structure of this "dazzling dialectic" (Bishop 1983, 185) in the idea of family. The poem recalls Walker Evans's tableaus of American life along the roads of the South. More concretely, Bishop may have seen Evans's photographs of small rural establishments that served as both home and business—the isolated barber shops and lonely gas stations backed by invisible private lives; Evans's compositional use of advertising signs comes to mind as Bishop's speaker reads off the "Esso-so-so-so" on the oil cans at the end of the poem; in Evans's interiors, as in Bishop's, American aspirations are mirrored back in awful but somehow resilient and even cheerful conditions of dwelling. The speaker, coming from the road, is marked by voice and attitude as different from her subjects, more sophisticated and more urban than they. She approaches a male tableau (father and sons handling fuel pumps) with anxiety. The "saucy" (sexual) father and sons in their "monkey suits" are not yet human. They must be "civilized" by the feminine principle (with her "sauces"?). But as the speaker's gaze shifts toward the porch and the world of still life, the "disturbance" is calmed. The animal element (now benignly embodied as a dog in a chair) is made "comfy." Bishop stresses that the domestic space is not an independent realm; the wickerwork is "grease impregnated," but sexuality has become familial. The demotic still life scene on the porch offers a "note of color" *within* this study in grays and blacks:

> Some comic books provide
> the only note of color—
> of certain color. They lie
> upon a big dim doily
> draping a taboret
> (part of the set), beside
> a big hirsute begonia.

The combination of books and flowers is a topos of still life arrangement, but here we have comic books in place of august bound volumes; instead of an elegant floral arrangement we have a "big hirsute begonia." "Hirsute" means "hairy," reminding us of the hairy males who live there. (The feminine "doily" drapes like a skirt; on it "lie" the

fictional comic books.) The conversion of nature to culture is provisional and by definition artificial. The decorative element seems indeed "extraneous" and a little ridiculous. Yet this is an affirmation of *both* the comic spirit and the aesthetic impulse, for calming the animal in us, and offering respite from the anxious drive of technology. Bishop here, in this generic portrait of the American family, confirms Constance Rourke's observation that humor is an element of national character. Is the comedy of the poem condescending to the people who live at the filling station? Perhaps at first. But the speaker-beholder is drawn to this aesthetic arrangement, "dim" though it may be; she (we suspect a female beholder from the knowledge of the embroidered "marguerite") interrogates the arrangement, but also recognizes and enjoys it, becoming an insider, overcoming the high/low distinction of cultural pleasures. The speaker pauses to note detail—the parentheses in the poem ("part of the set") providing a typographical equivalent to the stillness of still life, the arrangement suspended from the forward movement of travel. She forgets the road in the theater of the still life. The language of the speaker mirrors the still life incongruities, introducing words like "taboret" and "hirsute" (like the baroque elements of Jerónimo's house) into the colloquial world of comfy and saucy, rhyming "oily" with "doily." The still life moment here performs a calming function, the aesthetic principle quieting the "high-strung" life of the road.

The final stanza of the poem highlights two fundamental features of still life: the absence of agency and the intransitivity of the image. Still life, to recall Bryson's argument, is the world minus its narrative, or the world minus its capacity for generating narrative interest (Bryson 1990, 60–61). But Bishop's poem awakens just this interest. "Somebody embroidered the doily." The poem shifts to present tense, as if to merge the static "still moment" of still life and the continuous present of life: "Somebody / arranges the rows of cans" (somebody *still* does). Ultimately the poem evokes a third, transcendent temporality: "somebody loves us all." The last two stanzas of "Filling Station" evoke temporal paradoxes in a way characteristic of ecphrasis. If still life, a spatial art, suppresses narrative, the verbal art awakens it. The comic books visually provide a note of color, but who provides the comic books? The verbal here does not compete with the visual but compliments it. We see this particularly in the end of the poem, where the verbal and visual coincide in the oil cans lined up to read

"Esso . . . so . . . so . . . so . . ." Here is a still life moment anticipating Jasper Johns or Andy Warhol, whose word-images alert us to the layering of representation. The prompt may be advertising, the visual text scrawled with brand names, but Bishop's "so . . . so . . . so" reminds us also of the way poetry converts instrumental language to pleasurable sound. If we must leave the domestic world of still life and return to the world of "high strung automobiles," we can be calmed, at least, by the aesthetic order.

The Planet on the Desk

The space of still life as it is defined in these poems is not tightly enclosed. The map may be under glass, but the actual domestic spaces are open to weather and to travelers; above all to news from the outside world. These convergent strata of reality, the near and the distant, occur in another poem of the thirties titled "The Bight," which describes the "untidy activity" of dredging and transport. Beneath the title Bishop writes in brackets and italics "[*On my birthday*]," thus giving this impersonal space a personal significance. With other poems in Bishop's canon such as "Crusoe in England" and "The Riverman," it might be described as ethnographic self-portraiture. A bight is like a foyer in a landscape, and in Bishop's treatment it indeed becomes a foyer of the spirit in a landscape of the mind, at the same time retaining its strong sense of entry and exit into distant physical and social realities. The Bight is a multicultural place where African marimba music, French poetry, and Chinese cooking intersect. At the same time it is an intimate place. In connection with "The Bight" many have noted Bishop's description in a letter to Robert Lowell in which she says of the Key West harbor: "The water looks like blue gas—the harbor is always a mess, here, junky little boats all piled up, some hung with sponges and always a few half sunk or splintered up from the most recent hurricane. It reminds me a little of my desk" (Bishop 1994, 154). The desk here is also a table, where one takes bites, hence the imagery of restaurants, scavenging birds, and "jawful" (rhyming with "awful") of marl. The shallowness of the space at low tide again reminds us that we are in a scene of writing and its "litter of old correspondences." The "unanswered letters" remind us that the distant world continues to intrude.

In modern treatments of objects—in Joseph Cornell's boxes, in Marcel Duchamp's readymades, in Claes Oldenburg's pop art blow-ups, and also in some of Bishop's still lifes—"things hurry away from their names" (Bishop 1983, 275). If hers is poetry of the everyday, she is also concerned with transfigurations of the commonplace. And as with the contemporary art of the object, Bishop's transfigurations often involve uncanny disruptions of scale. But her aim is not Dada subversiveness, is it, or private metaphysics? We might consider "12 O'clock News" (Bishop 1986, 174–175) as a vocational still life (the philosopher's study, the artist's studio, the geographer's desk, the musician's chamber) in this mode. Whereas some of the poems I have discussed bring the distant culture near, this poem presses out from the personal. Bishop defamiliarizes the artist's materials in order both to achieve an ethnographer's distance from her own work and also, conversely, to bring her own scene of writing into contact with distant political realities. In 1950 Bishop would begin a poem titled "Desk at Night" which brings this image into the foreground but retains a second foreground. Camille Roman, who also has written about Bishop's desk as a center of political reflection, focuses on her position at the Library of Congress in Washington, D.C., during her "worst year." Bishop revived the poem in the sixties and seventies, finally publishing it just after the U.S. withdrawal from Saigon. Roman also quotes Brett Millier's biography of Bishop: "She recorded a series of transparent dreams that link the tools of her trade, particularly typewriters, with images suggesting war. In one dream, the typewriter keys are a code she must solve" (Millier 1993, 134). We can read Bishop's "12 O'clock News," published in 1976, as the fulfillment of that effort to write "Desk at Night," and thus see the political landscape of the poem as both contemporary and generic in its response to American foreign policy.

In "12 O'clock News" Bishop describes her writing desk, but she expands it to the scale of landscape while at the same time insisting on the nearness of the objects. On the left margin she provides, in italics, an inventory; to the right of each item, a prose block converts the item to a feature of landscape. Such convergence and even conflation of landscape and still life, and therefore of distance and nearness, is itself common in the tradition of painting, and was exploited to powerful effect in surrealist painting such as that by Picasso, di Chirico, Miró, and Dalí. Without a fixed perspective or vanishing point, we cannot

orient ourselves in this space. By describing the objects of her creative activity—typewriter, inkbottle, and typewriter eraser—as features of a third world war zone, she suggests the turmoil of the creative mind from the point of view of a hegemonic culture. The impersonal voice of the news broadcast (which echoes the voice of wartime bureaucracy) displaces the lyric voice. Rhetorical stance and point of view line up as the "tiny principality" is seen from the angle of aerial reconnaissance, yet the intimate perspective of the writer remains implicit. Bishop liberates objects from their quotidian, functional meaning and consequently releases the dream work of the personal and social psyche. The "superior vantage point" of the news report thus exposes the *numen* of objects (inkbottle in particular) even while it dissociates itself from spiritual affect.

Bishop's personification of the typewriter eraser produces the reverse effect of Claes Oldenburg's sculpture *The Typewriter Eraser*, now in front of the National Gallery of Art in Washington. Bishop's typewriter eraser, as "unicyclist-courier" and "native" of the land of creativity, lies in a fallen, pathetic state, defeated by the forces of normative reality. Oldenburg, in contrast, gives us a perky monument to the bureaucratic mind, an anachronism of cold war technology, absurd in a postmodern, computer culture.

In "12 O'clock News," as in many of the poems of *Geography III*, Bishop resists a steady, dichotomous calibration of objects (small converted to large), instead unsettling the scale of large and small several times over—for by what size is the world of the psyche measured? As she says of the typewriter eraser turned native insurgent, "Alive, he would have been small, but undoubtedly proud and erect, with the thick, bristling black hair typical of the indigenes." Several standards of measure—physical, spiritual, political—are at play here. As a personified object the typewriter eraser has been transformed by the poet from something hand-sized to something human-sized; but the "superior vantage point" of the rationalist diminishes the cyclist figure as a racial subaltern, putting the human back into the state's gigantic, invisible hand. This still life, like so many others, stands at the juncture of the personal and the public, the near and the distant. As an image of objects in an intimate, personal space, it points toward the world of the individual; as an image of vocational objects, it points toward the social position of the artist, which itself resembles the position of indigenous societies under the scrutiny of a hegemonic power. The

poem refuses to stabilize the relationship of tenor and vehicle; it protests an imperialist war (Bishop returned to and finished the poem during the Vietnam War) even as it surveys the private war of the imagination.

The scene of writing surfaces often in Bishop's poems, whether as figure or as ground. In "The Bight" the desk surfaces implicitly at the end of the poem, where metaphor gradually shifts the scale from landscape to still life, and the "little white boats" in the Key West harbor are "torn-opened, unanswered letters." In all Bishop's still life gestures we see her attraction to "untidy activity" over prim, static orders, but in "The Bight" she implies that disorder is linked to the absence of a key to all correspondences. To quote Rosemary Lloyd again, "Often and increasingly so in modernist works, the still life objects convey a sense of messiness, of disorder, of chaos impinging on a world from which theological certainties were being eroded" (Lloyd 2005, xiii). In "The Bight" the untidiness is "awful but cheerful," but in "12 O'clock News" the disorder is the result of war rather than neglect.

The ambiguity of this poem arises at every level, and at every level has bearing on the play of proximity and distance. "12 O'clock News" is a prose-poem. What is a prose-poem? The generic hybridity underscores the fusion of animate and inanimate objects, such as the *"gooseneck lamp."* Do the left-margin italics cataloging the objects designate a foreground? Do the italics offer a gloss on the block text on the right? A heading or title for each report (yet put to the side, not the top), a relation of metaphor? The list of things on the left seems voiceless as compared to the marked public voice of the newscaster/bureaucrat on the right. Is it twelve o'clock here in the scene of writing or there in the war-torn country? (The hour itself is an ambiguous threshold between P.M. and A.M.) We are given descriptions through a radio correspondent while the poem is set in an entirely different site.

Dislocation, defamiliarization, difficulty of seeing, ambiguity of what we are seeing—these are trademarks of Bishop's work, however living in detail. The "plain" is anything but plain. We are never just "here" or "there" in metaphoric structures or in life. These dualities are compounded rather than relieved as we try to enter the world described in the prose blocks. The problem is not simply in the white space between items and descriptions or in landscape's metaphoric relationship

to the desk (expansion of scale and distance, thematic implications of the analogy). Within the landscape description itself "visibility is poor."[2] For example, whereas identification is straightforward enough in the left-hand inventory, labeling is problematic throughout the right-hand prose. "Our aerial reconnaissance reports the discovery of a large rectangular 'field,' hitherto unknown to us, obviously man-made. It is dark-speckled. An airstrip? A cemetery?" The embedded metaphors dislodge the established adjustment of scale and perspective: the "typewriter," enlarged to an "escarpment," is then metaphorically reduced to fish scales. The voice of the narrator also reduces what the poet has expanded: while the desk has become a geographic region, it is a "tiny principality." The "*typewriter eraser*," enlarged to a fallen "unicyclist-courier," is judged in life to have been "small, but undoubtedly proud and erect." Problems of seeing and interpretation in fact mark every paragraph, and much is said to be "undisclosed," as if there were some superior position of knowledge from which the speaker is quoting. From her desk Bishop shatters the presumptions of knowing the other even as she insists that the other is us.

Vanitas

In most of the poems we have examined so far the space of still life affirms the domestic world, defending a human scale of order and comfort against larger forces that threaten the individual. "Who among us," asks Walter Benjamin, "has not taken a delicious pleasure in constructing for himself a . . . dream house, a house of dreams?" (Benjamin 1999, 227). "Perfect! But—impossible," Bishop admits in "The End of March" (Bishop 1983, 180). More often her houses are places of nightmare. Book and candle illuminate a world of troubles. Despite its Pieter de Hooch–like calm impersonality, "Sestina" creates a sense of the uncanny as the eye scans discrete objects of various textures—iron kettle and stove, the bread, book, bird, and tea. Containers don't hold, and surfaces yield to a menacing intentionality of ideas in things. The sestina's repetitions may be likened to the obsessive circling of trauma. While the description of childhood memory seems timeless, Bishop's childhood overlapped with the years of World War I, an era of public as well as private turmoil; the almanac

says "time to plant tears" (Bishop 1983, 124). In a reversal of still life, dead things come alive, but only to remind us of death.

Still life is based on the culture of the table (whether for food or for work), that site of transmission from public to personal space and conversion of raw to cooked (Bryson 1990, 29). But Bishop's art of the everyday includes the surrealism of everyday life. The art of the object, subjected to animation, peculiar lighting, shifts of scale and perspective, and incongruous metaphor, is central to the uncanny effect.

In several poems Bishop evokes the mood of *vanitas*, that element (marked in skulls, broken jars, torn papers, low candles) which tells us that all our provisions are conditional and that material wealth is not equivalent to spiritual health. Bishop works both ends of this *vanitas* association. In "First Death in Nova Scotia" the dead become associated with consumption and food (death is caught in a structure of desire); here the culture of the table repulses the beholder. In "Going to the Bakery," set in Brazil, food becomes associated with death and disease (desire is repulsed by the knowledge of economic decay). In both poems still life becomes a way of exploring large social and ontological questions on a personal scale.

"First Death in Nova Scotia" (Bishop 1983, 125–126) describes a "lay[ing] out," a wake, but the morbid display suggests still life's imagery of a feast and alludes to its structure of desire. The bird on the table is not a pheasant or a turkey but a "stuffed loon"; the table on which it rests has become a winter landscape, a "frozen lake." The coffin itself "was a little frosted cake," and the whole scene suggests a starved desire: the loon caressable but uncaressed, eyeing the little cake-like coffin as if wishing to consume it. Lurking in the poem, too, since the scene is described from a child's point of view, are fairy-tale fears of adults eating children. (Did Uncle Arthur kill not only the bird but also young Arthur himself? Has Arthur also been stuffed by the taxidermist for heroic display?) Still life painting often involves the depiction of several modes of being—natural and artificial, animate and inanimate, representational and "real"—on the same plane. This becomes a source of confusion for the beholder in "First Death" as she struggles to understand the various layers of presence and absence in the scene in relation to human mortality. The chromographs, "Edward, Prince of Wales, / with Princess Alexandra, / and King George with Queen Mary," signify the colonial presence

(Nova Scotia was still part of the United Kingdom). They place the larger world (a world at war in the time of the poem's scene) into this small space (with its own silent history of violence). The speaker longs for narrative transformation—Arthur has been invited to join the royal couples presiding in the photograph—but agency is interrupted (Jack Frost has dropped the brush), and all the figures are frozen.

"Going to the Bakery" (Bishop 1983, 151–152) presents another form of *vanitas*, from the Southern region of Bishop's experience, and the opposite perversion of the still life image. This time the scene is not home but the street—the world of the market and its window displays. Food stall images are common in Dutch still life, mirroring a pre-domestic stage of material culture. In these images facts of labor and economic exchange disappear and we see only a limitless supply of goods, as if there for the taking. But in "Going to the Bakery" the goods can never become part of a nurturing domestic reality, even for the beholder who can afford to purchase them. The hunger surrounding the plenitude contaminates it, shocking bourgeois complacency. Sight becomes infected with the truth of a troubled economy in which everything is rationed and adulterated. "One might have thought of sight. But who could think / Of what it sees, for all the ill it sees?" wrote Stevens (Stevens 1997, 287). Bishop here turns her eye to the sickly sights. As with many of Bishop's poems, her unique perspectives trouble the surface and expose truths suppressed in familiar angles:

> the round cakes look about to faint—
> each turns up a glazed white eye.
> The gooey tarts are red and sore.
> (Bishop 1983, 11)

This grotesque bakery–as–hospital ward is seen in moonlight—but such is also the light of the imagination, exposing certain truths within the everyday. Bishop's surrealism leads not to the fantastic but to the real—to the dysfunctional and inhumane conditions of society. Rosemary Lloyd notes that the poem's "deliberately trivialized fixed form" helps to "underpin the ugliness of modern mass-produced food" (Lloyd 2005, 13). In the monotonous jingle "buy, buy, what shall I buy?" we also hear the mood of *vanitas*.

We cannot leave the subject of still life in Bishop's work without examining its relation to memory, both personal and cultural. What Benjamin called "the mysterious power of memory—the power to generate nearness," is a key element of Bishop's imagination, and still life is often the agent of this work of memory (Benjamin 1999, 248). Still life stands against time and flux; it is inherently memorial. The objects of still life are often souvenirs signifying lost (or imagined) contexts of origin. In this way, again, still life both suppresses and evokes narrative. Memory is of course a problematic mental process in Bishop, defining the continuity of self but linked inevitably to both pain and nostalgia. Removed from time and place, souvenirs represent desire's always-future past. Crusoe at the end of "Crusoe in England" surveys the archived objects from his island days with a hopeless sense that their *numen* cannot be retrieved. They fail as still life, presenting neither order nor nostalgic value, but only waste.[3]

Finally, Bishop's imagination breaks with still life where it leaves depiction and becomes exhibition. Objects belong to flux; if objects are invested with human meaning, they do not ultimately belong to us. The mother's watch and the lost door key of "One Art" indeed like all material things "are filled with the intent / To be lost" (Bishop 1983, 178). They may be archived (the poem draws links to all the poems in *Geography III* and earlier), put in a box like a villanelle itself, labeled and arranged as a guide to memory, but we cannot hold them in our gaze for long. The sequential nature of poetry, for all its repetitions, reminds us of this fact.

Yet the archival imagination persists in Bishop's late poetry. If the art of still life must yield to the art of losing, the souvenir is not without value altogether. As Bishop returns at the very end of her life to remember Nova Scotia and Brazil, she is more willing to acknowledge the pleasures of memory without nostalgic longing. The great-uncle's painting in "Poem" is a "family relic," not metaphysical, but alive with inscribed temporalities. "Santarém," etched in the blue and gold of memory, is a fictive Eden, if an embattled and demotic one. She cannot stop there, but the poet finds a souvenir, something she sees in another display:

> In the blue pharmacy the pharmacist
> had hung an empty wasps' nest from a shelf:

small, exquisite, clean matte white,
and hard as stucco. I admired it
so much he gave it to me.
(Bishop 1983, 185)

What is there to admire? By asking us as readers to interpret the object, she causes it to speak and makes us value it with her. Obviously
this object—homely, ephemeral—has associations for Bishop with the
town's charming church ("Cathedral, rather"). The wasp nest is a
miniature version of an already modest, perishable architecture (subject to lightning). It resonates, too, with Jerónimo's home, that "fairy
palace . . . my gray wasps' nest," and thus with poetry itself, that
"chewed up paper glued with spit" which houses the sting of life.

Like all Bishop's houses, this image is full of ambivalence. Gaston
Bachelard writes of the nest as a key image in the poetics of interiority
(Bachelard [1958] 1969, 104–109). But the wasp nest is in some sense a
center of pain. The source of pain, the pain itself has fled, leaving
something "hard" but hollow. These things are not of museum quality
but take their place in the personal archive of memory and the public
archive of poetic emblems. Bishop knows this souvenir has no inherent value and stands little more chance against the ravages of time
than it did in nature. Her fellow traveler Mr. Swan, a romantic attuned to a sublime scale, who "wanted to see the Amazon before he
died," asks, "what's that ugly thing?" (Bishop 1983, 187). But if he gets
the last word in the poem, his view does not prevail. It simply marks
the limits of the speaker's power over things.

The blue pharmacy and the nest on the shelf suggest Joseph Cornell
and alchemy. Bishop's famous translation of Octavio Paz's tribute to
Cornell, "Objects and Apparitions," is not far off (Bishop 1983, 275).
Since it is the only translation she collected within a volume of her
own poetry, it seems valid to read it as an *ars poetica*. So it is unfortunate that it was withdrawn from *Geography III* in her posthumous
Complete Poems, 1927–1979 and placed in the back with other translations. Let us restore it to its proper place, at the center of Bishop's
finest work. Many of the images were hers before she found them in
Cornell: "Monuments to every moment, / refuse of every moment,
used"; "Fire buried in the mirror"; the inversions of scale, the mixing
of life and memory, children, spirits, that "extinct world" brought
back in the abidance of art. Bishop would certainly agree with Paz,

who in *The Bow and the Lyre* wrote that "matter conquered or deformed in the utensil recovers its splendor in the work of art. The poetic operation is the reverse of technical manipulation" (quoted in Matthews 1977, 176). The generic affinities with still life and poetry are strong. The keeping of poetry, like the keeping of still life, does not denote mastery over material things, let alone over landscapes. Both remove objects from utility and reconfigure them in an artificial space. But they mark out an environment shallower than landscape, but more intimate, more human—in which the material world is arranged and encoded for the individual beholder.

Joseph Cornell

Soap Bubbles and Shooting Galleries

We live in a world of suffering in which evil is rampant, a world whose events do not confirm our Being, a world that has to be resisted. It is in this situation that the aesthetic moment offers hope, that we find a crystal or a poppy beautiful means that we are less alone, that we are more deeply inserted into existence than the course of a single life would lead us to believe.... The energy of one's perception becomes inseparable from the energy of creation.

<div align="right">John Berger, "The White Bird"</div>

Children are irresistibly drawn by the detritus generated by building, gardening, housework, tailoring or carpentry. In waste products they recognize the face that the world of things turns directly and solely to them. In using these things, they do not so much imitate the works of adults as bring together, in the artifact produced in play, materials of widely differing kinds in a new, intuitive relationship. Children thus produce their own small worlds of things within the greater one.

<div align="right">Walter Benjamin, "Old Forgotten Children's Books"</div>

The "quiverings to and fro" in the relations among the arts can never be delimited, and the work of many American or émigré artists who employed the medium of still life—Charles Demuth, Stuart Davis, Marcel Duchamp, Max Ernst, Kurt Seligmann—would have relevance for this study. But more than anyone else, that magpie original Joseph Cornell created what can be called physical poetry,

and he invites the beholder to dwell in the work as he would in a poem. Like poetry, Cornell's work charts the force field of metaphysics; but like the poems I have investigated here, it also rests firmly on the ground of contemporary reality.

Cornell's profound interest in poetry deserves much more attention than it has received, and than I am able to give it here. References to and borrowings from poets abound: Guillaume Apollinaire, Charles Baudelaire, Emily Brontë, René Char, Emily Dickinson, T. S. Eliot, Heinrich Heine, Hugo von Hofmannsthal, A. E. Housman, Compte de Lautréamont, Stéphane Mallarmé, Walter de la Mare, Rainer Marie Rilke, Pierre de Ronsard, Phillip Soupault, Walt Whitman, W. B. Yeats, and many, many more. Naturally, art historians have focused on the visual image bank from which he so richly drew—the Italian Renaissance and Dutch seventeenth-century traditions, surrealism, folk art, abstract expressionism, collage. Even more important are the popular images and forms that became his source materials: maps, posters, movie magazines, popular science books, and so on. But Cornell's love of poetry was lifelong, and in many ways he seems to have identified more with the enterprise of poetry, its metaphoric and associative power, its punning and rhyme, its sense of compression, its linkage of the physical and the metaphysical, than with the traditions of or contemporary movements in painting and sculpture. His collection of poetry books—purchased in secondhand bookstores and lovingly clipped and marked—was vast and varied. Notes and quotations from these books run throughout his diaries. If one unpacks and repacks the boxes of books in the Smithsonian's pristine Joseph Cornell Study Center, a shower of paper bits, broken off from these aging volumes, leaves a puddle of debris on the counter. Cornell probably liked these books partly because they were secondhand, had passed under others' eyes and carried with them some residue of the look of things from other times. Books are not pristine objects transcending life but things that have been out on the streets, deeply imprinted by the social world yet still bespeaking the interior life. Many of Cornell's boxes are tributes to the book as a form, or attempts to present visually the rich dimensions of the literary imagination.

Not surprisingly, writers, especially poets, have returned this devotion. When Marianne Moore saw Cornell's *Crystal Cage: Portrait of Berenice* in *View* for 1943, she initiated a correspondence that produced enchanting collage responses from the artist. John Ashbery was

an early reviewer, and with Frank O'Hara he visited Cornell several times in Queens. I have already mentioned the admiration of Octavio Paz, seconded by Elizabeth Bishop in her translation of Paz's poem. Bishop drew sketches of Cornell-like "dream machines" and made her own box collages. Many contemporary poets also saw how their "words became visible" in Cornell's boxes (Bishop 1983, 275). Charles Simic's *Dime-Store Alchemy* (1992) reveals a sense of kinship, the émigré semi-surrealist poet finding in Cornell's work and in the sensibility recorded in the artist's diaries an expression of his own personal and metaphysical journey in things, and his own feeling of displacement and location in poetry. Simic has understood both the artist's metaphysical reach and his engagement in the realities of wartime New York. More recently there has been an explosion of interest in Cornell's work, including many art-historical studies, a biography, and a major exhibition connecting Cornell's work to its source materials. Jonathan Safran Foer, while still unpublished as a novelist, brazenly wrote to all his favorite writers and elicited a collection of literary responses to Cornell's aviary, which he collected and published as *Convergence of Birds: Original Fiction and Poetry Inspired by the Work of Joseph Cornell*. The outsider artist who invested scraps and trinkets with aesthetic and spiritual value has become a commodity. (In fact, the company Blick Art sells Joseph Cornell kits, so anyone can make a dream box.) For this least bureaucratic of artists the Smithsonian has set up an official "study center," where his storage boxes—the battered cardboard containers marked "feathers," "balls," "pipes," and so on—are stored inside other, uniform, government-issue boxes on shelves along the walls. But no one can really box in this poet of "eterniday." Like poems, Cornell's still life constructions are the residue of thought and imagination drawing on these source materials; his works are not things in themselves so much as records of a sensitive mind finding a durable path through ephemera, bringing aesthetic necessity to accidents of association and experience, and locating the various vibrations of the world within the intimate dwelling of the individual life.

My purpose here is not to trace Cornell's links to individual poets, or even to the genre of poetry, though these are worthy undertakings. In fact, I want to resist somewhat the main logic that has emerged from the characterization of Cornell's work as "poetic." His love of poetry and affinities with the genre should not be mistaken for a

vaporous dream life or a withdrawal into the self. Like the poets discussed in this book, Cornell kept up a lively dialectic of imagination and reality, and his boxes show involvement in the documentation of history as well as its transfiguration. Collage technique, supremely impure, indeterminate, and dialectical, is essential to his art. Cornell's poetic "alchemy" has been understood as a form of fantasy, or a private solace. But his "pharmacies" can also be seen as offering a cure for the world in asserting that the possible belongs in reality along with the actual.

Welcome to the Future

Cornell often testified that his work was rooted in the experience of New York. We can begin to see Cornell's engagement with the world by analyzing the way public spaces of the city enter into his private art. Such an analysis reveals these collages as meditations on, more than alternatives to, the scenes around him. And while his boxes shore up fragments from the past, nostalgia is not their only currency.

In 1939 in Flushing, in the New York City borough of Queens, America hosted the biggest exhibition the world had ever known. The New York World's Fair, covering 1,216 acres, was less than a mile from 37–08 Utopia Parkway, the modest home where Joseph Cornell lived with his mother and brother. He had watched it rise up from the old dumping ground. The scale of the fair is what most impressed people. The Underwood Company, for instance, built special tracks to bring in a fourteen-ton typewriter. A postwar generation, including figures like Claes Oldenburg, with his blown-up, anthropomorphic typewriter, would expose the inflation in such shrines to commodity. But in 1939 it represented substantial industrial hope rising from the ruins of the depression, still visible after the crash a decade before. The whole affair headlined "Building the World of Tomorrow." There was a block-wide "diorama" displaying the wonders of modern electricity, a utopian "city of light." Distance was conquered as well by the introduction of a new technology, television, which would, a decade later, become the world's favorite box (a fact not lost, surely, on the art world's favorite box maker). Cornell is often associated with nostalgia, but his work regularly draws from contemporary materials, such as the watch coils, glass cubes, chemists' flasks, and other elements of

industrial design he viewed at the 1934 Machine Art show at the Museum of Modern Art, and later at the 1939 World's Fair. The fair's major symbols were a seven hundred–foot "Trylon" tower and two hundred–foot "Perisphere" globe. Perhaps Cornell, always alert to "connections," saw their resonance with di Chirico's still life objects enlarged to the size of towers, or with his own *Soap Bubble Set* of 1936, with its truncated pillar and celestial globe (fig. 6).[1] Spheres and towers would remain central elements in Cornell's iconography.

If the fair was a phantasmagoria of looming, oversized objects, it was also a marketplace allowing the visitor to retrieve trinkets and souvenirs from around the world. Cornell was no conventional souvenir collector, of course. By appropriating objects into his unique collages, he converted absences to productive presences. The Dutch Pavilion proved an excellent source for the clay pipes that would appear in variant soap bubble sets throughout the next decade. And in the Italian Pavilion, Cornell was introduced to Leonardo da Vinci, Caravaggio, and other Renaissance artists, whose portraits would occupy his attention in the early forties. What was it like to view these masterworks, even as copies, within the gates of the fair, monument to technological progress? The Medici portrait boxes Cornell began making just two years later seem expressions of the machine age setting in which he saw the paintings; they present the grandeur of the Renaissance cropped in the grid of commercial exchange and mechanical reproduction.

These early works also owe something to the "Dream of Venus" Pavilion, Salvador Dalí's surrealist installation at the fair. Cornell was likely fascinated by the façade of this erotic grotto, which included an enshrined reproduction of Botticelli's Venus and a window with Leonardo's Saint John the Baptist leaning out, converted in this context from an apostle to a panderer, his hand pointing toward the topless beauties waiting inside. By incorporating Renaissance portraits of children into table-sized glass portals, Cornell was perhaps repudiating Dalí's vulgar vision with an assertion of innocence, and of the imaginary over the literal. By contrast, Cornell seems to have paid little attention to the fair's "American Art Today" exhibition, a large hall of mostly realist works within the "American Scene" tradition of Thomas Hart Benton and Ben Shahn—paintings and murals of regional landscape and common folk struggling and working, many of these works financed by the WPA.

If Cornell viewed John Crowley's promotional film *The World of To-morrow* at the entry gate, as most of the crowd did, he would likely have appreciated the peculiar timespace Crowley associated with the fair: "I think that there are moments where you can see the world turning from what it is into what it will be. For me, the New York World's Fair is such a moment. It is a compass rose pointing in all directions, toward imaginary future and real past, false future and immutable present, a world of tomorrow contained in the lost America of yesterday."[2] This compass rose would shortly appear in several of Cornell's works, but with less of a magnetic pull toward the future, at least as the fair described that future: an industrial utopia in which "the Lagoon of Nations" formed a perfect unity of international cooperation. (The real lagoon of nations would soon become a quagmire.) The superhuman scale of the fair, and its drive to bring all human affairs into one impersonal form, had a tinge of fascism about it, as its later critics observed. And of course official fascism had arisen in Europe as a grotesque inversion of "international cooperation," the fair's espoused theme. Before the 1939 fair closed for the season, Germany had taken Czechoslovakia and Poland, and Britain had declared war on Germany. As Walter Susman writes in *Culture as History*: "The four thousand tons of steel that went into the making of the Trylon and Perisphere became scrap destined to make bombs and other instruments of war. Designed to teach lessons of mutual interdependence that would make all future wars impossible, in its own final function the symbol became an instrument of the war" (Susman 1973, 229). The fair was a theater that turned history to spectacle; it was undermined by the actual spectacle of history, which belied utopian fantasies. But Cornell, out of this contradiction between utopian fantasy and grim history, created imaginary worlds that expressed global and personal agonies and aspirations. His answer to "welcome to the future" was "welcome to the past and the present," to the ever unfinished image of the ideal, embedded in a suffering, beautiful, transitory reality.

A Symbolist at the Automat: Grids and Ephemera

If Cornell was drawn east in Queens as far as the fair, he continued his forays west into Manhattan, where old and new, high and low, American and European mixed in an undesigned flux. "My work was

the natural outcome of my love of the city," he wrote. What the city presented expansively, he put in a box (Cornell 1993, 46). New York in the late thirties and forties was itself a giant collage. The city was changing, in unpredictable and uncontrollable ways, as Lewis Mumford, the great spokesman of cities (and fellow denizen of Flushing) had documented in *The Culture of Cities*, just the year before the World's Fair. New York was itself a microcosm of the world, a major port with refugees flooding in and goods arriving from everywhere. In this dynamic city Cornell would find endless source material, and would experience the epiphanies he so often memorialized in his art. Having discovered, after seeing a work by Max Ernst in 1931, that his own dossiers and souvenir assemblages might make him an "artist" and not just a collector, Cornell had begun to frequent the new art establishments springing up in midtown. His strongest and most enduring association was with the Julien Levy Gallery, a haven for émigrés later in the decade. They would bring with them a very different, and far less optimistic, story of the world than the one heralded at the fair in Flushing Meadows. Meyer Schapiro, writing of Arshile Gorky, observed, "In the advanced American art of the 1940's, one cannot stress too much the importance of the influx of European artists in New York during the war, and most of all the surrealists, in spite of the barrier of language" (Schapiro 1978, 181). The surrealists brought in a different aesthetic from the one promoted by the Federal Arts Project, which supported murals and other forms of public art (and whose products were represented in the American Pavilion at the fair). Levy may also have introduced Cornell to the work of the French photographer Eugène Atget, whose views of turn-of-the-century Paris shop windows, with camera angled to open the space, declared a love for "the visibly time worn, the naïve, and the popular" Evans 2000, 20).

But Manhattan itself and its distinctive spaces were the major stimulus to Cornell's imagination. His boxes and collages evoke an esoteric order forming in the mind of artist and beholder—but prompted by the particularity of the New York environment of his time. Cornell's films, made with Rudy Burckhardt and others, tapped the evocative power of the city's spaces, the elegance of the "El" (the elevated train tracks, destined to be dismantled), for instance, or the romance of the smaller parks and squares, where angel-ornamented stone and the ever present pigeons embodied the ethereal and eternal

within the everyday. The city represented a cache of "source materi-als" as well as imaginative stimulations, its five-and-ten detritus turn-ing to treasure in the artist's creative alchemy. His *Jewel Box* of 1940, in tribute to the dancer Marie Taglioni, captured the elegance of that world even while he acknowledged that "ice being loaded onto trains (seen through the grill gates of Grand Central Station), spilling from supply trucks about the city etc. evoked in the most graphic manner the 'feerie' of the ballet footlights" (quoted on wall label for exhibition "Joseph Cornell: Navigating the Imagination," Smithsonian Museum of American Art, 2007). These were not rival realities but one reality, including high and low, elegant and quotidian, small-scale and large-scale experiences. As Elizabeth Bishop revealed in "Varick Street," to dwell in New York was to be challenged continually in adjustments of scale, to embrace the vast and outsized while establishing a local ori-entation, to shuttle between darkness and light.

The New York Horn and Hardart Automat chain was the spatial triumph of art deco and a central image as we consider the way that public spaces enter Cornell's private world.[3] The Automat was labora-tory and nutrient for his art. Cornell's diaries sometimes sound like Frank O'Hara's poems, jouncing from lists to invocations, with notes on Verlaine and Valéry followed by a gallery visit or a quick stop for a malt and hamburger. We probably know more about Cornell's eating habits than about those of any other modern artist; his diary is full of accounts of food purchased or consumed—not memorable meals in special places but cafeteria fare. Cornell has his epiphanies while eat-ing liverwurst sandwiches: "December 21, 1942 (entered 2/17/47) Uptown—lunch in Automat 58 & 8 Ave.—found Malibran Bajelito Waltz continuing the thread of the large litho portrait" (Cornell 1993, 98); "Feb. 7, 1946: Automat 2 choc. drinks & layer cake—(thought while eating of making 'scrapbooks' of personal reactions to various people & things . . . this feeling so strong in city and evaporates at home)" (Cornell 1993, 128); "April 16, 1946 (Tuesday) . . . To Matta Exhibition—'argumouth' etc, etc. Stimulus at energy sweep and modernity of paintings but disappointed after last year. Bought some prune twist buns (6) and 2 honey caramel buns at Automat (day-old) shop at 11th Avenue and 50" (Cornell 1993, 129). The impact of these cafeteria spaces—their architecture, their social dynamic, their struc-ture of display and exchange, their role in popular culture—may be more than incidental in the formal expression of these epiphanies in

his art. " 'The medium is the message' . . . that is this activity of pen-ning here on out in the open 'Cafeteria joint' etc. etc." (Cornell 1993, 236). This entry suggests a particular creative dynamic.

Cornell liked to think in public spaces; at home he was more in-clined to productive activity. But the Automat in particular, a space in which he could be present in his body through the act of consum-ing food and at the same time feel the expansiveness of high ceilings and the flux of people passing, himself invisible yet part of the whole, offers a message pertinent to the near distances of Cornell's work. Certain features recur in Cornell's notations: not only what he has to eat (donut, Danish, liverwurst sandwich) and what he is reading (Rilke, Valéry, Nerval, Mallarmé), but also how the dynamic of space and crowd affects him. From the published diaries alone (only a frac-tion of the records he kept) I note more than thirty recordings, within a fifteen-year period, of stops at such eateries, and these al-most always contain references to food—usually Cornell's favorite comfort foods—and literature or art consumed with it. The two modes of consumption seem to be in a dialectical relation to each other, and to the cafeteria space he inhabits. That is, the reading and thinking tend to draw Cornell into an abstracted, buoyant, but also disembodied consciousness. The notations about food pull him back into his physical presence, offsetting the "nervousness" that arises from his abstraction.

While Cornell occasionally socialized with dadaists and surrealists, he preferred to lunch alone with the symbolists, and his work belongs more centrally to a symbolist aesthetic. Believers in ideal beauty, the symbolists lent an aura to ordinary life and a visionary unity to motley humanity: "Nothing to do but wait but the assurance came as a relief and so after another call to home (speaking to Mother and Robert) went into the Automat with the book [Rilke's letters] under my arm in a kind of 'glow' about the hot, busy city, thoughts of home, the past of New York and a state of mind that formerly bordered on the over-emotional, hysterical even in a sense of 'alleviation' in seeing phases in a perspective that becomes significant and stimulating on such occa-sions" (Cornell 1993, 157–158). Cornell positioned himself as a contem-porary *flâneur*, for whom it is "an immense joy to set up house in the heart of the multitude, amid the ebb and flow of movement, in the midst of the fugitive and the infinite" (Baudelaire 1965, 7). Cornell writes in his diary: "Glass of weak iced tea and liverwurst sandwich on

the balcony about 4 o'clock overlooking 42 and 3rd Ave. with its typical stream of motley N.Y. humanity this sunny afternoon—right against the window with a ledge where I could open the RILKE in unhurried leisure and enjoy it along with all the minutiae of commonplace spectacle that at times like this take on so much 'festivity' . . . a real glow in the lines of 'the Paris of Gérard de Nerval' " (Cornell 1993, 158). Several sentences later he writes: "—the preoccupation with the crowds below formerly a morbid obsession in the infinity of faces and heterogeneity— . . . thoughts lifted about things in general although not completely (pressure) as usual a significant kind of happiness is difficult to get into this 'cataloging' but there it was none the less—this 'on-the-edgeness' of something apocalyptic, something really satisfying" (Cornell 1993, 158).

Cornell expresses a symbolist desire to loosen time and space constraints, and he enjoys the indefinite associations arising in the blend of sensations. But he adds the modernist insistence as well on concrete particulars and on the intuition of "new wholes" out of the fragments of dissociated thought and feeling. Eliot's understanding of the metaphysical poet applies as well to Cornell: "When a poet's mind is perfectly equipped for its work, it is constantly amalgamating disparate experience; the ordinary man's experience is chaotic, irregular, fragmentary. The latter falls in love, or reads Spinoza [or eats a liverwurst sandwich and reads Rilke], and these two experiences have nothing to do with each other, or with the noise of the typewriter or the smell of cooking; in the mind of the poet these experiences are always forming new wholes" (Eliot [1921] 1975, 64). Is Eliot, another poet featured in Cornell's diaries, one of the figures behind the artist's *Pantry Ballet (for Jacques Offenbach)* of 1942, with its coffee spoons hanging from the kitchen-proscenium lined with shells and ragged lobster claws taking the stage? It seems likely, but in addition we should observe that the Rockettes were performing their cancan around the corner from the cafeteria; he has comically metamorphosed and domesticated these sirens. The amalgamating mind of Cornell brings all these elements together to make a "new whole." Any highbrow allusions to Prufrock must be reconciled with Cornell's pleasure in elements of popular culture. To read Nerval and Baudelaire, or to think of Offenbach in a New York Automat, was not just to escape to Paris circa 1850 (although the Automat's interior design clearly alludes to the large café-restaurants of Montparnasse), but to transpose that world into the

context of postwar America, where it becomes something different. These cafeterias, elegant and populist at once, were themselves nodes of the great collage of New York, places of eclecticism, transition, and diversity. But at the same time they were popular because they offered an element of simplicity, predictability, and order against the crazy quilt of the city.

While a few Cornell scholars have mentioned the cafeteria as a site of his "connections," they have not seen the Automat as a "connection" in itself. The Automat layout provided a direct link to Cornell's art of compartmentalization and repetition. In the quintessential style of art deco, display is essential; the Automat took the idea of the grid to an aesthetic height. Did these simple nickel slot machines dispensing sandwiches and pies recall the penny arcades of his childhood? Cornell's Medici "slot machine" series and Lauren Bacall penny arcade are contemporary with these sojourns to Horn and Hardart's and mark the beginning of his obsession with the grid. Cornell's art notably anticipates the grid art and display art of a later generation (Sol Lewitt and Wayne Thiebaud, for instance), and certainly the Automat's interior would have satisfied his eye for grids, especially interactive grids. Berenice Abbott, as part of the Federal Arts Project, had photographed the Automat, already an icon in American urban culture, and her images of its elegant wall-to-wall grids were widely disseminated. Her photographs, put next to the work Cornell would produce in the forties and fifties, suggest an affinity.

Like William Carlos Williams and Hart Crane, Cornell fused art and industry. The machine aesthetic of the Automat may seem hard to reconcile with Cornell's love of symbolist poetry. But the prominent grid of the slot machines, along with the cafeteria's many windows and mirrors, actually form a symbolist trope. As Rosalind Krauss has pointed out in discussing the emergence of the grid in art, the structure is central to the symbolist quest for the absolute; the central grid is the window, which in Cornell's work is also a mirror. "For Mallarmé particularly the window functioned as this complex, polysemic sign by which he would also project the 'crystallization of reality into art.' The window, as an element of a grid, is anti developmental—it asks us to think etiologically rather than narratively" (Krauss 1979, 58). Could the Automat have nudged Cornell's imagination from the proscenium and exhibition space into the grid aesthetic? Krauss's discussion of the grid as a paradox of science and spirituality fits Cornell

especially well. She notes that the window grid has a profound doubleness in symbolist poetry, and it is the poet Mallarmé, to whom Cornell would turn frequently, who most embodies this principle: "As a transparent vehicle, the window is that which admits light—or spirit—into the initial darkness of the room. But if glass transmits, it also reflects. And so the window is experienced by the symbolist as a mirror as well—something that freezes and locks the self into the space of its own reduplicated being. Following and freezing: *glace* in French [as the Francophile Cornell would know] means glass, mirror, and ice; transparency, opacity, and water" (Krauss 1979, 58–59). The grid of Renaissance perspective anticipates (and in Cornell intersects with) the grid of modernist abstraction. Most of Krauss's argument about the window suggests a looking out, but of course we are also looking into this alcove/room of another time and place.

As grids Cornell's works "box in," but they are also infinitely expandable. The grid, without the vanishing point of Renaissance perspective, sees reality as grist for its paradigm. We fasten on a particular thing, a node or convergence of ideas, but the grid offers an infinity of such intersections. For Cornell, collage and grid work in a tense dynamic, the one evoking idiosyncrasy, materiality, and irrational assemblage, the other rationality, abstraction, and classification. By giving the grid a sense of the infinite, Cornell evokes a transcendental order of the world for which his box is an idiosyncratic section, a fragment, and a microcosm.

But Cornell's obsession with the grid must be reconciled with his technique of collage and its principle of randomness, metonymy and fragmentation. The ideality of the grid must engage the materiality of collage. The street plans of Rome that line Cornell's Medici boxes may resemble Piet Mondrian's *Broadway Boogie Woogie*, but more often Cornell moves into the localized helter-skelter grids of magazine layout, store window design, and hotel façades (Perl 2005, 283). What makes Cornell's work so formally compelling is this mix of collage and grid, of fragmented narrative and etiology. Cornell's art frames the city's high/low mix, which was nowhere more visible than at the Automat, proffering elegance for the masses. Edward Hopper may have associated it with loneliness and poverty, but for five cents you could drink a cup of coffee with real cream in a cup with a gold rim, or read Mallarmé for hours while sipping a chocolate malt. The Automat had entered the lyrics of popular songs by Jule Styne and Irving Berlin and

had become a place where high society wanted to see and be seen by the public. It was frequently a setting for the movies, as the stargazer Cornell would certainly have noted. It was a place to dress up when there was no place to go, as Diane Arbus's *Two Ladies at the Automat* testifies. High-low, glamorous and humble, old-new, solitary-social, homey-mechanical, grid and collage—it contained all the paradoxes closest to Cornell's heart. So as we consider modernism in relation to public spaces, we should remember Cornell's diary citation of Marshall McLuhan: "the medium is the message." Cornell's intimate boxes are not descriptions of urban space, but they certainly reflect it.

Soap Bubbles and Shooting Galleries

If Cornell's work embodies New York spaces, it shows considerable sensitivity as well to more distant realities. Worlds and bubbles have a long history of association, especially in art and poetry, where the dreams of childhood meet the vanity of human wishes. Jean-Baptiste-Siméon Chardin's young boy, leaning godlike out a high window, pipe to mouth, ready to send an enormous soap bubble down into the atmosphere below, is a prototype of the artist. "And now a bubble burst, and now a world," wrote Alexander Pope. The idea would certainly have resonated with New Yorkers in the mid-thirties, still suffering the consequences of the stock market crash. But dreams are resilient, and the artist's dreams lie outside the economic sphere. Cornell catches that bubble and that dreamy boy and places them in his *Soap Bubble Set*, his first box construction, in 1936 (fig. 6). The construction evokes a natural history display, and it was thus that the work was exhibited in the Museum of Modern Art's 1938 show "Fantastic Art, Dada, Surrealism," alongside Miró's parrot-object. (Cornell, more magpie than parrot in relation to other artists, would borrow Miró's bird and place him in a box a few years later.) But as we gaze into this box, we could easily be looking out a window rather than into one. We could be blowing a bubble from a pipe like Chardin's boy, only this time his soap bubble has lifted itself to the sky and we are gazing at the moon. So if the soap bubble is a figure of solipsism, it is complicated here by the invitation to voyage.

Perhaps Wallace Stevens saw *Soap Bubble Set* this way when it was acquired later that year by the Hartford Atheneum, a museum

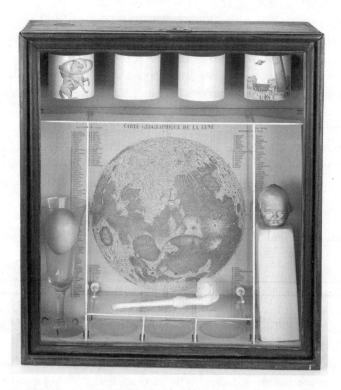

Figure 6. Joseph Cornell, *Soap Bubble Set*, 1936. Wadsworth Atheneum Museum of Art, Hartford, Conn. Purchased through the gift of Henry and Walter Keney. Copyright The Joseph and Robert Cornell Memorial Foundation/Licensed by VAGA, New York, N.Y.

Stevens often visited on his lunch hour. While Cornell's box was not included in the Atheneum's 1938 show "The Painters of Still Life," Stevens might nevertheless have noted the link with a painting by Pierre Roy that was in that show, *The Electrification of the Country*, done around 1930. In this painting, which had also been in the Museum of Modern Art show and was later acquired by the Atheneum, Roy hangs an egg between two cordial glasses, merging the imagery of table still life (glass, plate, egg, knife, and fork) with the imagery of a chemistry demonstration. In his own work Cornell puts the egg inside the cordial glass. Cornell also pays quiet homage to di Chirico here, flanking the moon with a pedestal and sightless bust, and setting on the upper shelf the image of a Renaissance plaza. Conventional scale is baffled: the soap bubble moon looms large, the container (like a cordial glass, an egg, a mind, a bubble) has become the contained

(an egg inside a glass, a moon inside a box), a transient breath become a celestial body. Cornell would go on blowing soap bubbles, in variants of this construction, for many years.

Since the work presents itself as an assemblage for display rather than as a representational space, the disjunctions of scale and category do not have the shock effect of surrealism. This is not an illusionary scene but an exhibition. Yet we begin to notice the internal laws, both formal and associative, governing the arrangement. This is a "set" in *Webster's Dictionary*'s several senses: "a group or combination of things of similar nature, design or function," but also a "construction representing a place or scene in which an action takes place" and "a collection of articles designed for use together." The formal structure heightens the first sense. The symmetry of the grid is reinforced by the central globe flanked by two smaller, sky-blue ovals (doll's head and egg). The ringed Saturn appears in each upper corner. More subtly, on the vertical plane, the truncated Renaissance tower in the upper-right corner is probably the leaning tower in Bologna, di Chirico country, and also a reference to Galileo's experiments with gravity. Cornell offers its missing top as the pillar with doll's head, the disembodied Kewpie looking more like an archaeological fragment recovered and archived.

Contrasts work with parallels (the transparent cordial glass is opposed to the opaque pillar, the smooth egg to the featured face, blank forms against imaged forms, linear and curved forms, two dimensions and three dimensions) and conceptually (levity against weight, liquid against solid and gas, shadowless things against those that cast shadows). But this set is also for performance—a scene of action in which we might be the players as well as the audience. Cornell gives us a map in order that we might explore. In *Soap Bubble Set* the pipe, resting just so that it appears to have produced the moon, invites more interactions. The horse and rider could be a bit of heroic statuary, lifted from the town plaza and now entering the orbit of Saturn: the population of the town has hurried out to see. (The Renaissance scene is also a nod to that era's great enthusiasm for astronomy.) The four cylinder blocks, not resting on the top shelf but hovering over it, might be more bubbles (despite their flat base); two are left for you to paint. The three glass disks at the bottom—perhaps microscope plates—are bubbles too, waiting to be lifted by our breath. (They appear, lifted, in later soap bubble sets.)

The whole thing has the effect of weightlessness: the cordial glass, an inverted bell jar, proffers rather than contains. Of course the display is uncannily still as well, gathering dust as it would in a natural history museum. The doll is asleep, blind and mute; the egg will never hatch. Yet the map, in black and yellowed white, more propped than pinned to its wall, is bursting with activity, its little explosions like faraway fireworks, or like the kinetic swirls on a soap bubble, like an egg that is hatching, a mind that is alert. Here there is life, it seems to say, in dreams and bubbles, on the moon. Yet the "geography" of the moon seems oddly similar to that of earth. We are more familiar with maps of our own world. Indeed, this map was a famously inaccurate design by a nineteenth-century scientist who projected earthly form onto the moon. It appears to have continents and oceans, for instance. Perhaps it is our own world after all that emerges from this clay pipe, rediscovered in imagination, in dreams.

The cultural climate of the thirties in which Cornell made his entry into the art world is dominated by "the real," understood in public and social terms. The imagination, if it was to justify itself, must have something to say about the public world; must not be merely a romantic indulgence, whether agonist or hedonistic. In an ambivalent review of the "Fantastic Art, Dada, Surrealism" show in the January 1937 issue of *Art Front*, Charom Von Wiegard writes that the surrealists were "not all corrupt with the festering sores of dying individualism. . . . [Surrealism] contributes new discoveries of the inner life of fantasy by pictorializing the destructive process of the subconscious mind" (quoted in Sawin 2005, 93). The work coming out of Europe saw the private psyche as a place of disturbing energies. Objects absorbed the brunt of this disturbance. Dalí, Miró, Duchamp, who had come to America much earlier, were able to combine this trauma with a sense of elegance and a sense of play, as if to defuse the violence or convert it to creative energy; Cornell clearly drew from their example, especially in the work he produced later in the decade.

If man is prolific of dreams, of bubbles and worlds, he is also their devourer, as we see in *Black Hunter* of 1939 (fig. 7). The world is a darker place now, despite the willed optimism of the World's Fair. Cornell paints this box black, and it is mostly closed, opaque, not lit from within by the white and sky-blue imagery of *Soap Bubble Set*. Yet there is a formal elegance to its high contrasts. The primary contrasting color is red, and it makes a swirling frame like a river of blood, if also like a

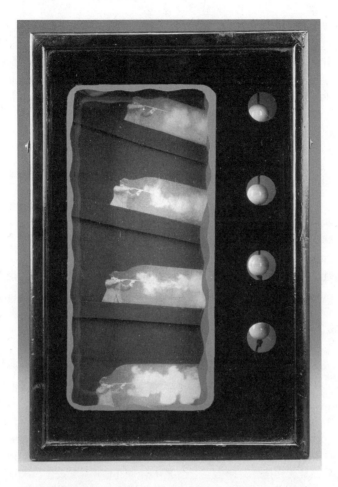

Figure 7. Joseph Cornell, *Untitled (Black Hunter)*, ca. 1939. Painted wood box with painted glass front, metal hook clasps, colored paper, wood slats, photostated images, glass disks, string, and wood balls, 30.5×20.3×7 cm, Lindy and Edwin Bergman Joseph Cornell Collection, 1982.1844, The Art Institute of Chicago. Photography copyright The Art Institute of Chicago. Copyright The Joseph and Robert Cornell Memorial Foundation/Licensed by VAGA, New York, N.Y.

proscenium curtain. In place of the solitary doll's head of the *Soap Bubble Set* we have four men, and in place of a pipe, transmitter of human breath, Cornell includes four rifles—a military phalanx, an execu-tioner's squad. Yet the handsome style and the visual allusions of this box disarm the threatening figures. They are aimed (without accuracy)

at a vertical string of white spheres—like moons or planets or bubbles in a night sky. Smoke clouds billow from the rifles; they have been fired, but have not yet reached their targets, perhaps cannot. Of course it is a game, like other toys for adults Cornell would make from then on. The elegant black and red design suggests a vertical pool table. The rifles are sticks, the white spheres are cue balls, each fallen into a little recess as in a billiard table. (And the "shots" are also like those of *Monsieur Phot* in Cornell's collage homage to photography and to his friend—not foe—Marcel Duchamp, lover of puns and master of all that is "faux.") Cornell was fond of revising his work, and there is a curious variant in one photographic reproduction of *Black Hunter*. It is clearly the same box, but over the body of the bottom marksman Cornell has placed a print of a shell, covered by a round glass disk—an image that seems to have migrated from one of his *Soap Bubble* variants. With the gun protruding from this bubble shell, the hunter suddenly becomes a comical snail, blindly feeling his way through the world, pulling back into his house when danger approaches.

Black Hunter gives us a profile of this drama. In later "shooting galleries" as he called them Cornell turns the box frontally open to us. We become the players. In *Swiss Shoot the Chute* of 1941 (fig. 8), we are invited to fling the ball into one of the many holes (as at a country fair booth); if we are successful, the ball will travel down a "chute" behind the board and ring a series of cowbells. (Cornell loved the auditory dimension of his art, and later constructions would include music boxes.) This is one of Cornell's first boxes to use a regional map—here a topographical map of the Alps. He must have enjoyed the paradox of a flat map of a mountainous region, which he then filled with holes. Some of the openings contain images, like detail enlargements in a lunette or binoculars. We see a skier shooting down a slope (like a ball down a chute), a milkmaid, a cluster of edelweiss, lots of cows, some grazing, some in close-up profile—all the things one would expect in a travel brochure about Switzerland. In this gathering of clichés about Switzerland we might add the holes themselves, which make the map into Swiss cheese.

It is all perfectly enchanting; we can stay in the *Hotel de l'Ange* (the hotel of the angel, with perhaps a pun on an Angus cow, profiled in one lunette). But what is Little Red Riding Hood doing here? The story has Alpine origins, but the narrative itself has relevance as well. The wolf looms large here, and unlike the other featured images, this

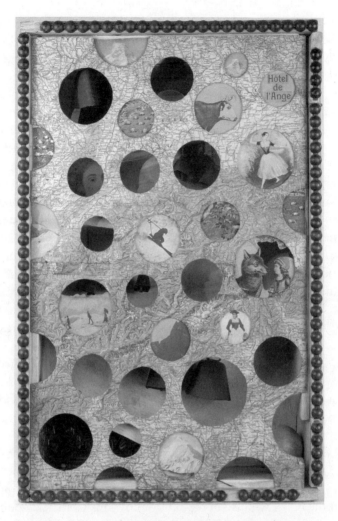

Figure 8. Joseph Cornell, *Swiss Shoot the Chute*, 1941. Box Construction 21
1/16×13 13/16×4⅛ inches; The Solomon R. Guggenheim Foundation, New
York. Peggy Guggenheim Collection, Venice, 1976.76.2553.127. Photograph by
David Heald, copyright The Solomon R. Guggenheim Foundation, New York.
Copyright The Joseph and Robert Cornell Memorial Foundation/Licensed by
VAGA, New York, N.Y.

one only partially covers the hole. The landscape has been cut out so
that the darkness inside the box brings a deeper dimension to the dark
woods. Where is the hunter who can save Red Riding Hood once the
wolf has swallowed her? (He is off shooting at soap bubble planets.)
Whether or not Cornell meditated on the precarious innocence of

Swiss "neutrality" while Hitler advanced on Europe, he certainly understood that fairy tales convey the terrors of a world made by adults. (His *Nouveaux Contes de Fées*—little boxes on a grid shelf uniformly wrapped in text—was subtitled *Poison Box*.) But he approached this terror with the charm of fairy tales, a charm in keeping with the spirit of Duchamp, who perhaps knew Cornell's *Swiss Shoot the Chute* when a year later he made his covers for *First Papers of Surrealism* (October 1942). The front showed a wall penetrated by bullets. The back presented a close-up of Swiss cheese.

One of the results of the war news dominating the headlines in New York was that those at home were intensely aware of countries they might otherwise know only in fairy tales. Cornell's interest in the international nature of World War II can be seen in an untitled collage constructed between 1940 and 1942 in which news clippings are prominent. The news becomes material for his fairy tale art. The 1940 installment is a news clip fragment about a military leader in Sydney, Australia, that reads "Rabbit Joins Battalion." (The collage has been thus titled by curators.) Cornell associated his brother Robert, who suffered from cerebral palsy, with the rabbit image (Robert's rabbit drawing appears iconographically in Cornell's work), so in effect his disabled brother is now joined with the war cause, and Robert/Rabbit begins a military adventure. When America entered the war, Cornell returned to this collage, adding another image—or perhaps the collage was begun in 1942, when a later news clipping linked in his mind to "Rabbit Joins Battalion." In the later newsprint image, which dominates the collage, a child is feeding what the article describes as a "(not ugly) duckling" in the park. Cornell would certainly have appreciated the bit of whimsy in the allusion to Hans Christian Andersen. But having worked briefly as a layout artist himself, he also had an eye for the way newspaper layout is its own collage, juxtaposing items that have little real connection but much potential for imaginative association. In small print under the park scene with girl and duckling is a headline in capital letters—"WAR GIVES A BREAK"—announcing a practice blackout to be performed in Brooklyn: "45 square miles of Brooklyn to be darkened for 20 minutes tonight in Blackout." Cornell included a similar clipping in his Duchamp dossier, suggesting that he had a special interest in this local simulation of what was a constant occurrence in Europe. In "Rabbit Joins Battalion," children, invalids, and fairy tale creatures are recruited to the Allied cause.

Cornell's work has mostly been treated as "the opposite of history," without much regard for the idea that opposites imply each other. Ingrid Schaffner's study *The Essential Joseph Cornell* is typical. "His art does not appear to be influenced by world events," she writes "except perhaps for a box called *Habitat Group for a Shooting Gallery*" (Schaffner 2003, 88). But we might take the reverse approach and wonder if the fairly explicit evocation of world events in this box doesn't offer a key to reading other work. The violence in *Habitat Group for a Shooting Gallery* (fig. 9) is inescapable, and it is one of the few of Cornell's boxes for which critics have been compelled to acknowledge a "historical dimension." The title itself creates a dissonance that the images reinforce; the bullet goes right through the center of the glass and seems to enter the skull of the cockatoo, though it has bowed its head as if to avoid being killed. Red paint oozes, as if from a wound. One critic has identified the birds with world powers, and perhaps the strong red, white, and blue coloring of this construction, in contrast to Cornell's usual preference for muted or diachromatic schemes, suggests a certain patriotism. Unlike *Soap Bubble Set* with its timeless sleep, this work of 1942 seems to have the immediacy of abstract expressionism; indeed, the splattered paint anticipates Jackson Pollock. The lovely oversized birds—symbols of spirit and imagination, colorful as poetry, figures of the artist's freedom to fly off—are indeed at risk in this violent, destructive world.

Yet this *Habitat Group for a Shooting Gallery* does not seem entirely agonistic; indeed it is less terrifying than *Black Hunter*. Cornell's birds would survive to inhabit other box constructions, so many that in 1949 the artist presented a show at the Egan Gallery titled "Aviary." They may enter our pigeonholes or dovecotes, but in another sense they are immortal birds, embodiments of the poetic spirit, ready at any moment to mount, like Emily Dickinson, "toward the blue peninsula." In *Habitat*, the yellow and blue alongside the red remind us that this is paint, not blood, and that the birds themselves are painted. Indeed, one yellow paint splatter suggests the cockatoo's comb; a blue brushstroke suggests a tail feather. The tail feathers themselves, next to the scroll seal, look like Chinese calligraphic strokes. The violence of art hurls itself at the spirit, trying to capture it in form. Other drips, red, yellow, and blue around a black and white imperial seal, suggest wax. (Stamps—both imperial seals and postage stamps—were figures for Cornell of voyaging and migration.) The blue speckled above the

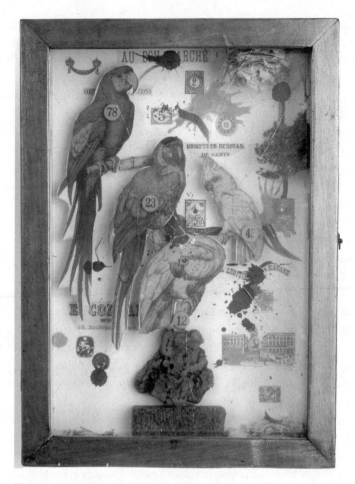

Figure 9. Joseph Cornell, *Habitat Group for a Shooting Gallery*, 1943. Mixed media; overall 15½×111/8×4¼ inches. Purchased with funds from the Coffin Fine Arts Trust; Nathan Emory Coffin Collection of the Des Moines Art Center, 1975.27. Copyright The Joseph and Robert Cornell Memorial Foundation/Licensed by VAGA, New York, N.Y.

tiny image of the Campidoglio could be rain. The birds are also transfigurers. They have converted the daily newspaper into a nest of shreds; it hovers at the top of the "habitat" in counterpoint to the wooden perch, a solid foundation resembling the Chinese philosopher's stone. (In some photographs of this box there is also a nest below; in others it has shifted around until all that is left is debris.) All the textual clippings point to economics—"au bon marché," "comptoir special," "cost" (the last hidden behind the parrot's back)—but

the economy inside the world of this box transmutes the material world into a spiritual economy where the numbers define less price than chance in touch with a mystical order. It is the economy of art, too, of course. The broken glass, signifying the shattering of illusionary space, would undoubtedly evoke Cornell's friend Marcel Duchamp, his *Bride Stripped Bare by Her Bachelors, Even*. So as we consider the "historical dimension" of Cornell's "shooting galleries," we might consider not just the pressure of reality but the pressure of the imagination pushing back, to help us live our lives.

Theaters of War

Cornell worked briefly on a war plant radio assembly line, and his notes and diaries in 1943 provide ample evidence of his interest in the theater of war (Smithsonian, roll 1067, .0571, .0573, .0589, 10612). But his sense of art's relationship to power can be seen in earlier works of the war period. His dossier on King Ludwig II (mad King Ludwig of Bavaria, patron of Wagner) begins as America is at war with Germany, trying to push back its domination of Europe. Cornell's Medici portraits shift focus from the powerful to their offspring, who seem trapped in rather than aggrandized by their status. This comes through most subtly in *Medici Slot Machine* of 1942 (fig. 10), one of Cornell's most moving works and the progenitor of another series. As we consider the "historical dimension" of Cornell's work, the *Medici Slot Machine* makes a good example. Cornell had seen some of these Renaissance portraits at the World's Fair. He also owned a book, *Masterpieces of Italian Art Lent by the Royal Government*, which had been produced in connection with a show at the Art Institute of Chicago in 1939–40, just before America went to war against Italy, then Germany's ally. Many critics have seen in the fawn-eyed gaze of the Medici boy Cornell's recovery of his own childhood. But this child seems trapped—the prepubescent boy squeezed into a role in Italian history, then squeezed again into the fragile ontology of art. Diane Waldman suggests that in Cornell's imaginary space the boy escapes the bloody history of Florence. The argument for Cornell's transcendentalism overlooks the dynastic framing of the image (male and female faces in strips). Sandra Starr has pursued an elaborate close reading of the construction, in which Cornell symbolically rescues the

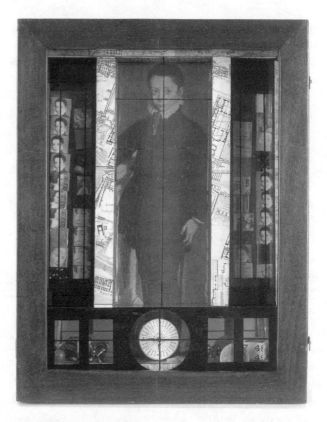

Figure 10. Joseph Cornell, *Medici Slot Machine*, 1942.
15½× 12¼× 43/8. Blue glass-paned, stained, and papered wood box
with photomechanical reproduction, bark, glitter, and electric
light. Private collection; courtesy The Menil Collection, Houston.
Copyright The Joseph and Robert Cornell Memorial
Foundation/Licensed by VAGA, New York, N.Y. Photograph by
Hickey-Robertson, Houston.

boy, Pietro Medici, from the wicked line of Cosimo and gives him instead to the Lorenzo Medicis, by an analogy to Michelangelo's tomb for the patron. One could equally claim that he evokes that tumultuous history, and by association the bloody history of contemporary Fascist Italy as well.

The *Medici Slot Machine* box construction suggests a threshold that requires our reciprocity to bring the boy out of confinement. Critics have observed the innovative approach to portraiture taken in this work. Does the image represent a figure in political and eco-

nomic history or in art history? Historical generation and mechanical (subway photo booth) reproduction overlap. Does all portraiture ultimately blend the former into the latter? We know these figures as often by the artist as by the subject. To judge by the quotation from Bernard Berenson which Cornell pasted to the back, he believed the image to be one of Cosimo Medici's children, Pietro. But the painting (by the female artist Sofonisba Anguissola, at the Baltimore Museum of Art) identifies the figure as Marchese Massimiliano Stampa. Perhaps the pun-loving Cornell did not know this, but we can enjoy the play on "stamp" and "press," since Cornell loved visual and verbal games, collected stamps, and made photocopies of all his images.

A comparison of the effects of Anguissola's portrait and Cornell's box is of more interest. On the one hand, Cornell's figure is less vivid—in black, white, and blue, and sepia tinted, with a barrier separating the figure from the viewer. But that same barrier also strangely makes the encounter more real, for it suggests a window and thus displaces the palace-insider painter. What was a court affair now becomes transhistorical. A window invites us to look inside; an alcove becomes a foyer, whereas the portrait in its original is obviously posed for an artist, not for us. (Cornell played with levels of reality and representation—mixing fragments of things with images of things, not just to signify artifice but to signify "levels" of reality itself; its material and its spiritual dimensions, its physical and symbolic qualities coincide.) The real toys at the base of the box—are they his toys at rest, or the trinket-rewards we might obtain by engaging with the slot machine?

Cornell's relationship to the boy's geographical place is both identified and loosened. The image is framed by a map. The map inside is of Rome, not of Florence—surely Cornell, with his intense sense of detail and precision, would have chosen it deliberately. The newsprint letters "ITALIE" appear beneath one image, again suggesting a generalizing location. Yet a compass at the bottom further insists on location, and the Baedeker maps invite us to explore.

The maps suggest what we might see if we were looking out the window as this boy does—what we might see if we gazed with him, for we are on both sides of the glass, and the window is a mirror (like all portraiture). Yet the space he looks out from is strikingly narrow and shallow, a kind of alcove (or crude foyer?), various proportions of

which are revealed in different images in the Medici series. Painted space and constructed space overlap so that the child appears at once inside the alcove and standing on the compass as if on a suspended ball, a world or a toy. The chances of history, the chances of play (jacks), and the chances of art converge here, not to escape location but to compound it.

Cornell, as we have seen, is entranced by the grid, but what is more striking is that within the construction of verticals and horizontals, the historical material—the boy's body, the streets and buildings, the photographs—is all in a tilt. (We know this tilt from the Bologna street scene in *Soap Bubble Set*; and Cornell was also obsessed with the Leaning Tower of Pisa.) The gaze is featured as a thematic focus by the compass below and the focusing cross intersecting the boy's eye. The cross may suggest the panels of a window. The boy looks out at us differently from the boy of the original portrait, who has no window and accepts the unmediated gaze of the painter. The window creates the sense of real space, not just represented space. One can almost imagine him as a zoomed-in figure behind a window-mirror in the later work *Pink Palace*. But the window grid also marks the line of sight in a photo shoot (*camera* is Italian for "room"; *un appareil à foyer fixe* is French for "fixed-lens camera"). Or is this another play on "shooting gallery"? The cross Cornell has made over this camera obscura space marks a more lethal shooting practice. Elizabeth Bishop treated a gambling slot machine as a sinister deity in her abandoned poem "The Soldier and the Slot Machine" (Bishop 2006, 57). Cornell's boy is not a soldier but a bystander, likely destroyed in crossfire, like so many of Italy's children in 1942. The Medici boy in the slot machine–foyer stands, in 1942, in the shadow of Il Duce; he is Joseph Cornell; he is the beholder. We are his intimates and his destroyers. Cornell's notebook of the next year reads: "Sept. 8, 1943—lunch along water bakery . . . Italy surrenders @5:30 . . . Lex Ave bus to 59th St" (Smithsonian, roll 1067. 0573).

In the same year as the first *Medici Slot Machine*, Cornell made another box, titled *Naples* (fig. 11). Like many of his works, it is an invitation to voyage, but it may also be a form of rescue for a loved place in distress. He lined the back of the box with a famous photograph of a Naples street scene. (The same photograph is reproduced in *A History of Private Life*.) It depicts a classically Neapolitan open-air stairway taking the eye up among tenements strung with laundry. People

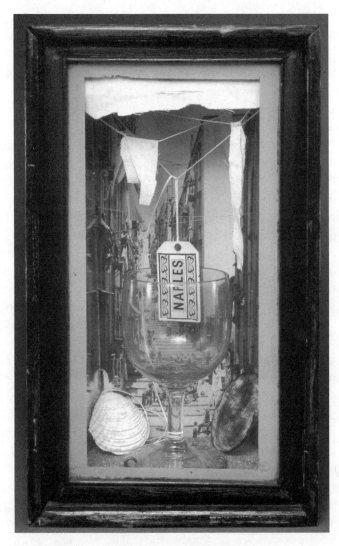

Figure 11. Joseph Cornell, *Naples*, 1942. 11¼ × 6¾ × 4¼ inches. Box Construction. The Robert Lehrman Art Trust, courtesy of Aimee and Robert Lehrman, Washington, D.C. Copyright The Joseph and Robert Cornell Memorial Foundation/Licensed by VAGA, New York, N.Y.

are ascending and descending the steps. In front of the box he placed a cordial glass, into which dangles a baggage ticket, marked "Naples," literally hanging by a thread. The glass is lashed to a bit of string as well so that the eye forms a continuum between the laundry lines in the photograph and the real string, like bits of fishnet, roping

together the objects of the foreground. A woman in the photograph, who is leaning out a window to hang her laundry, seems to have cast her net over both dimensions. The association of Naples with the sea is further made by the placement of a scallop shell and a bit of torn canvas, like the fragment of a sail.

Critics have connected this box to Cornell's fascination with the figure of the water sprite Ondine, and the ballet performed by a Neapolitan artist. But Sandra Starr is correct, I think, to associate this construction with contemporary history as well. Indeed, in December 1942 the Americans were conducting bombing raids over Naples (as the British had before). The cordial glass is a symbol in Cornell for the invisible element that holds the world in an order; the eggshell a symbol for origin and perfection. "Airplanes drop eggs," writes Apollinaire (quoted in Starr 1982, 62); "shells" may have a sinister connotation. But this is also an invitation to travel: the cordial glass marks hospitality; a baggage ticket dangles from fishnet against a background street scene. If Cornell's art is marked by the tragedies of history, it invites us to imagine peace. We are in a restaurant or hotel, and the glass set on the sill or table stands before our view of Naples. We look across to other windows; we are linked by the rope to the native woman who is hanging her wash.

Cornell was a regular reader of the newspaper and would have been interested in the Pacific theater of war as well. His fascination with navigation may have been lifelong, but its focus on the Far East is timely. He dates his compass-navigation box *Solomon Islands* "1940–42." These are not ordinary years. The Guadalcanal invasion of 1942 was one of the most momentous of the war, with sixteen thousand troops landing on the Japanese-occupied island. Many other battles also occurred in the Eastern Solomons. Whether Cornell actually initiated the box earlier, or whether the real date is in fact 1942, when the islands were in the news daily, it seems very likely that the U.S. theater of war had found a place in his theatrical art. The design of the box allows the frame to become a window. Through these windows we see compartments containing representational objects of different scale and dimension—maps, bits of coral, nautical materials—that bring the distant near and align nature, science, and art, offering the viewer an alternative, intimate and creative, relation to this faraway place.

Cold War Containers

While critical discussion of the arts during the cold war often extends the logic of "containment" to an ideology of form (Brunner, Davidson, Nadel, Nelson), Cornell, the master of containers—bell jars, slot machines, cages, rooms, boxes of all types—probably had little thought of this analogy. Having established a style and method out of surrealist and dada innovations of the late twenties, he continued to explore his central fascinations—with ballet and opera, fairy tale and romantic narrative, symbolist poetry, and Renaissance dynasty. He had a show of "aviaries" in 1949, and his themes of astronomy and navigation persisted. Perhaps in response to developments in abstract expressionism, his grids became less faceted and representational. The hotels that emerged as a new motif in this period are unfurnished and whitewashed. Sandboxes mark an intensifying awareness of time passing. Yet if the metaphysical had gained priority, for Cornell, over public event and external particulars, this increasingly inward art retained the power to respond to the pressure of reality, to find in the news not just material for reverie but occasion for comment.

Cornell's fascination with the Pacific, for instance, coincided with that of the American public during the Korean War. *Isabelle/Dien Bien Phu* (1954), depicting a cockatoo in a box, the glass splattered with blood, is the one box construction critics agree to read as a response to contemporary events, since its title, enhanced by the newspaper article pasted on the back, forces the connection. But as with the earlier *Habitat Group*, to which it alludes, the critical tendency has been to read this box as an anomaly, a detour into historical reality from Cornell's dream world. Instead, one might argue that public circumstance sometimes overlapped with Cornell's romantic vision, whether to disturb it or enhance it. Certainly Cornell's love for everything French, for distant voyaging, and for the heroic would have drawn him to the newspaper account he pasted on the back of this construction, collaged with a German map of Asia and the East Indian Ocean:

A hard core band of 2,000 Foreign Legionnaires chose to go / down fighting for the glory of France in a suicidal attack on / the Communist captors of Dien Bien Phu. / the French High Command at Hanoi said the Legionnaire[s] / under the command of Col. André Lalande at outpost "Isabell[é] / preferred a fight to

the end than to surrender. / A Communist Radio Peking broad-cast heard in Tokyo said / the Communist Indochinese con-querors of Dien Bien Phu h[ad] / "annihilated" the Legionnaires hours after the main fortress [had] fallen. (Quoted in McShine 1980, 290)

Like Wallace Stevens, Cornell read the newspaper from the point of view of his artistic world, not the other way around; the cockatoo has already established an identity in connection with Juan Gris and with the community of artists more generally; but this box certainly establishes Cornell's continuing interplay between fact and imagina-tion, art and history. And it is not the isolated instance that critics have claimed. The idea that art might present an alternative to the political standoffs of cold war diplomacy is implicit in the title *Hotel de l'Etoile: The Diplomacy of Lucile Grahn* (1953). Lucile Grahn, one of Cornell's favorite nineteenth-century ballerinas, began her career in Denmark but was known as an international star, touring Europe, becoming a prominent figure in Paris and Milan, and settling in Germany, where she donated her substantial estate to the city of Hamburg. She stands as a paragon of cosmopolitanism in an age of diplomatic standoff.

Cornell's increasing fascination with space exploration similarly co-incided with a national preoccupation during the "race for space." His ambiguously titled collage *Observations of a Satellite* (1960) suggests a certain amusement in response to the Sputnik panic. Again, he ab-sorbs public event into his dream vocabulary. A cover of *Scientific American*, featuring an article on "hummingbird metabolism," repre-sents some of his most cherished elements, offering a kind of "ready-made." The tiny bird, uncannily large inside its bell jar environment, is angled upward toward a device at the top of the container—a trian-gular feeder or meter of some kind. With the collage addition of a hexagonal prism outside the bell jar, as stylized moon-jewel, Cornell evokes a completely different scale from the one in the magazine, yok-ing space science to its natural history and perhaps thus resisting the emerging hierarchy in which technology triumphs over nature. The bell jar becomes earth's atmosphere, the hummingbird becomes a rocket, a torn and grayed patch of the magazine paper below its nether end just signifying rocket exhaust, the wiring at the bottom of

the bell jar now fencing in Cape Canaveral, the light bulb/feeder now a "satellite" between rocket and moon.

The satiric quality or at least whimsy of the collage arises not just from the play of scale between hummingbird and rocket but in the addition of a cutout from Velásquez's *Las Meninas* (itself a scale-subverting work), a dazed and dainty Infanta Margarita, sharing the space of the bell jar. Art thus enters the equation of nature and technology in the race for space. With her ballooning skirts she resembles Cornell's Tilly Losch of 1935, balloon-landing on a moonlike landscape. And for a figure from imperial Spain to arrive in the space age with its cold-warring superpowers and its "satellite" countries would certainly be equivalent in outlandish traveling. Much about this collage is ambiguous. One can say, at least, that there are many points of view proximate and distant in these "observations of a satellite."

More solemn in its relevance to cold war preoccupations is *Birth of the Nuclear Atom* of the same year. Like many of Cornell's works, this one evokes a table-top physics demonstration. Whereas the dominant theme of other physics boxes is unity (suggested in hanging rings, trade wind lines, seamless globes), this box demonstrates division. The central blue marble in a cordial glass has a white wavy line through its center. Pasted to the interior wall of the box are several circles, one in which small dots (electrons) surround a central nucleus, another in which the dots pair off in apparently random clusters, without a center. The paper backing of the box is torn and stained—not an unusual feature in Cornell's hotels and cages, but atypical of his astronomy and physics boxes, which tend to be pristine. There is no exhortation or emotionality here, just the cool evidence of a broken order, the "birth" by rupture.

History is the past, what is fixed and determinate, what has happened and cannot be altered. The imagination is the realm of the possible, the metamorphic, and the indeterminate. We have seen that Cornell's work involves the constant dialectic between these poles. Not only personal but also public circumstance casts its shadows in Cornell's boxes. But it would be a mistake to replace the simplistic image of Cornell's work as romantic fantasy with an equally reductive classification as historical commentary. Rather the boxes and collages create a dialogue between romance and history. The artist does not

passively register contemporary events; nor does he project a public redemption. The imagination presses back by transfiguring the matter that has been broken in time in order to form new wholes. Cornell's work is not so much ahistorical as it is "the opposite of history," as Octavio Paz and Elizabeth Bishop knew: "out of its ruins you have made creations" (Bishop 1983, 275). To oppose history is not to turn away from it but to engage it and resist it, as Stevens argued.

Museums or Pharmacies

When Cornell made cases for his collection of vials, he sometimes called them "Museum" and at other times "Pharmacy." Whereas museums preserve the dead, pharmacies revitalize the living. Working within the idiom of still life, an idiom "below" history, Cornell does not merely display ephemera, he *uses* ephemera to awaken a sense of eternity. This has been the major source of pleasure noted by all commentators of Cornell's art. The most fugitive, ground-down elements of existence, not historically significant but nonetheless impacted by history, paradoxically establish a space for metaphysical reverie. Certainly there is an element of nostalgia in Cornell's work. But ultimately his constructions and collages relinquish the hold of the past in favor of the epiphanic moment represented in the luminous nodes of his art. John Berger observed in his 1979 essay "Painting and Time" that such a dialectical relation of the ephemeral and the eternal was disappearing from the art world:

After the [first world] war, the surrealists made the unresolved problematic of time the constant theme of their work; all surrealist paintings conjure up the time of dreams; dreams being by then the only realm of the timeless left in art. . . . During the last forty years transatlantic painting has demonstrated how there is no longer anything left to mediate and therefore anything left to paint. The timeless—as Rothko so intensely showed us—had been emptied. The ephemeral has become the sole category of time. Banalized by pragmatism and consumerism, the ephemeral was excluded from abstract art, or fetishized as short-lived fashion in pop art and its derivatives. The ephemeral, no longer appealing to the timeless, becomes as trivial and instant

as the fashionable. Without an acknowledged coexistence of the ephemeral and the timeless, there is nothing of consequence for pictorial art to do.

Conceptual art is merely a discussion of the fact. (Berger 1985, 210)

Berger might find in Cornell's boxes some vestige of what the artist called "metaphysics of ephemera." This idea has been much discussed in criticism about Cornell, and it is generally linked to his Christian Science beliefs, and his fascination with Gérard de Nerval, from whom he borrowed the phrase. Cornell made a box in homage to Nerval, titled *Métaphysique d'éphemres*, in which we look through the blue glass and see a newspaper, a watch, and a feather. But the principle predates these associations, being a perennial element of the still life tradition. Still life combines a focus on the detritus of life with an impulse toward the spiritual, both in symbol and in abstract form.

With their insistence on place, on materiality, on memorabilia, Cornell's boxes resemble the still life tradition's caress of the quotidian rather than fashion's fetish for the new. (Indeed, Cornell relished the instances of still life in the everyday world of advertising, such as the "floral still lifes" at the Garden City Nursery where he worked, and the cornucopias decaled on fruit trucks.) Yet in their insistent grid forms and their anti-mimetic coherences, their allusions to cosmography and their play with voids and absences, his boxes take on a timeless dimension. Rather than turn memorabilia into more durable matter, Cornell stresses the entropic nature of all matter, adding a scrim of sepia, aging the wood frames, tearing the maps, antiquing and distressing his surfaces. He did not just take things out of use; he gathered things that were obsolete—especially childish things such as forgotten toys, jacks, old blocks. The flea market was the artist's gold mine. Ephemeral things are recycled, placed into a new order of value where chance intersections evoke a transcendental order. Cornell's work defies time by emphasizing it, featuring its ravages. And they are not just the ravages of age but the byproducts of human "decreative" energy—the creative obsolescence of technology, the brutality of war (why a "red" sandbox?). To enter "eterniday" one must, it seems, submit to history and embrace the fugitive nature of the material world. That eternity exists in the imagination, not in art's embodiments, is announced in the humble nature of Cornell's materials and

the conspicuous artifice and makeshift quality of his cutout birds and ballerinas. The newspaper and other printed text have a special place in Cornell's work. He liked the graphics of ads, the collage effect of newspaper layout, and the arbitrariness of the prose block. But the newspaper also symbolizes ephemeral event put to new use, one day's layout absorbed into a more abiding grid.

Museums would seem to be on the side of history, embalming the material traces of the cultural past. A museum gazer is passive, his objects static. Robert Harbison's remarks on museums in *Eccentric Spaces* suggest the ambivalence we feel about the archiving impulse. But in coming so close to describing Cornell (he is describing Ruskin), Harbison reveals the essential difference between Cornell's dossiers, cabinets, and exhibits and the traditional museum display: "The act of museumifying takes an object out of use and immobilizes it in a secluded attic like environment among nothing but more objects, another space of pieces. If a museum is first of all a place of things, its two extremes are a graveyard and a department store, things entombed or up for sale, and its life naturally ghost life, meant for those who are more comfortable with ghosts, frightened by waking life but not by the past" (Harbison 1977, 140). One cannot deny the element of "ghost life" in these shadow boxes, or their resemblance to shop window displays. Yet one is aware of the new life these relics are given in the unique assemblage of transitory fragments. The beholder, too, is invited to participate in the forming of connections. These boxes and collages require an active imagination, and many include moveable parts. The dossiers are indeterminate in their order, the kits waiting for the creative assembler. Cornell's *Museum* pharmacy illustrates the point, for while it is made up of remnants from previous boxes, it offers them for further creative use. What happens to a museum when it becomes a pharmacy? It becomes dynamic again, capable of change, of recombination, of healing, "unfolding experiences as seeds within itself so that the reader or audience may apply it to his own experience," as Cornell wrote in his diary (Smithsonian roll 1067). By contrast, "museums seek to end change, a perfect stasis or stillness. . . . [I]n order to enter, an object must die" (Harbison 1977, 147). Cornell's *Museum* is less a tomb or casket than a supply closet, from which distillations of the past provide the raw material of the future. We might see in this distinction between the static museum and the useful pharmacy a distinction between two different approaches to the lyric,

one that admires the well-wrought urn, still and remote, another that finds in "marbles, buttons, thimbles, dice, / pins, stamps, and glass beads: / tales of the time" (Bishop 1983, 275).

Humor as a Cure for the Terror of History

But it would be a mistake to treat Cornell's work only as a solemn struggle with the tensions between history and imagination. If critics have overlooked his historical engagement in their focus on his romanticism, they have also undervalued his humor and his sense of art as play. Cornell was profoundly drawn to Duchamp, and much of his work has been read as imitation of and homage to the anti-master; but the tone of Cornell's humor is different, less nihilistic in its tenor, more often in the spirit of Lewis Carroll or the wise foolishness of Chaplin. Cornell's wit can be seen in the domestication of surrealist shock (rather than the surrealist shock to the domestic), as in the *Homage to Offenbach*, where the famous Paris cancan is performed by lobsters in fishnet bibs, themselves a mock-homage to Nerval and his famous pet. The humor can involve puns, as in the play of "ange" and "angle" in *Shoot the Chute*. Cornell's sense of humor is Emily Dickinson's; each knows the power of the imagination to triumph over convention and propriety. Humor trumps the pigeonholing of the grid, evoking systems in order to subvert them. Humor invents a new economy of chance by putting the heir to an Italian Renaissance banking family inside a penny arcade. If history is often the story of power, humor may be its opposite, the gesture of the individual who refuses to submit his spirit to its tyranny.

FIVE

Richard Wilbur

Xenia

Rose colored cup and saucer,
Flowery demitasses:
They lie beside the river
Where an armored column passes.

. . .

The ground everywhere is strewn
With bits of brittle and froth—
Of all things broken and lost
The porcelain troubles me most.

 Czeslaw Milosz, "Song of Porcelain" (translated by Robert Pinsky)

Wallace Stevens wrote that "modern reality is a reality of de-creation, in which our revelations are . . . the precious portents of our own powers" (Stevens 1997, 750). In time of war, modern reality came to seem more a reality of destruction. The dump was no longer a place of privileged revelation but a ruin where, as Simone Weil noted, the creative passes not into the decreative but into nothingness.[1] For the generation who experienced the Second World War directly, the challenge was to keep the decreative tied to the creative, and to resist the overwhelming force of destruction.

Richard Wilbur's impulse was not to bear witness to the horror he saw in the war (though a few early poems curse a Nazi's eyes or remark on the ancient faces of returning French soldiers), nor to treat poetry as part of the war, "a different sector of the field" of battle, as

William Carlos Williams had done. Instead he sought to create what Stevens called "amenable circumstance[s]" (Stevens 1997, 789) in resistance to the pressure of ominous circumstances. As Edward Brunner has put it, Wilbur's poems are often about "movements of repossessing and renewing" (Brunner 2001, 32). But James Longenbach has argued persuasively that Wilbur swerves from the reactionary potential of this postwar emphasis on order and domesticity, pointing out that "the material that lies below the surface of the poem, giving it power, tends to be public and historical rather than private and personal" (Longenbach 1997, 67). By reading Wilbur's work in terms of the trope of still life, we can see the truth in both arguments. The power of Wilbur's poetry lies in the reciprocity between public and private, broken and mended worlds.

In many interviews Wilbur has traced his life in poetry to his experience as a soldier:

> World War II, of course, had doubtless a greater effect on me than I could possibly account for. I said once, in writing a little biography of myself, that I thought I had come to take poetry seriously for the first time as a soldier in World War II. . . . You do a lot of waiting, and it's a waiting both anxious and boring. And during these periods of anxious and boring waiting you contemplate a personal and an objective world in disorder. And one way of putting the world to rights a little bit, or at least articulating your sense of the disorder, is to write poetry. (Wilbur 1990, 37)

Entering Europe through Africa, into Italy, and on up the Siegfried line into France, Wilbur might have recognized himself in Stevens's soldier of "Esthétique du Mal" who sits in a café "at Naples writing letters home" as Vesuvius groans: "He could describe the pain because the pain was ancient" (Stevens 1997, 277). In an essay titled "Round About a Poem of Housman's," Wilbur narrates just such a moment in his own life, sitting in a bar in wartime Italy as Vesuvius spits out ashes. Rather than impress the reader with his experiences under fire, Wilbur tells an anecdote about his division's withdrawal for rest near Naples, and an excursion of a few soldiers to Pompeii, guided by a Greek woman, an entrepreneurial DP. As the ashes carpeted the ruins and the sky darkened, the guide cut her tour short, and "we found our

way back to the modern city and established ourselves in a bar, sitting near the window so that we could watch for the return of our truck" (Wilbur 1976, 17).

The scene is quintessential Wilbur in directing us away from destruction, dust, and ash toward the life of conviviality over food and drink. An inventory of objects creates an informal still life, each object a prompt to memory: "Most of us had some trophy or memento to show or show around: one had a bottle of Marsala, another a bottle of grappa; one had an album of colored views of the ruins; another . . . a packet of French postcards. And then there were the cameos from Naples, and salamis, and pure silk placemats." His narrative features the "good farmer [from] East Texas" who carried a miniature Romulus and Remus with mother-wolf, unaware of its significance, yet who was "not inferior, as a man, to the solider who happened to know that Pliny the Elder was done in by Vesuvius" (Wilbur 1976, 17). In the background one senses the tensions of class, feels the dust of the volcano, and hears, all the more profoundly in the spring of 1944, the roaring of modern guns. The future poet and his friends joke that they must sit up straight, lest they be caught like the unsuspecting citizens of Pompeii. The mood is anxious but affirmative. Characteristically, this scene of community is an interlude, set near a window as the men wait until the truck arrives to return them to duty. Yet the focus of the essay remains on fellowship and art, as it turns to the sensitive poetry of Housman, who ennobled poor mercenary soldiers by association with Hercules, Atlas, and the golden apples of Hesperides. (Those apples make a frequent appearance in Wilbur's poetry, too, from his earliest volume, and one feels, as here, the turmoil that threatens their preservation.) If Wilbur concentrates his imagination on "amenable circumstances," he does so in active knowledge of the ominous circumstances that surround us. And this purpose will sustain him sixty years after this wartime interlude, when he reminds us that "words, which can make our terrors bravely clear, / Can also thus domesticate a fear" (Wilbur 2004, 29). In our contemporary usage "domesticate" is often pejorative. Wilbur reminds us that home is hard to come by and well worth protecting. He understands, as Milosz did, that broken porcelain is a sign of a shattered civilization.

Certainly much of Europe seemed like post-volcanic Pompeii in 1944. But in citing John Ciardi's quip that "Pompeii is everybody's

town sooner or later," perhaps Wilbur was thinking as well of that pre-eruptive Pompeii, still freeze-framed in volcanic ash. Here the ordinary life of domestic hospitality (*xenia* in Greek means both "host" and "guest") was celebrated with extraordinary painting, also called *xenia*. These paintings were written about by Philostratus and Vitruvius, but perhaps most famously by Pliny. Pliny's description is considered the first account of a still life; it presents Zeuxis' dish of peaches, so real the birds pecked at them. Wilbur expressed the spirit of many veterans in his desire to turn from extraordinary catastrophe to ordinary pleasure; art's "second finding" (Wilbur 2004, 462) has a special urgency under such conditions. Wilbur's praise of domestic ceremony has seemed less heroic to postwar readers restless in what Robert Lowell called "the tranquillized *Fifties*" (Lowell 2003, 187); his defenders have attempted to redefine him as a poet of "darkness" and political protest, and there is plenty of support for such a reading.[2] But if terrors motivate Wilbur's art, they are not its hidden message. "When you are living in a hole on a hillside [at Monte Cassino] subject to harassing artillery fire you can never quite escape anxiety," or the abhorrence at your part in the destruction (Wilbur 1990, 185). But the effort to convert this foxhole to a "trench of light" must surely be one of the great tasks of art. Scenes of hospitality dominate the work Wilbur would go on to write, and they defy the power of the void (Wilbur 2004, 431). Pliny the Elder named still life as the lowest of the art forms, but for Wilbur these offerings to household gods suspend the power of human tyrants. Wilbur's Christianity, his sense of ultimate causes, strengthens rather than releases him from his struggle with proximate realities. If he is "obscurely yet most surely called to praise" more often than to rage, if he is more congenial than provocative, more ready to believe than to doubt, to shelter than to warn, it is not through complacency but through vigilance (Wilbur 2004, 461).

One hears that nervous soldier healing himself in *The Beautiful Changes*, particularly in "Grace," which uses the rhetorical form of correction and inversion. Inspired by Hopkins and in the style and attitude of Marianne Moore, the poem offers an inventory of grace as response rather than deliberate action, as a mystery we obey, where "lambs are constrained to bound" as if flung by the earth (Wilbur 2004, 455). The poem ends with a Moore-like caveat: "Nevertheless, the praiseful, graceful soldier / Shouldn't be fired by his gun." In

"Lightness" and elsewhere, the shells strewn on beaches are conspicu-
ously *not* the shells of guns, but in "Mined Country" the world's
surface is less reliable. The poet's hallucinations, in which "gray hills
[are] quilled with birches" and "cows in mid-munch go splattered over
the sky," show us that his mind, as much as the landscape, has been
"mined" (Wilbur 2004, 414).

Wilbur's Windows

Asked by John Ciardi to remark on his artistic predilections for a
collection of *Mid-century American Poets*, Wilbur wrote:

If art is a window, then the poem is something intermediate in
character, limited, synecdochic, a partial vision of a part of the
world. It is the means of a dynamic relation between the eye
within and the world without. If art is conceived to be a door,
then that dynamic relation is destroyed. The artist no longer
perceives a wall between him and the world; the world becomes
an extension of himself, and is deprived of its reality. The poet's
words cease to be a means of liaison with the world. They take
the place of the world. This is bad aesthetics—and incidentally,
bad morals. (Wilbur 1950, 7)

Form itself can be understood as a window (a framed transparency);
it must not become a door, locking out the world or pretending to
contain it.

It is not surprising, then, that windows appear in so many of
Wilbur's poems, from first to last books, and that they condition his
idea of the domestic and of interiority. Wanting to keep the "clever
blinds" up, he is constantly qualifying his own constructions (Wilbur
2004, 343). Of course Wilbur is not unique in this sense. As his poem
"The Writer" suggests, the window is an inevitable focus for the artist,
who tends to work at home alone in his room yet mediates between
the private and public worlds. In "Altitudes" Wilbur imagines Emily
Dickinson's window, her "sumptuous destitution" so different (since
Wilbur thinks in opposites) from the presumptuous heights of "a
great salon, a brilliant place" with its dome and "oval windows"

(Wilbur 2004, 305). The fact of a desk near a window has produced innumerable window-works, such as Baudelaire's "L'invitation au Voyage," a work Wilbur translated. But the image seems to have a special salience for Wilbur. He is that "boy at the window" (half Frost, half Stevens) who looks at the snowman as an "outcast Adam" who looks back and knows pain through the "bright pane" (Wilbur 2004, 340). But he is also one of the "suitors of excellence" at "high windows" who "sigh and turn from their work to construe again the painful / Beauty of heaven" (Wilbur 2004, 337).

What Wilbur's war memories most desperately record is the destruction of the domestic and community life—the destruction of love, neighborhood, the securities of childhood, of lively dwelling in interiors. Shattered or darkened windows signify for Wilbur the fragility of civilization, not only "rose windows / Shattered by bomb-shock; the leads touselled; the glass-grains / broadcast," but also the windows of houses, the signs of open correspondence between the inner world and the public life (Wilbur 2004, 341). As a soldier in Europe during the war, Wilbur is positioned on the outside, looking into the windows of occupied or violated homes. In the Eliotic "Place Pigalle" he watches a personified "evening" reveal "homing tradesmen" and take up "by nursery windows its assigned position" in feeble guard against the violence below (Wlibur 2004, 420). In "Violet and Jasper" the characters inside the pub in Cambridge, Massachusetts, escape into drink and fantasies of El Dorado, but Wilbur, wandering the streets, sees a "pharmacy window-globe . . . / Suddenly streaming with blood" (Wilbur 2004, 421). "The Peace of Cities," the best of these war poems, describes occupied Italy as if it were a "manichee hell of twilight" too difficult to navigate securely as terror "glides between your windows":

> Withinwalls voices, past the ports and locks,
> Murmur below the shifting of crockery

> I know not what; the barriered day expires
> In scattered sounds of dread inconsequence.
> (Wilbur 2004, 422)

The violence without has penetrated this interior; conviviality and community are frozen by fear of exposure. The paralysis is more terrible

than the trauma that beset it when the blasted windows let in, instead of sunshine, the menace of German planes:

> And there they heard
>
> The Luftwaffe waft what let the sunshine in
> And blew the bolt from everybody's door.
> (Wilbur 2004, 422)

The door forced open stands as the antithesis of the open window and marks the beginning of a drowning. The homes are like sunken boats in the dark sea of twilight, the windows like portholes of a giant wreck. It is difficult to breathe. "Waft" was once a poetic word but is now contaminated like everything else; the excessive alliteration at the ends makes us feel again the blow—as "windows" inverts to "minnows" and the reader experiences the claustrophobia "withinwalls" of the locks closing on the crockery. One might call "The Peace of Cities" an anti–still life. Its death-in-life, with "shifting of crockery" and unnatural "murmur below," the images of household objects "scattered" rather than arranged, suggests not merely violent disorder but the destruction of a valued domestic order. A poem like this one reminds us just how fragile ordinary living really is, how much it is missed in tyranny's wake. The poem longs for the prewar sound of domestic interiors, the chatter of families and friends coming through the windows of cities.

Wilbur's Augustinian "Love Calls Us to the Things of This World" should be read as a relief from this false "peace" of occupied Europe. A postwar stateside poem of the open window and clear light of day, it describes people unafraid to hang their laundry out, a city like Elizabeth Bishop's Manhattan under the gaze of Marianne Moore, a city "awash with morals this fine morning" (Bishop 1983, 82). To George Herbert's vertical pulley between man and angels is added here a horizontal line between inside and outside, private and public life. The end of Wilbur's poem returns us to the realities of an unredeemed world and casts the shadow of Hart Crane's "sheer shirt ballooning," but love has clearly replaced disgust and despair.[3] Wilbur remains the outsider here, and he will occasionally return to this position. In "After the Last Bulletins" he is left as a ghostly observer of the trash of news, "after the last bulletins the windows darken" and the "day's litter" thrashes at the

stony faces of monuments (Wilbur 2004, 315). But Wilbur's predilection, especially after his first book, is to come inside, to look from within the ordered domestic space out again to the inchoate, fluent, and expansive world. He is seldom alone in these interiors.

As Wilbur turns his attention to interiors, his eye naturally falls on the objects that make up the domestic life, and his descriptions often have the quality of still life. But the principle of the window gives a distinct aspect to Wilbur's nearness. Norman Bryson has argued that still life is "anti-Albertian," dependent on blocking out the schemata of one-point perspective and therefore the sense of distance. "What [still life] opposes is the idea of the canvas as a window on the world, leading to a distant view" (Bryson 1990, 71). But sometimes still life includes a window; by insisting on the window, Wilbur reintroduces this distance without sacrificing "proximal space." In *Ceremony* (1950) Wilbur has put the war behind him and explores the open commerce of inside and outside, the window way of making poetry. In "Wellfleet: The House" (echoing Moore's exploration of pastoral values in "Steeple Jack"), the daylight gradually moves inside to mingle with objects. Wilbur's still life sensibility explores the human by suspending human presence. (He seems to be following a lesson from Virginia Woolf's *To the Lighthouse*: "Think of the kitchen table when you're not there.") Here indeed is *nature morte*. The stillness of this old house is inhuman, "lichenlike grown, a coating of quietudes." Yet in a surprising inversion of feeling toward stillness and change, the poet "mends" the stasis with the sun's precious "blight" of temporality. The transience here is no offense as the walls wallow in light that "floods at the seaside windows":

> Making the kitchen silver blindly gleam,
> The yellow floorboards swim, the dazzled clock
> Boom with a buoy sound, the chambers seem
> Alluvial as that champed and glittering rock.
> (Wilbur 2004, 391)

The poem's richly alliterative and assonantal music features gentle "f's," in order to create the seaside mood; in "roof overwoven" and "lilac lofts and falls in the yard" to "guarded" and "garlanded" one hears the lapping ocean. Wilbur's meandering description blends inside and outside, stillness and flux, but finally arrives at rhetorically

simple and semantically rich assertion: "one is at home here." The permanent and the ephemeral blend in this notion of home so that neither terrifies.

Objects on a Table

As the artist gazes into and out of windows, he reminds us that much of life goes on around a table. Food—gazed at, tasted, touched, and above all shared—is the focus of his praise of things. In this respect he carries forward the Horatian invitational tradition and Dutch still life and genre painting.

Whether the setting is high or low, profane or sacred, a mean table or a lavish wedding feast, the objects of still life are not just delightful surfaces but metonymies and metaphors of the larger, historical world. If Wilbur's treatment of the object owes much to classical and Dutch genre traditions, its more immediate sources are the image-rich poetics of the American writer Marianne Moore and the French writer Francis Ponge, both of whom he read in his formative years. Moore's wartime volume *Nevertheless* undoubtedly played a part in Wilbur's approach to "things." Moore solves the problem of transitivity by presenting objects as formed rather than deformed by event. Ponge published *Le parti pris des choses* in 1942, and in taking the part of things, he is resisting the partisan, ideological impulses that had inflamed Europe. Like Ponge, Wilbur treats the object without suppressing the subjective life. "Our soul is transitive, it needs an object that affects it, immediately, like a direct complement," writes Ponge (Ponge 1979, 47), but unlike the surrealists, with whom Ponge had a prewar association, he did not treat the object as a projection of the psyche. Things have a life of their own which the poet respects, and which allows him to generate associations. Ponge's long fascination with still life—from Chardin to Braque—prompted his treatment of things removed from what Wilbur called "uses and prices" (Wilbur 2004, 431) to the space of sensuous particularity and, from there, to metaphor. Close scrutiny of the particular prompts rather than inhibits the imagination, making the local universal. Wilbur may admire "the devout, intransitive eye" (Wilbur 2004, 431) of the painter de Hooch, but his own literary imagination, like Ponge's, is transitive and constative. He turns *toward* by troping and "wrenching things

away" (Wilbur 2004, 461), by making beautiful changes and maintaining a dynamic relationship between object, self, and world.

Wilbur is even closer to Marianne Moore in modernizing the emblematic tradition and probing the object for its historical and ethical significance even as she praises its sensuous reality. Moore's "Nevertheless," a poem that responds to World War II in its imagery of fortitude under duress, exemplifies her use of still life topoi. Moore gathers before her imagination diverse fruits and vegetables (diverse in color, shape, texture, but also in origin) and examines their surfaces and insides for the pleasure of the senses and the instruction of the moral life:

> you've seen a strawberry
> that's had a struggle; yet
> was, where the fragments met,
> a hedgehog or a star-
> fish for the multitude
> of seeds.
> (Moore 1981, 125)

"Nevertheless" invites the reader to look and only later to reflect on a general moral. Like many still life artists, Moore appreciates the flaws because they register a process and suggest resilience. While the poem focuses a "devout, intransitive eye" (Wilbur 2004, 431) on the organic objects stilled in a particular state, their flaws introduce the possibility of transition. The flaw becomes a sign of virtue, of struggle and "victory" over adversity, of distinctiveness rather than entropy. As in many still life paintings, Moore's fruits resemble other things; the transformation is not only organic but metaphoric—a strawberry looks like starfish; apple seeds like "twin hazel-nuts"; carrots like "ram's horn," and only peripherally human as "mandrakes." This internalized system of analogy adds to the trope of abundance: this is a crowded cornucopia, despite the history of struggle, with strawberries, apples, prickly pears, cherries, grapes, carrots, hazelnuts, and starfish—a still life of fruit, leaf, tendril, and root. She presents things as ordered without human intervention.

Yet surely as Moore creates this canvas of small-scale natural objects with its integuments and curves and rich palette of hues and colors, she has war on her mind. "What is there like fortitude! What sap / went

through the little thread / to make the cherry red!" The language throughout of "struggle" and "victory," "fortitude" or survival underground, of "barbed wire," certainly evokes the public reality, so that the image of the "cherry red" and "sap" inevitably, without weighty symbolism, become associated with both human and sacred blood.

We see Moore's influence—her descriptive vitality and her social and moral subnarrative—particularly well in two early poems by Wilbur: "Potato" and "Mclongène." They form a hierarchical pair, peasant and king, and at the same time undermine social distinction in a language of commonality, for the "melongène" is just a "polished potato" exemplifying elegance without ambition; and the commonplace potato is elevated through attention. As Bryson says of Jean-Baptiste-Siméon Chardin, megalography enters the material world directly here, as if prior to cultural arrangement (Bryson 1990, 95). The poems are exercises in the mock-heroic, but they demonstrate Wilbur's early effort to "make objects speak" not only of nature but of man's aspirations as well. Yet the human story arises in close scrutiny of the inhuman object.

In "Potato" (Wilbur 2004, 416–417) the poet has challenged himself to write in praise of the humblest of objects, and he works in a poetic form appropriate to it. As in still life traditions, Wilbur examines the natural object in various states and degrees of rawness—freshly picked or washed, intact or cut open, in various light, in stages of consumption or decay. His close attention produces less a sense of familiarity than a sense of the uncanny, as what is near evokes a primordial distance: "therein the taste of first stones. . . . / Flint chips, and peat, and the cinders of buried camps." The etymological root of the potato allows Wilbur to explore it as a sign of man's earthiness but also his wandering nature. This *pomme de terre* is "crowded as earth with all" and "earth-apples" and is later called the more idealized "planet" (Greek for "wandering") ("scrubbed under faucet water the planet skin / Polishes yellow, but tears to the plain insides"). This poem is a still life of the minimal and impoverished, of "what saves us, what fills the need"; the object remains close to its natural state. As the poet describes this unchronicled vegetable, its associations with human history become less narrative and more metaphorical. Wilbur draws on still life's tactility and anthropomorphism, by which the withdrawn human agency is reintroduced by desire and association. The "skin," the flesh that turns "blue-hearted like hungry hands" when parched,

the eyes of the potato "blind and common brown," make this object a metonym for the poor human animal that has depended on it for sustenance. Cut open, the potato evokes primordial tombs, "hands of the dead slaves, / Waters men drank in the earliest frightful woods." The sense of smell, taste, and even of hearing are imported by association: it looses a "cool clean stench," "taste of the first stones," and so on. The emphasis on hands throughout the poem reminds us that the eye in still life can be an organ of tactility.

The blending of the senses creates a Poe-like hyperreality. But the poem gradually shifts from a metaphor-rich generic description to a metonymic, anecdotal focus. From this collective history of humans on the planet—united in their hunger—emerges a more localized history, of "cold dark kitchens, and war-frozen gray / Evening at window; I remember so many / Peeling potatoes quietly into chipt pails." In this simple act of preparation Wilbur recognizes not only army drudgery (KP) but also the persistent will of civilization. (Perhaps he is even thinking of Chardin's *Caring for a Convalescent*, a tender image of a woman peeling potatoes.) With this narrative turn, the focus is on the object, but the object is now set in a particular domestic space, and the chipped pail added to create a still life scene. A voice breaks in to mark a social exchange. Perhaps it is the voice of the dedicatee, Wilbur's literary friend André du Bouchet, to whom he owed his first publications (in the journal *Foreground* and with the publishers Reynold and Hitchcock), a friend who had himself "survived" during activity in the French Resistance and later became a well-known poet. The banality of the statement keeps our attention on the object rather than on the narrative of war: " 'It was potatoes saved us, they kept us alive.' " The voice speaks at the end of war, with the expectation of "packets [boats] again, with Algerian fruits" adding the French colonial narrative to the already layered historical time of this object-centered poem.

If issues of class and race are implicit in "Potato," "a common brown," they are foregrounded in "Melongène" (Wilbur 2004, 430). In this poem labor and consumption are suspended; we encounter the eggplant in the garden, a little society in itself. The object's appearance is its own excuse for being; it is theatrical, even costumed, a "kingly fruit" deserving elaborate diction and syntax, and eighteenth-century circumlocutions and vocatives in mock-heroic style with intricate six-line stanza rhymes. But Wilbur also attacks his own circumlocutions,

his "cant / Celestial," with a story of man's fall through pride. At the end of the poem we return to origins and to "unimaginative Adam's" simple English noun, "the Egg-plant." The Francophone melongène (a variety of the more familiar aubergine) is the natural aristocrat, but unconcerned with dominance, "it makes no suit // For rule in the garden" and "yields" to the upstart European, the "Brussels sprout." Kidney shaped, it nonetheless "does not store spleen." With its "regal rind" this mere vegetable, this thing of the earth, takes on grandeur with its humility, its "stain." Again we are in a world where hospitality rather than aggression prevails.

Performing the Still Life

In his first volume, *The Beautiful Changes*, Wilbur turned from the ruins of culture to celebrate the fundamental value of physical beauty and human connection to nature. A pear tossed up to a window, an eggplant in a garden, even a meager potato in a wartime kitchen were cause enough for praise. But Wilbur's next volume, *Ceremony*, looks at a life restored to rituals of hospitality and conviviality. Deep inside the concept of ceremony one may find Wilbur's religious belief, but his praise of social ritual is largely independent of a metaphysical principle. And the rituals remain casual, spontaneous; the scent and flavor of the raw still present in them. "Part of a Letter" for instance, assembles a composition of sea sounds, sun, and rain around a gathering of friends at a café where nature mixes with "whiffs of anise, a clear clinking / Of coins and glasses," and where the sounds of the sea mingle with the music of human speech and commerce (Wilbur 2004, 359). The poems of *Ceremony* convey the pleasures of the domestic life as theater and perform their moments of plenitude in a dialectic of inside and outside, culture and nature. Norman Bryson's approach to still life is pertinent here: "*Xenia* elevates life to refinement—combines rhopography with elegance/theater; culture's circularity between luxury and necessity" (Bryson 1990, 60).[4] The shadows that play across the pleasures of *Ceremony* evoke an embarrassment of riches rather than a memory of desperate times.

"Terrace" concentrates this pleasure of *xenia* in a performance that both invites and warns and in an image that is both still life and landscape (Wilbur 2004, 381–382). It is one of many poems in which

Wilbur explores the problem of "altitudes"—of solipsistic and elitist attitudes that form at lofty heights. Collapsing scale and distance, the poet imagines a landscape as if it were a still life, a table set with delicacies for his and his companion's pleasure. Throughout his work Wilbur, like Bishop and Stevens, measures distances and brings the distant near by association. But he is wary of taking dominion. In its centripetal and centrifugal movement "Terrace" follows Stevens's "Anecdote of the Jar" (another still life–landscape combination). The callous solipsism of the epicurean emerges satirically as Wilbur contemplates women in the valley washing linens and "the sound of water over their knuckles" as a "sauce rare" for his delectation. His theater of ceremonial pleasures grows dark, and the curtain closes on the artifice. Yet Wilbur's self-irony is not severe. Why shouldn't the passing sense of abundance be enjoyed, even reenacted? Why shouldn't he and his companion, like Stevens, treat "appearance [as] a toy" (Stevens 1997, 318)? Wilbur relishes this Baudelairean "voyage" in which he can feast on the distant landscape. The slippage of homonyms in "seas of view" creates an illusion of infinite pleasure but also of human subjectivity. But well before the darker close of the poem we are aware of the limits of this trope and the poet's reassertion of distances. This limit is itself part of theater, the framing of illusion.

Wilbur in "Terrace" makes reverie a process, a movement from center to periphery, from "Moi" to "Tout," in Baudelaire's punning terms. But even as he invites us into his lavish metaphoric repast, he reminds us that he and his companion see through "glasses of rosé." The dialectic within still life acknowledges that the sea and liquidity prevail over all attempts to escape time and necessity. In this luscious, Keatsian scene, "the spice / Of many tangy bees / Eddying through the miles-deep / Salad of flowers" flavors the evening. So we expect the sting of recognition when it comes, when evening has stolen "our provender" (from *providere*, "to look out from"), and we know what was spacious is "specious." The final double negative reminds us again of Stevens:

> And we knew we had eaten not the manna of heaven
> But our own reflected light,
> And we were the only part of the night that we
> Couldn't believe.
> (Wilbur 2004, 382)

The negative turn in Wilbur's imagination will never abolish ceremony. If the "imminent towns" and "weatherbeaten walls" show more the age of human history than that of "the finest cheese," nevertheless the courage of living well remains, for Wilbur, one of the virtues.

The self-parodying epicure speaks in "A Late Aubade" as well, though again the spirit of hospitality overrides the imperial manner. The modern and middle-aged poet employs the rhetoric of courtship to enumerate the worldly "wastes of time" that draw his companion from the bed. Like all aubades, this one is a rhetorical performance. But as it is "almost noon," food, not sex, drives the appetites of this speaker:

> If you *must* go,
> Wait for a while, then slip downstairs
> And bring us up some chilled white wine,
> And some blue cheese, and crackers, and some fine
> Ruddy-skinned pears.
> (Wilbur 2004, 229)

As in still life, we are linked to the image by appetite. The substitution of the sexual "pairing" for this scene of consumption is a familiar trope of still life. In a more serious mood a younger Wilbur had compared his Eve-like beloved to a pear: "your face / As legible as pearskin's fleck and trace, / Which promise always wine" (Wilbur 2004, 427). Even the offering in "A Late Aubade" is not rejected in irony. If this is a middle-aged carpe diem, it is also an invitation to the reader.

One feels this courage of good living in a skeptical age more earnestly in a later poem, "53 Cottage St.," where Wilbur implicitly reflects on his poetic choices within a genteel tea ceremony (Wilbur 2004, 143). The poem remembers Sylvia Plath as guest in the home of Edna Ward, whose "phoenix fire-screen" defines an enduring hearth against the suicidal rage of Lady Lazarus rising out of ash. The archaic rituals marked in the still life "tray of Canton" with its "tea" and choice of "milk or lemon" surely cannot rescue the drowning Plath, whose eyes of pearl have already changed to something rich and strange. Wilbur will not force the moment to its crisis, but neither is he ridiculous in this "genteel chat." In taking the measure of Sylvia's sublime and "brilliant negative," Wilbur implies the measure of his own choice—not "free," perhaps, in relation to decorum, not

sublimely ablaze, but aspiring to warm, to be helpful and just against the terrors of the "brewing dusk." As the last image suggests, the poem is, among other things, a reflection on containment—the tea ("weak or strong," "strained") an image of life's fluency, which can refresh or inundate.

Yet Wilbur knows as well "the voice from under the table," and it should be heard in the context of these poems of ceremony. "A Voice from under the Table" (Wilbur 2004, 321–322) reminds us of human lusts and urges that underlie civility. The desire beneath still life awakens: "seeing rose carafes conceive the sun / My thirst conceives a fierier universe." This is man as dog, "the softest hands against my shoulder-blades." If Wilbur is wary of the terrace, he is glad in other poems of the courtyard or wall that contains the wildness, glad of the "lady by Bazille" in "Ceremony," with "social smile and formal dress," who "teaches leaves to curtsy and quadrille" (Wilbur 2004, 406). But "Ceremony" does not pretend the woods are tame, nor mistake aesthetic form for reality. On the contrary, Wilbur's love of ceremony depends on, even sharpens, his sense of the uncontainable.

Things Transitive and Intransitive, Broken and Mended

Wilbur announces throughout his work that he is a poet of sensible objects. The news of being that comes to us through the senses is of prime value, prior to any ideas in things. His compass, his "rose des vents" (Wilbur 2004, 360), must be "things of this world" (Wilbur 2004, 303). Again Wilbur's war experience, the constant exposure to annihilations great and small, shaped his predilections. Wilbur's inventory of things is a way of counting his blessings and recalling himself to being. Item by item he can refute the nothingness that war precipitates, as in this description from "The Day After the War," published in 1946:

When all you can remember is the getting up in the morning, the lineup, the bored cruelties of the guards, the tasteless soup and sawdust bread, the goaded dragging hurrying line to the field, the road, the tunnel, the mine, the lathe, the sawmill, the powder-plant; and the grey shadows on the ceiling all night when it was too cold to sleep

When you have lost all identity, all relation, all significance of speech, all notion of belonging anywhere in the world, when you have experienced *nothing* as a real entity, touching, filling, numbing and abolishing you

Then the passing of a truck will fill your whole head with the clatter of bouncing planking, and the sight of leaves silvered on the undersides by road-dust will please you to smiling, and the sight of a child suckling will make you want to fall to your knees, and the explosion of a thrush will make you laugh in your throat, and the rain falling on you and coursing down your face and plastering your shirt to your skin, running down your stomach and your legs and filling your shoes will make you grin like a fool. (quoted in Longenbach 1997, 71–72)

The final image of rain conveys the fluency of being and links with the water imagery that runs throughout the poet's work. Poetry, like still life, like all representation, emerges from a desire to repeat what gives pleasure, and what gives pleasure is often, tragically, something transient.

The senses affirm not only being but also "order and goodness": "I feel that the universe is full of glorious energy, that the energy tends to take pattern and shape, and that the ultimate character of things is comely and good" (Wilbur 1990, 190). The poet's role is to "discover" rather than "impose" order. Art seeks to record and still these fluent realities for the imagination and to repair the sense of order that time's erosions and human destructiveness impose. Mimesis is a "second finding"; the artist's "devout, intransitive eye" holds the transient world before us against its natural and unnatural but always "tacit, tragic fading away" (Wilbur 2004, 462, 431). "The Beautiful Changes" (Wilbur 2004, 462) seeks to make art natural, to unite metaphor and metamorphosis, and to counteract the horrific changes brought about by war. Here the domestic, formal arrangements of still life are masked in nature's own display. In a series of lovely paradoxes, turns become returns and losing becomes finding. These "natural" effects depend on a series of poetic devices—wordplay, syntactic ambiguity, passive voice, and shifts of logic, beginning with the title itself, where adjectives are nouns and nouns are verbs. Similarly, the preposition "as" in the poem denotes both resemblance and temporal coincidence ("The

Queen Anne's Lace . . . turns / Dry grass to a lake, as the slightest shade of you / Valleys my mind in fabulous blue Lucernes"). And while the poem is not describing a still life, it attends to the quality of objects and to trompe l'oeil effects:

> The beautiful changes as a forest is changed
> By a chameleon tuning his skin to it;
> As a mantis, arranged
> On a green leaf, grows
> Into it, makes the leaf leafier, and proves
> Any greenness is deeper than anyone knows.
> (Wilbur 2004, 462)

The chameleon recalls Keats by way of Marianne Moore, making mimesis more adaptive than artificial. And in the image of the beloved whose "hands hold roses always in a way that says / They are not only yours," we hear the carpe diem motif. Behind all of this lies "a Fall"— a Christian narrative of second finding through which Wilbur understands the labors of art and the dialectic of mending and being mended, of nature's touch and art's. Touch itself, as it becomes an expression of desire and thus a transitive force, is problematic. And here is where still life comes in, as a form that orders but shows no signs of the ordering agency; that heals transitivity itself.

Wilbur's contribution to this tradition of object poetry, then, is his effort to mend and be mended by a world of things rather than simply cured by the ground. Where his modernist precursors might find the dump a privileged site, Wilbur is a poet of the well made, and his well-made poems are the setting for this homage to things. *The Beautiful Changes* is full of the "still moment" sensibility, as in "Caserta Garden," a *hortus conclusus* of "changeless time" in dialectic with a world that "rots and thrives" (Wilbur 2004, 459). The title poem evades the question of brokenness, focusing its gaze on a "kind" sundering, a happy fall, that is nature's before it is man's. In "Objects" Wilbur's eye is more directly on artifice, that "catches nothing" and that will "guard . . . by praising" (Wilbur 2004, 431). This mind that has always worked by opposites goes on to praise two kinds of human arrangement, the Greek and the Dutch, both involved with objects, one idealizing, the other devoted to rendering every flaw, one immortal, the other capturing a fleeting moment. Wilbur's regard for the

"classic" is clear, and the Hesperidean garden will appear again in his work as a space set apart from the world where "uses and prices" are forgotten. But his preference here is not for the "golden MacIntoshes" or any remote *hortus conclusus*, but for the more permeable and familiar "courtyard wall of brick" by Pieter de Hooch, where the gilding seems to come not from the gods but directly as "sun submerged in beer." In a scene of casual hospitality, a serving girl proffers a drink to a thirsty cavalier. Wilbur studies the techniques, not just the illusion he invites us to "see feinting from his plot of paint." Again we are reminded of artifice as he plays "feinting" off against "feigning" and "pots" (later "potsherd") off "plots." This "intransitive" plot represents an already humanly formed but transitive world; the light on the "boards," the tile "careful and undulant," the "weave of the sleeve" suggest a life of making and mending. The poem marks a wariness about artistic intervention—"there's classic and there's quaint"— "quaint" signifying a verbal cleverness and craftiness that will arise again at the end of the poem. But de Hooch establishes the artist as a mender rather than a mere trickster even as he captures the flaws and distortions that give the visual world distinction. He collaborates with the light to catch and hold an ephemeral world. The soldier Wilbur would certainly not use the word "trench" incidentally—a "trench of light" mends the memory of dark trenches. This made plot of a made plot (a courtyard wall of brick), where the eye is held for a moment, seems to suspend the world's destructive force even as it records the damage, "maculate, cracked, askew, / Gay-pocked and potsherd"— anything but "classic." The poet's eye caresses the "true textures, . . . true / Integuments" in the tradition of Dutch still life, playing light against shadow, opaque wall against transparent glass, solid tile against "streaming" beer.

But the turn in all of Wilbur's poems of contemplation, the turn in most ecphrasis in fact, is just at that point where the beholder resumes his temporal "voyaging," with a "tacit, tragic / Fading away" (Wilbur 2004, 431). Pieter de Hooch has trained the poet's eye to search out the sacramental "depth" in surfaces, the "magic" within the "common." From the table the eye moves up to the "tangible tree" and notices a murky light source, a form which resembles "the Cheshire smile." The "Cheshire smile" seems an odd image here, an ambivalent one that turns the "devout" artist into a trickster and tease. But Wilbur is referring to a real quality of the painting, the

glow of light within the dark trees at the top of the picture, above the sunny courtyard. This moment unites the poet with Hanno, who heard "the clear high hidden chant / . . . where under drifts / Of sunlight, under plated leaves," the gods protect the flowers of Hesperides. So classical ideals and Dutch realism are not so separate after all when human making, in its thrust against transience, works in consort with a transient nature.

In "Driftwood" Wilbur probes the intransitive object in search of narratives of human making and unmaking for which it is the trace. In this poem not just temporality but history is at stake (Wilbur 2004, 393–394). What Adorno says of Benjamin might apply here to Wilbur: "He is driven not merely to awaken congealed life in petrified objects—as in allegory—but also to scrutinize living things so that they present themselves as being ancient, 'Ur-historical' and abruptly release their significance" (quoted in Taussig 1993, 1). James Longenbach has noted contemporary cold war history behind this poem as it questions "dry abdications" and "damp complicities" (Longenbach 1997, 74). Keeping an object in the foreground as he imagines the various contexts and changes that make up its background history, Wilbur removes the object as an historical icon but gives it the metaphysical aura of a relic. The Anglo-Saxon incantations themselves introduce the theme of epic wars suffered and the fates of kings. The "ingenerate grain" of the wood, the closing image of the poem, is a trope of still life: nature frozen in change. It has grown into this "ingenerate" state, into art.

Driftwood is subject to many "changes" in the poem between its condition as vegetable growth in "greenwoods" and its "ingenerate" state, its formation into a useful vehicle for physical transport, and its formation into "signs" and "emblems" for the present in the allegorical sense. Indeed, the poem might be read not only as an allegory of history, that "old engine of grief," and its survival by art, but also of the human sundering of nature from itself, which art both causes and redeems. The turn is from nature to history to art, "relic" suggesting art's connection with something holy and transcendental ("the lathe of all the sea" a final craftsman). Again Wilbur focuses on stories of human making and breaking:

> Say, for the seven cities or a war
> Their solitude was taken,

They into masts shaven, or milled into
Oar and plank.

.

Well they availed their vessels till they
Smashed and sank.
(Wilbur 2004, 393)

But the art of still life rescues things from the flux, brings the drift-wood back from the background of history into the foreground of art and symbol:

Curious crowns and scepters they look to me
Here on the gold sand,
Warped, wry, but having the beauty of
Excellence earned.
(Wilbur 2004, 394)

Having rescued the object from history, the poet now applies it to his own cold war "time of continual dry abdications / And of damp complicities." It is a song of praise for these "royally sane" objects that in their natural nobility form an old admonishment against the reckless vanity of power.

These driftwood "relics" are cast "like slag," and the word-loving Wilbur knows that "slag" denotes not just metallic waste but, in an old Scottish terminology, wetness or dampness. Yet even as they are cast up on the shore, they present a sharp contrast to "junk," to the poorly made that ends on that anti–still life, the dump. Stevens or Williams might find "the dump" a place for epiphany, but for Wilbur, the master craftsman, the lover of the well made, the dump is the site of our shame. The epigraph for "Junk," again evokes a medieval world. Wilbur translates the Anglo-Saxon as "Truly, Wayland's handiwork—the sword Mimming which he made—will never fail any man who knows how to use it bravely" (Wilbur 2004, 302). Again the poet holds up the standard of ancient traditions; the broken lines of the powerful Old English rhythms, well made as they are, register the catalogue of broken things. The modern axe, which "angles / from my neighbor's ashcan," marks the fall from Waldere's ideal. The axe has been a symbol of craft for Whitman, Frost, Pound, and Gary Snyder, among many others. Wilbur makes a thing of strength and beauty

from all this brokenness, giving an overall unity in the music of rupture, and he enjoys the trope of the list as much as any poet of things. The "shellheap" (here as elsewhere "shell" carrying both the military association and its etymology of skull) must be itemized, "the sheer shards / of shattered tumblers," "a cast-off cabinet / Of wavily warped / unseasoned wood." But the poet's impatience with these signs of modern corruption is palpable, explicit: "Haul them off! Hide them!" The Dylan Thomas–like "making dark" of course answers to any exceptionalism even of the well made, any undue pride the poet might hold for Wayland or himself. As he reminds himself elsewhere, "it is by words and the defeat of words, / Down sudden vistas of the vain attempt" that the poet finds his way.

The Hole in the Floor

We have seen how sensible objects ward off the annihilations of war, how art can help to mend a broken world, how a well-made thing might wield some limited force against entropy. Against "those who said God is praised / By hurt pillars" and who found their theme in the ruins of the recent war, Wilbur praised the makers (Wilbur 2004, 350). His turn to the parks and courtyards and hearths of community and domestic life, as to lovely patterns of resemblance and resonance, marked an effort to establish sturdy, amenable local orders in resistance to the overpowering disorder and negation of war. Part of his success was simply a matter of distance, of the American soldier returned from a foreign war to domestic peace. Throughout the fifties Wilbur's work "imagine[d] excellence, and tr[ied] to make it" (Wilbur 2004, 351) on an intimate scale that would not risk the treacherous "altitudes" of the prewar political sublime. But in the sixties, and especially as America entered another, morally uncertain theater of war, Wilbur's ability to stay focused on the praise of the local, on "sensible objects" and the intimate graces of the domestic world, was threatened. The very distance of the war tended to allow it to poison more immediate perceptions. "I didn't have concrete material to deal with," he wrote, "as I did in such poems as I got out of World War II. In World War II I'm talking about the gun that's strapped on your. shoulder, and the mine detectors that you're observing as they sweep back and forth across the ground—all kinds of details" (Wilbur 1990,

196). Instead, the remote horror infected the pleasures of the proximate world, awakening violence within. All the poetry of mending and healing, of the love for "things of this world" that might cure the soldier sick of death, threatens to become inverted during this period. "On The Marginal Way" symbolizes this distant menace in the image of a newspaper whose "spread wings of newsprint flap" like a harpy's or like a bad omen of "the time's fright."

"On the Marginal Way" is Wilbur's contribution to a long line of seashore poems from Arnold, Poe, and Whitman to Stevens, Moore, and Bishop, which meditate on human history against a backdrop of eternal flux and mortality. It stands as an antithesis to his poems of *xenia*, presenting instead a scene of exposure, of an inner violence provoked by outer violence, of dread contaminating sensation. The title evokes not just the shoreline but "the negative way" to spiritual truth, and perhaps also the "marginal" position of the poet's thought, between imagination and reality. Wilbur has frequently acknowledged Poe as his progenitor—the master of form and symbol, of the hypnagogic state and the transcendental aim, whose influence he resisted. If Wilbur had set himself as the poet of "things" and of life-affirming order, through Poe he retained a capacity for abstraction and for the uncanny, the *unheimlich* or unhomely—and a fascination with death, with *nature morte*. In his earlier work Wilbur justified his "seeing things awry" as a mode of discovery, to see "the world resist my ordering of it, so that I can feel it is real and that I'm honoring its reality" (Wilbur 1990, 51). But in "The Marginal Way" (Wilbur 2004, 197–199), the link to original sin is more disturbing. This tension between proximity and distance, between local objects and distant wars, is enacted through shifts of tenor and vehicle.

Walking along a "cove of shale," Wilbur seeks human form in the sleek rock. As if to sidestep his own violence, the poet begins with a surrogate figure, a Puritan writer, George Borrow, unsettled by a display of too abundant flesh, "a hundred women basking in the raw." But this metaphor in fact only releases a chain of associations, one more terrible than the previous. As the gaze turns to Géricault's world of "blood and rape," the immediate scene of the shore withdraws to the position of simile. Géricault's narrative turns the waves to retreating plunderers. Even this simile of the waves, "galloping off, a receding line in the dust," encompasses the previous, grotesque eroticism, "like the wave's white, withdrawing hem." The relationship of the

imagination to immediate fact is increasingly marginal. All lust in the violence is quieted only by the shift from Géricault's art to history's living death, "Auschwitz's final kill," where people turn to stone, to a "death too dead": "poor slaty flesh abandoned in a heap / . . . / Bulldozed at last." Indeed he has bulldozed his heap of images. At this point the metaphor comes full circle: the fleshlike stones on the beach are like Auschwitz's victims because these people have become stones. The directions, the turning away and the turning toward, have reversed.

The stasis of the rocks is counterpoint to the violent eruptions of the mind. In exhaustion the poet turns back from history to the geological realm and locates the violence outwardly, imagining the primordial eruption that must have produced the land forms. But even here the anthropomorphic impulse "wells up" in "shrinking skin," "sweaty quartz" and "deep retorts," "glacial heel," and "manhood of this stone" aroused by light and sun. The biblical narrative becomes a way of controlling the proliferation of grotesque metaphor and restoring the innocent eye. He views "three girls" who "lie golden in the lee / Of a great arm or thigh" of geological innocence. The menacing text of the newspaper is supplanted by scripture, and his own "breaking thought" is mended by the flood of joy in "divine motive" which overrides the margin of reality and imagination, and faith rescues the poet from his time's and his own eruptions.

But Wilbur is not naïve about this recovery in "a perfect day," and while his later poems continue their course of praise, a greater chiaroscuro shades much of the work. In "A Hole in the Floor" (for René Magritte) he confesses, without apology, that his domestic mending might be a kind of repression (Wilbur 2004, 265–266). In this sense the hole in the floor is a counterpoint to Wilbur's windows, only facing inward. The scene is one of remodeling: "the carpenter's made a hole / In the parlor floor, and I'm standing / Staring down into it." At first the confident Wilbur looks into the excavation of his domestic space as if it were layers of paradise, the carpenter's dust familiar as his own "Hesperian apple-parings." But as Magritte (after all the most domestic of the surrealists) takes over the classical sensibility, as he looks into "the house's very soul," into "the buried strangeness / Which nourishes the known," the room grows "dangerous." And it is just there that Wilbur retreats from the "news of night" to the "visible world" which the carpenter (and all good workers in wood) will restore.

The pattern of turning from rage to restraint recurs as Wilbur forgoes "Beethoven during breakfast," preferring the light breakfast still life of "bran-flakes [crackling] in the cereal-bowl" and later "light on fennel plumes" and "dew like mercury on cabbage-hide." These domestic particulars do not entirely anchor him against the predawn hypnagogic state, which in "In Limbo" unhinges the immediate world to carry the poet from a childhood in Brewster, Maine, to an anonymous hotel on a reading tour, and then to a purgatorial journey into "the shocked night of France" in World War II. Such poems remind us that Wilbur, the "poet of suburbia" as his detractors have called him, certainly the poet of domestic orders, is often "homelessly at home."

Yet the later Wilbur is much more likely to look into such holes in the domestic world than was the young man returned from the wars, eager to put it all behind him. Not surprisingly, Wilbur's late still life aesthetic tends toward *vanitas* rather than abundance or ceremony, though with typical humor and wit. "To His Skeleton" is the most explicit poem of this tradition. Like Hamlet to Yorick (but more in Yorick's than in Hamlet's spirit), Wilbur addresses his "noblest of armatures": "The grin which bares my teeth / Is mine as yet, not yours." But the weight of mortality is on him. The poet who read Poe in a foxhole in Monte Cassino has found a way of blessing his demons, however. Indeed, "dark berries [are] savage-sweet and worth the wait" (Wilbur 2004, 16). "Children of Darkness" is a mushroom still life, done in "the holy chiaroscuro of the woods" (Wilbur 2004, 155). The challenge of the poem is to say of these anthropomorphic grotesques, these rotting brains and putrid phalloi and "dead men's fingers"—"they are good."

Wilbur's profoundest association, uncommon in our age, is with poetry and happiness, and the happiness for which he strives is of a particular kind. It is the happiness of a onetime soldier (and cryptographer!) poet, who turned from messages of war to messages of love, from death to life, from destruction to creation, violence to ceremony, the battlefield to the home, the clash of nations to the idea of community. And these modes of happiness are linked. The domestic order and ceremonies of the private life, the rituals of eating and drinking, locate him in a dialogue with the public world. Wilbur knows that this is an ideal; praise and cultivation of these images is not a retreat into bourgeois fantasy but an offering to his "world."

These themes are profoundly expressed in his essay "Poetry and Happiness," which helps us understand the relationship between the planet and the table (Wilbur 1976, 91–114). A poet's sense of a *world* (a shared place) is not the same as his "world-view" (an alienated vision). Wilbur begins with the poet's perennial "itch to call the roll of things" and moves to "the discovery and projection of the self," but the latter passage is the shortest section of the essay, since clearly for Wilbur this "self" exists properly to connect the "world" of others and of particular "things." (Even his account of listing is set in a game with a college roommate.) And as we have seen, poetry for Wilbur happens not in a retreat into interiority but at the window: "Stevens [in "Crude Foyer"] acknowledges that poets are tempted to turn inward and conceive an interior paradise; but that is a false happiness; we can only, he says, be 'content, / At last, there, when it turns out to be here.'" Wilbur continues: "We cannot enjoy poetic happiness, until the inner paradise is brought to terms with the world before us, and our vision fuses with the view from the window."

But as Wilbur turns to that window, the essay begins to expose a hole: his *un*happiness with the contemporary state of the world and of the arts. For instead of corroborating his beloved domestic rituals and harmonies, his gaze finds an incoherent culture, not "the humane unity of a whole people" out of which the Dutch painted their "objects" and Dante wrote his *Commedia*, not a Stevensian "diamond" that "sums us up," but rather an atomistic world, not a world at all, not one that could gather at his imaginary table. And yet, "helplessly optimistic," he has gone on sending the world his brilliant, consoling invitations to civility, with the prayer that they might reach some place of common values in our hearts (Wilbur 1998, 21).

Individual freedom is not, for Wilbur, conditioned on autonomous and atomic privacy. He recognizes the private life and the ordering imagination as limited, as part of a community, responsive to the call of community, and to the demands of the polis and of history.

CONCLUSION

Domestic Disturbance

> A larger object includes more of the space around itself than does a smaller one. It is necessary literally to keep one's distance from large objects in order to take the whole of any one view into one's field of vision.
>
> Robert Morris, "Notes on Sculpture Part 2"

Richard Wilbur's praise of ceremony would continue to offer an assertion of peace, not oblivious to holes in the floor, but confidently defending the planks of reason and civility. Such a defense depended on a distinction between the spheres of private and public life, and of art and history, even as it called for congress between them. But by the fifties the crude foyer between these spheres was collapsing, and with it the lively dialectic of still life. An official defense of home and nation against collectivist ideology kept the spheres nominally isolated. But as many critics have noted (Nelson, Davidson, Brunner, Bailey), this protection of privacy paradoxically justified an excessive control by the state over individual expression. In response, literature sometimes seemed to retreat into noncontroversial affairs of heart and hearth. Donald Hall complained about the reduced scope of poetry among his contemporaries, where he found "a reliance on the domestic at the expense of the historical" (quoted in Brunner 2001, 185). By the end of the fifties, however, many artists were pushing back against such perceived "containment," declaring that resistance begins in domestic disturbance.[1] The courtesies of the foyer were trampled by the insistence that the personal is political.

Poets and artists of many different aesthetic orientations were by the late fifties rupturing complacent surfaces and further transforming the spirit of still life, bringing objects of the domestic world outside, where they became totemic and terrifying, or fragmented and dispersed. For these acolytes of the "psycho-political muse" (Breslin 1987, 1), the culture of the table and other household rituals were simply an extension of a discredited ideology, and came to symbolize subjection or exclusion rather than amenable order. The feminist critique of the public/private distinction was one of many challenges to the contract of the foyer. When Adrienne Rich, in "When We Dead Awaken" (1971), revisits her poem of 1951, "Aunt Jennifer's Tigers," she is struck by its formal containment and displacement of anger. The poem could be by Richard Wilbur, except that where Wilbur's Aunt Edna *arranges* her environment in "Cottage Street, 1953," Rich's Aunt Jennifer is "mastered" by her "ordeals" (Rich 1993, 4). A repressed longing for freedom and agency, in the form of the tigers she is embroidering, is unleashed in the poetic work of the niece, who assumes that such agency requires a departure from the domestic space. In later poems she leaves the interior environment of Aunt Jennifer to explore the self, alone in Orion's sky and Carl Jung's sea or, collectively, empowered by group movements.

Sylvia Plath's "Tulips" denotes the opposite of domestic order and beauty; the flowers are explosive red intruders into an impersonal hygienic void, hyperbolic messengers of the heart, disturbing the numbness of white hospital walls, taking up more and more space, becoming engines, eating oxygen, roaring "like the mouth of some African cat" (Plath 1993, 160). Private insecurities and torments spill out in metaphors appropriated from public events (Hiroshima, Auschwitz). As Michael Davidson remarks, "Replacement of public by private pains is a characteristic move among poets of Plath's milieu . . . and could serve as a more general feature of 1950s personalism" (Davidson 1998, 270).

To Wilbur, Plath is "immensely drowned," and his discourse of scale is revealing (Wilbur 2004, 143). Whereas the work of Stevens, Williams, Bishop, Cornell, and Wilbur often relies on a familiar local scale, in which the world is miniaturized or emblematized, many poets and artists of mid-century blow up the domestic object and extend the realm of the personal out into very public spaces and gigantic dimensions. The result of this expansion of the private into the public is

not intimacy but distance and impersonality, as in the sublime. At the same time, the public, historical world becomes something shadowy, a projection of internal violence.

The artists I have described in the previous chapters felt an immense pressure of public news, and worked to restore local, personal orders that might engage this news at a personal level without collapsing from its force. Whereas predecessors such as Stevens or Moore might bring the planet to the table, intimating a distant world within a personal scale, many of Wilbur's generation and after made the opposite imaginative move. The private world became, for Sylvia Plath, Allen Ginsberg, Anne Sexton, and others, a "colossus," and the recent historical distresses were viewed in a continuum with personal, psychological disturbance. In "Lady Lazarus," most famously, holocaust imagery produces a grotesque *vanitas*, not to critique history but to rage over patriarchal power, and even over life itself:

> My skin
> Bright as a Nazi lampshade
> My right foot
>
> A paperweight
> My face a featureless, fine
> Jew linen.
> (Plath 1993, 160)

The radical split between the bodily self and the performing voice subsumes the dialectic between inside and outside, personal and public, near and distant. The desire to break open the placid surface of the domestic world is summed up in Margaret Atwood's "Against Still Life," in which oranges on a table become associated with the street, the market, the historical world, not so much to evoke these external realities as to project the personal life onto them. The artists discussed in the previous chapters worked to restore equilibrium to a dialectic threatened by the pressures of public history; that dialectic was now collapsing in the opposite direction, toward the limitless expansion of the private life into public space.

Not only confessional and feminist poets wanted to disturb the still life idea and spill the object out of an intimate formal container. Poets of the Black Mountain and Beat traditions, experimenting with open

form, were equally anti-domestic in their depiction of postwar America. Allen Ginsberg's vision of beatitude depends upon a refusal of the domestic sphere, for him, as for Plath, the sphere of repression and madness: he sings his sunflower sutra not in a garden or a sunny room, but amidst the desolate and transitory space of a railway depot. And whereas Williams often focused his inner violence on objects at rest, these poets were more likely to set the object in motion, reflecting the mobility and transience of postwar living, in contrast to bourgeois domesticity. Robert Creeley smashes the object, dislocates it, and sends it into a vortex of dynamic relationships. In "Still Life Or," the "or" is "mobiles" (Creeley 1982, 20). The work welcomes in wind and speed. Hence "A Wicker Basket" (1959) begins in a table scene, but a restaurant table, not at home, and rather than pause on discrete objects as Williams might do, Creeley puts in motion a series of changes, soon "out the door" into half-formed perceptions and disappearances (Creeley 1982, 161). Events are abbreviated, with motion featured everywhere in anti-domestic imagery of cars and casual sex. The imagination goes out into vast space, "huge stars, man, in the sky," though it eventually returns "from somewhere very far off" to a local object, ironically a "slice of apple pie," announcing a new kind of American poem for a fast-moving age. The poem itself becomes an object, but like the "wicker basket" that first sent it in orbit, it is woven of intersecting events and dynamic consciousness, a most porous container, more open than closed, the opposite of the sealed-off bourgeois home, the poem as globed fruit, and the work of art as a bell jar or a well-wrought urn.

Everywhere in the arts of the late fifties and early sixties we see still life in reverse—not the world arranged on an intimate table, but the private and domestic life fragmented, dispersed, and expanded to occupy a public scale and space. The phenomenon is even more apparent in the visual arts, where mass media forms, installations, and happenings were overtaking traditional painting and sculpture. In pop art, for instance, we see the still life tradition inflated and giganticized, the domestic depersonalized and emptied out. Mass culture images are used to challenge the romantic thrust of abstract expressionism, which had already displaced domestic subjectivity with the sublime. The social and political force of pop art parody is hard to gauge, since the collapse of dialectic driving the work (refusing such dualities as art/life, private/public, reality/representation, and so on)

seems to mirror rather than resist the consumer culture. Jean Baudrillard's extensive account, beginning in 1968, of the end of experience in the age of simulacra had long been anticipated in the postmodern work of Warhol, Lichtenstein, Rauschenberg, and Johns. And Baudrillard's analysis of the flattening of reality is itself as much symptom as critique. Claes Oldenburg's *The Store* (1961) trumps consumer culture by making plaster and gaudy paint copies of popular consumer goods (from hamburgers to wedding dresses) to be sold as art, or rather refusing the distinctive categories of art and commodity, along with their many cognate dualisms.

Joseph Cornell is often cited as a precursor to pop art because his boxes collaged together high and low objects. But as Linda Hartigan has observed, Cornell's work depends for its power on a dance rather than a rejection of dualisms, among them private and public, small and vast, temporal and eternal. Such dualisms develop an art of paradox rather than of parody. Oldenburg, like Cornell raised a Christian Scientist, may want to spiritualize the everyday with his erotic, anthropomorphic, and totemic representations of household objects, but he is party to the materialism, to the voraciousness, and to the commodity fetishism he seeks to expose and assault. His happenings expressed the desire that art be more than a part in dialogue with the whole; rather they were total environments, total works of art, and Wagnerian theaters for a postmodern age. As Barbara Rose has shown, they expunged all sense of life and art as separate realms by bringing reality inside the aesthetic site as a neo-Freudian libidinized present. Gratification extended to fill all space and all object relations. In many ways Oldenburg's art epitomizes the collapse of dialectic I am describing, and the shift in tone, scale, and direction of the art of his time.[2] He is a spirit without a foyer in a world without a foyer, or rather the body is shelterless and the world is the body, including the body's drives and waste. Oldenburg in the late fifties and early sixties promoted the expansion of the domestic into the public world rather than the bringing of the planet to the table, and thus forged an expressionism which has lost the element of the personal as distinct from the public. Such work reflects and emphasizes violence and disturbance rather than resisting it with local order and ceremony; it features satire rather than idealism, is more physical than metaphysical, is monumental instead of miniature. Its forms collapse into erotic release or entropic waste rather than gathering into provisional order.

Of *The Store* Oldenburg wrote, "Store is cloaca; defecation is passage," indicating, according to Barbara Rose, that art spills out into society as an end to the "constipation of the Fifties" (Rose 1970, 33).[3] In *The Store*, art had expanded and moved from the wall and table to the floor, and the logic pushed on eventually to bring the household object to the city plaza. In an age against monuments Oldenburg proposed anti-monuments on a scale worthy of the World's Fair: a frankfurter and tomato monument for Ellis Island, a clothespin for Chicago, a Good Humor bar for Times Square. Art and advertising occupy the same space and are hard to distinguish; still life competes with architecture for public space; commodity replaces conversation in the polis. No wonder the eminent architect Philip Johnson bought Oldenburg's nine-foot-by-six-foot *Floor Cake* in 1962 (fig. 12). And all these images are anthropomorphic, indeed phallic. In Oldenburg's work "the human body is visualized as a landscape" (Rose 1970, 11). With no distinguishable outside, the artist does not so much ask us to touch the world (as in Cornell) as to become the world. Figure and ground converge.

But still life is a perennial genre, not an exhausted medium, and recent work suggests a return to dialectic. In poetry the term and topoi of still life have been revived; indeed, the "Still Life with X" has grown into a full-blown subgenre of Thing poems. The tendency among many recent poets has been to connect without collapsing proximity and distance, still life and landscape. The juxtaposition and convergence of genres has become a common trope of contemporary poetry. Such juxtapositions again make the poem a foyer between private and public concerns.

Set against the blowups of the sixties and seventies, James Merrill's poems can seem like a retreat into the enclosures of the bourgeois interior. The very titles of his volumes—*Late Settings*, *The Fire Screen*, *The Inner Room*, and so on—encourage such a reading. But Merrill was nevertheless "braving the elements," and his poems reverberate with twentieth-century pressures, even the contemporary explosions of the Vietnam War. The contemplative object of Merrill's "Willowware Cup" begins as a symbol for the world of Victorian bourgeois privacy and its links to empire (Merrill 2001, 324). But the "prewar" colonial pattern represents "a version of heaven / In its day more trouble to mend than to replace." Merrill's speaker is ambivalent before this

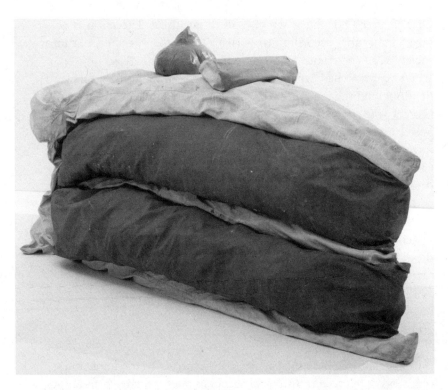

Figure 12. Claes Oldenburg, *Floor Cake (Giant Piece of Cake)*, 1962. Synthetic polymer paint and latex on canvas filled with foam rubber and cardboard boxes, 58⅜"×9' 6¼×58⅜". Gift of Philip Johnson (414.1975). Courtesy of Claes Oldenburg; digital image copyright The Museum of Modern Art/Licensed by SCALA/ Art Resource, N.Y.

choice, and the poem ultimately performs both functions, evoking without imitating the craft and literature of the past. The fading images on the cup evoke a tattoo, bringing the distant, depicted scene into the realm of personal, erotic memory. Merrill is a great poet of autobiography. But public history inflects the life within the domestic interior. From beginning to end the poem reverberates with wars, and while it may turn in the middle to personal longings and lost love, the poem does not settle its attentions there any more than on the idealized world depicted on the cup in blue and white. Leslie Brisman distinguishes Auden and Yeats from Merrill by noting "Merrill's almost total obliviousness to politics" (Brisman 1985, 192).[4] Merrill, he implies, is concerned with the personal world of chinaware, not the historical world of Chinamen. But if the "old, odd designs / . . . seem to concentrate on you," they have evoked much more along the way,

including Auden's meditations on the war in China in the 1930s. Merrill's poem begins with a powerful allusion to war, not just one war but "wave after breaking wave." The "chipped vessel" of art and domestic ritual retains the scar of "its destroyer," the ship of war, of state, of fate. Writing during the height of the Vietnam War, Merrill is certainly concerned not only with his morning coffee or tea but also with what is in the newspaper: news of Southeast Asia. No one would want to turn this poem about love, loss, memory, and art into a Vietnam protest poem, but if Merrill is "oblivious to politics," he is anything but oblivious to contemporary history and to war. For Merrill the planet is on the table, to be touched and connected to the self.

The association of still life with landscape has provided many contemporary writers with a language for negotiating proximity and distance without collapsing their difference. The distance has been mostly ahistorical, however. Ted Hughes's poem "Still Life" describes an "outcrop of stone," an unmoving presence as a foreground and fulcrum for a dynamic, seasonal landscape (Hughes 1982, 53). In Charles Wright's "Still Life with Stick and Word," Giorgio Morandi's art, both his still life and his landscape, provide a model for the writer as he converts nature to landscape and landscape to still life (Wright 2000, 60). As for Cézanne, the other artist always in Wright's mind, world is working table and working table is world. Sometimes the convergence of genres allows the poet to see the strangeness in the familiar, to create an effect of the uncanny. This is often a technique in the work of Charles Simic, whose "Return to a Place Lit by a Glass of Milk" takes a journey that ends in a domestic space glowing with metaphysical light (Simic 1974, 61). Jennifer Clarvoe, perhaps inspired by Simic in "Landscape Lit by an Apricot," explores the relation of the impersonal and alien to the personal and familiar, first in quotidian terms, then back out again to the metaphysical (Clarvoe 2000, 67–68). In August Kleinzahler's "Red Sauce, Whiskey and Snow: A Still Life on Two Moving Panels," where the flow of inside and outside, personal and impersonal, proximity and distance, large and small, depends especially clearly on the convergence of genres (Kleinzahler 1995, 90), the two panels might be the interior scene and the scene outside the window, both set in a temporal drift. Why this conjunction of genres? The still life/landscape trope answers our need for intimacy and connection with an object within our immediate range and scale, and at the same time our desire to escape, to move out into

deep space. The trope reminds us as well that our cultural organization of the material world is a continuum, an arrangement set against flux—something taken from or put into the landscape, something that has a human touch, even if only the touch of symbolism.

This intertwining of still life and landscape attracts poets in pursuit of psychological and metaphysical truths, but historical realities often creep in. A refugee's history of violence and displacement certainly haunts all the objects in Simic's work, especially the objects of the table, as in "Fork," "Mother Tongue," and "Eastern European Cooking," where the experiences of displacement and war trauma lurk in the uncanny feeling within ordinary life. In "Still Life with Aspirin" Lucie Brock-Broido has a visitation from her dead mother and recounts her own journey to what she calls, citing Stevens, "the Ever" (Brock-Broido 2004, 6). One expects such out-of-body experiences from the poet of "Domestic Mysticism." But as the tactile world falls into an analgesic void and "*all of my objects have lost their correlative states,*" the poem finds its concreteness in a surprising simile. "Ever" turns out to be a distance not only of metaphysics but of history too, just as "the West Bank / Is an eternal circle of chalk and bruise and war." Brock-Broido manages to evoke such hyperbolic, fraught images with Stevensian dialectic rather than Plathian personalism. The poet abruptly addresses her reader's surprise, as if it is her own surprise as well: "You did not dream I held political / Ideals, did you." But it is not that the poet of "everything intimate" has written a political poem. Rather, in declaring "All is not well," she brings the world's trouble to mind and makes it intimate with her inner life.

Robert Pinsky's 2006 chapbook *First Things to Hand*, also collected in *Gulf Music*, perhaps best characterizes this desire to bring the world to the table, to evoke distant realities through a meditation on proximate realities. A poet known for explanations of America rather than confessions of his private life, Pinsky turned his attentions, in this first volume of poetry since 2000, to his immediate surroundings, the intimate objects and space that make up his writer's world. The series includes poems on a jar of pens, a water glass (perhaps recalling Stevens), a book, a photograph, a door, a banknote. First published as a chapbook, but now set in the middle of a volume concerned with public spaces, objects, and events (the Galveston hurricane, an indirect response to Hurricane Katrina; Stalinist Russia; Inman Square multiculturalism; and of course the collapse of the Trade Center towers),

these meditations on proximate, tactile reality help the poet to locate being. But readers familiar with Pinsky's poem "Shirt" will recognize that the objects closest "to hand," the things we wear and use every day, are impacted with history and collapse the degrees of separation between ourselves and the others. The title poem, "First Things to Hand," begins as a *vanitas*: "In the skull kept on the desk. / In the spider-pod in the dust. // Or nowhere." And of course these local objects are chosen not only for their proximity, which gives thought its vitality, but also for their evocation of absences and dispersals; these still objects remind us of mutability, and later, of history. Among the catalogue of "each / Several thing you touch" is an increasing degree of separation, dispersing the personal into the economic, the political, the social, so that the "proximate, intimate" becomes linked to what is remote:

> The dollar bill, the button
> That works the television.
>
> Even in the joke, the three
> Words American men say
>
> After making love. *Where's*
> *The remote?*
> (Pinsky 2006, 9–10)

In this poem, too, in the coming and going between home and the world, high mingles with low, Buddha's "Enlightenment" finds its source not only in the "odor of the lamp," not only in the humble imagery of "milkmaids" and "loaves," but even in waste itself and "the stick / You use to clear the path." In *Gulf Music* the clearings will require much more than a stick, for they include the seemingly endless dust of history, past and contemporary. But in creating music in the media-saturated "gulf" between private and public worlds, Pinsky offers not merely a sense of the remote real but a hopeful sense of the possible.

In visual art, too, there are signs of a return to dialectic, and a new appreciation of the camera obscura process of representation that Oldenburg and others reject. An awareness of the limits as well as the

power of this technique of illusion as a means of beholding the world allows for its renovation. The camera obscura might simulate not just a dark room but another crude foyer for confluence between inner and outer worlds. The mind itself is the camera obscura, an obscure room, and conversely, the domestic space, the room where we dwell, is like a mind.

No contemporary artist better epitomizes this return to the planet on the table than the photographer Abelardo Morell. The affinities between his photographs and Joseph Cornell's art are conspicuous and probably deliberate: both artists have recognized the freedom in the modest genre of still life; both have recognized the power of poetry, and of the book more generally, to create freedom in the intercourse between mind and world. Morell's explorations of camera obscura are his best-known work. He has sealed off whole rooms and let a pinhole of light enter, bringing with it, in a slow, unintrusive inversion like thought itself, the expansive world without. A few bits of

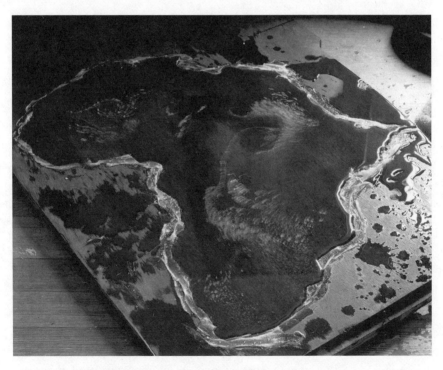

Figure 13. Abelardo Morell, *Map of Africa*, 1996. Courtesy of Abelardo Morell and the Bonni Benrubi Gallery, N.Y.

furniture establish the relation of scale between room and world. This miniaturized world is not tamed but imagined. The sea is in the attic; the forest is in the living room; the Empire State Building streaks across the bed; and the city sprawls along the boardroom table.

The camera obscura procedure became, as Jonathan Crary has shown in *Techniques of the Observer*, an internalized and generalized formula for understanding the world. It erased the viewer's body and gave metaphysical status to the order beheld. But by foregrounding this technology, Morell takes us beyond the reifications with which it is associated. He encourages dialogue between inside and outside, imagination and reality, by reminding us that they are distinct but interdependent. By drawing attention to the mechanism of the camera, Morell does not so much declare the end of the real as affirm the imaginary as part of the life of the individual.

As in all still life, the worlds Morell creates with his camera are conspicuously invented worlds, dream worlds, not-the-real world, but

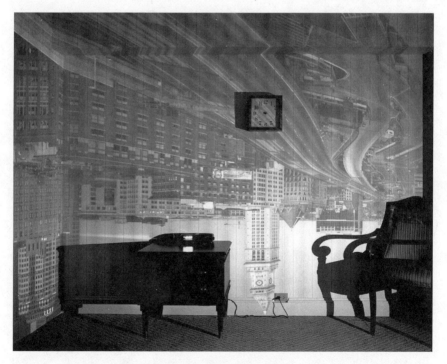

Figure 14. Abelardo Morell, *Boston's Old Custom House in Hotel Room*, 1999. Courtesy of Abelardo Morell and the Bonni Benrubi Gallery, N.Y.

they are never escapist; indeed they often feature a controlled chaos. The camera obscura literally, materially brings the world into the room. Morell's regular still life photography conveys a similar spirit, enlivening the interplay between near and far, inside and outside, design and contingency. In the most ordinary of domestic settings, the world is brought to mind and its magic renewed (figs. 13, 14). A water spill on a table looks like a map of Africa; a window is reflected in a glass of wine; the tangle of highways spreads out on a hotel room wall. In this most intimate, modest art of the table, Morell restores a dialogue with the planet.

NOTES

PREFACE: APOLOGIES FOR POETRY

1. This study involves extensive close reading of individual poems. While I have included supporting quotations throughout, space and costs prohibit the presentation of complete poems. My hope is that the argument is clear from the cited material, but also that the reader will turn to the full texts to appreciate their integrity beyond the narrow concerns of my analysis.

2. The phrase "public sphere" has a long and varied history, along with its corollary, "private sphere." The terms must be understood within their historical context, their forms and boundaries being historically determined. A particular feature of the period (approximately 1930–1955) which concerns me in this book is the sense that the division is threatened, and that the forces of state and capital are destroying not only public discourse but also the private life. It is not my intention here to offer a sociological survey of this phenomenon. The Frankfurt school theorists, especially Theodor Adorno and Walter Benjamin, and their associates, such as Hannah Arendt in *The Human Condition* and Jürgen Habermas in *The Transformation of the Public Sphere*, offered powerful analyses of these spheres in the face of fascism and totalitarianism. Benjamin's notes in "The Interior, The Trace," which include several citations from Adorno, offer a richly suggestive analysis of the private realm, especially the bourgeois interior. While much of the analysis is critical of, or at least distanced from, the nineteenth-century ideal of the bourgeois interior, which depended upon substituting semblance for history, at the same time it also expresses a loss in modernity's relinquishment of "dwelling." *A History of Private Life*, edited by Phillippe Ariés and Georges Duby, offered an exhaustive sociological history, documenting the changes that critics like Benjamin and his contemporaries were describing more theoretically. Many recent scholars of the private/public divide have pursued the lead of Frankfurt school

theorists, most notably Michael McKeon in *The Secret History of Domesticity: Public, Private, and the Division of Knowledge,* which provides an early history of the division of these realms. Phenomenologists such as Gaston Bachelard, and geographers such as David Harvey and Henri Lefebvre, have explored the spatial expression of the division. In this book I discuss an aesthetic response to a particular historical shape of this division, a response that works less to transform the division socially than to negotiate it imaginatively (a distinction that is, I realize, within the umbrella of the division). I also use the term "public realm" in the context of "public events" or the historical affairs of "the world" as they are experienced by individuals socially, politically, or geographically removed from these events, and as they become symbolized by objects and arrangements of the domestic and aesthetic life, beneath historical notice. For an excellent summary of the issues raised by modern thinking concerning the private/public divide, see "The Theory and Politics of the Public/Private Distinction" by Jeff Weintraub, in *Public and Private in Thought and Practice: Perspectives on a Grand Dichotomy,* 1–43. My exploration of the private/public divide is also informed by its expression in art history, where the often gendered division of labor and the dialectic of home and world produce generic distinctions such as still life and history painting.

INTRODUCTION: CRUDE FOYERS

1. For an overview of the political climate in the arts, see Herschel Chipp, ed., *Theories of Modern Art,* 456–500. See also Edith Kurzweil, ed., *A Partisan Review Century: Political Writings of the Partisan Review,* 1–59.

2. In her long poem titled *The Book of the Dead* (1938), Rukeyser brings West Virginia's Hawk's Nest industrial disaster, in which thousands of workers died, to public notice. The Spanish civil war, which she witnessed directly, became another focus for poetry. The private consciousness and the domestic world were largely set aside in order to "reach beyond" herself. For some, like Lorine Niedecker, who was for a time supported by Writers' Project grants, personal lyric could be adapted to this new social agenda. Writing out of her experiences in rural Wisconsin, she created poems depicting working-class life on an intimate scale, and drew on memory and unconscious feeling in her treatment of local objects, anticipating work by Elizabeth Bishop. But her spare style, schooled in objectivism, almost erases the subjective consciousness from these images.

3. Maud Blessingbourne, the main character in "The Story in It" (1903), has a hidden passion for a man, and that is the drama of her life, the story in it. The whole story takes place in the parlor of the friend she is visiting during a rainy afternoon. Oppen justified his surprising allusion to James: "Hemingway's style, the model of all the left-wing writers of the thirties, [was] an essentially and incorrigibly right-wing style,—whereas H James, the very symbol of 'snobbery' to such writers, displayed a style and a sensibility which made possible a political and

social critique. In acknowledgment of this, I placed on the first page of Discrete Series the quotation from James" (quoted in Gioia 2004, 602).

4. Adorno writes: "The contents of the interior are mere decoration, alienated from the purposes they represent, deprived of their own use value, engendered solely by the isolated dwelling-space. . . . [T]he self is overwhelmed in its own domain by commodities and their historical essence. Their semblance-character is historically-economically produced by the alienation of thing from use value. But in the interior, things do not remain alien. . . . Foreignness transforms itself from alienated things into expression; mute things speak as "symbols." The ordering of things in the dwelling-space is called 'arrangement.' Historically illusory . . . objects are arranged in it as the semblance of unchangeable nature. In the interior, archaic images unfold: the image of the flower as that of organic life; the image of the orient as specifically the homeland of yearning; the image of the sea as that of eternity itself. For the semblance to which the historical hour condemns things is eternal" (quoted in Benjamin 1999, 220).

5. Benjamin writes: "What didn't the nineteenth century invent some sort of casing for! Pocket watches, slippers, egg cups, thermometers, playing cards—and, in lieu of cases, there were jackets, carpets, wrappers, and covers. The twentieth century, with its porosity and transparency, its tendency toward the well-lit and the airy, has put an end to dwelling in the old sense" (Benjamin 1999, 220–221).

6. Still life had, of course, been a major genre of modernism. In pursuing formal problems, and in their quest for "the thing," writers and painters often chose still life as their focus. Its relative neutrality of subject, as compared with portraiture and narrative, made it an ideal space for investigating formal and perceptual themes. Hence Gertrude Stein's "Tender Buttons" and various imagist and objectivist experiments, such as H.D.'s flower poems, owe something to the still life tradition even as they resist pictorial norms.

7. For excellent discussions of the tradition, practices, and meanings of still life, see Charles Sterling, *Still-Life Painting from Antiquity to the Twentieth Century*; Margit Rowell, *Objects of Desire: The Modern Still Life*; Anne Lowenthal, *The Object as Subject: Studies in the Interpretation of Still Life*; Eliza Rathbone and George Shackelford, *Impressionist Still Life*.

8. Douglas Mao borrows the phrase from a title by Virginia Woolf.

WALLACE STEVENS: LOCAL OBJECTS AND DISTANT WARS

1. Longenbach's excellent study locates and interprets Stevens's poems in light of a variety of historical circumstances and political debates. For a comparison of Longenbach and Filreis, see my review "Wallace Stevens and the Real World."

2. In these reflections on the notion of ideas in things, and for the reference to Heidegger, I am indebted to Bill Brown's suggestive study *The Sense of Things*.

Although his focus is on an earlier period in American literature, his introductory chapter has important implications for the study of the modernist object.

3. Stevens's subjects are often generic, and I have not located a particular painting in connection with this poem; women with flowers is a favorite subject of impressionism. Two such paintings, Degas's *Woman Seated beside a Vase of Flowers* and Courbet's *Woman with Flowers (The Trellis)* were both included in the Wadsworth Atheneum's exhibition of still life in 1938.

4. For a thorough history of Stevens's acquisition and a persuasive analysis of his transposition from painting to poem, see Alan Filreis's "Still Life without Substance: Wallace Stevens and the Language of Agency." Filreis argues that Stevens works between the arts with an interest in relational structure rather than in substances. While I agree with this reading, I believe that the genre of still life, with its emphasis on what the movement between rhopography (an art-historical term for common, trivial matter) and megalography (transfiguration to spiritual matter), remains generically if not substantively relevant to the poem.

5. For Filreis, Stevens's late images of "poverty," often familiar motifs of still life, are part of the idealized version of Europe that his isolationist tendencies could cultivate. "The list of images of poverty in the poem ["An Ordinary Evening in New Haven"]—"the tin plate, the loaf of bread on it, / The long-bladed knife, the little to drink"—is hardly persuasive in denoting . . . a background of reality. These stock images of the common life actually conform more to the conventions of the front of the postcard (ideal view) than to the reverse (descriptions of or pointings to things seen in the world" (Filreis 1991, 225). Stevens's claim is not toward denotative reality, for "it is not in the premise that reality / is a solid." These simple images become, as still life, part of a fictional space rather than a mimetic space, where, to follow Sarah Riggs, "word-objects are felt to be suspended and arranged in imaginary space" (Riggs 2002, 22). The objects of still life are not, that is, indices of the historical world; but from this imaginary domestic space the poet will launch himself back into the distances of the real.

6. Filreis identifies the visual source: "Yet again the evidence suggests that the modernist pineapple likenesses are based on a painting of pineapples dismantled by another modernist imagination, namely, one of the Cuban *origenistas*, Mariano Rodriguez, whose watercolor Stevens had received as a gift and hung in his private bedroom" (Filreis 1989, 370–371).

WILLIAM CARLOS WILLIAMS: CONTENDING IN STILL LIFE

1. For a thoughtful discussion of the relation between politics and aesthetics in Williams's work and his sense of how art can work in and for democracy, see John Beck, *Writing the Radical Center: William Carlos Williams, John Dewey, and American Cultural Politics*. Chapters 2 and 5 are especially relevant to my discussion of Williams's art of contentions. "What is clear is that, if art is somehow to be the

embodiment of democracy, it cannot be a separate sphere of activity but must move into the world of which it is a part and embrace it. It cannot be a higher realm but a piece with everyday life even as it seeks to transform that life. Such a conception of art cannot shun the fallen world or retreat into its own untouchable autonomy but must become entwined with the forces that might destroy it. . . . It *is* the world, fraught with contradictions and imperfections, a process, an act, a force" (Beck 2001, 36).

ELIZABETH BISHOP'S ETHNOGRAPHIC EYE

1. Warren Susman discusses Stuart Chase's *Mexico: A Study of Two Americas*, writing: "Chase contrasts the urban-industrial culture of the United States and the folk culture of a more primitivist and traditional Mexico. While the United States might well have the advantages that come with 'civilization,' the author of *Mexico* clearly found special benefits in the simple folkways of Tepoztlan" (Susman 1973, 155).

2. Sarah Riggs mentions this poem only in passing, but it clearly exemplifies her point that Bishop's "reality effects" manage both to engage and baffle our experience of looking (Riggs 2002, 71–75).

3. Robert Harbison's *Eccentric Spaces* appeared at the same time as *Geography III*, and its view of museums echoes Crusoe's lament in "Crusoe in England": "The act of museumifying takes an object out of use and immobilizes it in a secluded atticlike environment among nothing but more objects, another space made up of pieces. If a museum is first of all a place of things, its two extremes are the graveyard and a department store, things entombed or up for sale, and its life naturally ghost life. . . . In order to enter, an object must die" (Harbison 1977, 140, 147). Susan Stewart's description of nostalgia in *Robinson Crusoe* also resonates with Bishop's poem (Stewart 1993, 15–16). Robert Pinsky's account of the poem in "Poetry and the World" is among the most compelling and addresses itself to the relation between private and public, personal and worldly affairs that concerns me here: "In the conflict between the isolated world of the self and the communal world of England, the knife is a charmed artifact, a sacred weapon— but only in its primal context. . . . But what is inspiring . . . is the insistent, credible enactment of a human soul that is in the World, but not entirely of it, outside the World, but not entirely apart from it" (Pinsky 1988, 14).

JOSEPH CORNELL: SOAP BUBBLES AND SHOOTING GALLERIES

1. I have reproduced here black and white images of the works by Cornell that I discuss at length. Obviously, these are poor representatives of the colorful three-dimensional products of Cornell's imagination. Many of these images can be seen on-line in color reproductions. For the best representation of Cornell's work in

book form, I refer the reader to *Shadowplay, Eterniday*, produced by Linda Hartigan et al., and especially to the accompanying interactive CD.

2. For this quotation and for a range of images from the fair, I am indebted to the Web site http://xroads.virginia.edu/~1930s/DISPLAY/39wf/frame.htm, set up by John Baran.

3. For an excellent account of the Automat, including images I refer to in my discussion of Cornell, see http://www.theautomat.net/. This Web site accompanies a book by Lorraine B. Diehl and Marianne Hardart, *The Automat.*

RICHARD WILBUR: *XENIA*

1. For other commentaries dealing with the influence of Wilbur's war experience, see *War, Literature, and the Arts* 10.1 (Spring–Summer 1998): 1–71.

2. See, for instance, James Longenbach, "Richard Wilbur's Small World," in *Modern Poetry after Modernism*, 65–84.

3. Marjorie Perloff's famous criticism of the poem, in *Poetry On and Off the Page: Essays on Emergent Occasions*, that it is out of touch with urban actualities in its yoking of angels and laundry, has been thoughtfully addressed by Edward Brunner in *Cold War Poetry*.

4. One finds the same principle in the poems Eugenio Montale collected under the title *Xenia*, with their attention to domestic details; the work is demotic in its imagery yet elegant in its form.

CONCLUSION: DOMESTIC DISTURBANCE

1. Edward Brunner characterizes a growing complaint about cold war poetry: "To choose the domestic over the historical was to record small-time events in an American locale instead of enacting broad gestures within a vast expanse. It was to turn away from political and cultural responsibilities to withdraw into the pleasantries of the private world" (Brunner 2001, 185). As Brunner and James Longenbach have noted, this reading, which has continued to be the dominant interpretation of much mid-century poetry, wrongly denigrates the achievement of poets of formal restraint, as if their formalism were a private palliative against the shocks of social and political reality. As Deborah Nelson has argued in her study of confessional poetry, *Pursuing Privacy*, privacy was made "visible" and was "reinvented" in this period in the courts, in politics, and in the arts. Her argument locates in historical and legal documents what has been explored widely since the emergence of confessional poetry and of feminist and queer theory. Other important studies of the private/public distinction in contemporary poetry include Alan Nadel's *Containment Culture: American Narratives, Postmodernism, and the Atomic Age*, and Kevin Stein's *Private Poets, Worldly Acts: Public and Private History in Contemporary Poetry*.

2. See Barbara Rose, *Claes Oldenburg*, for a more affirmative discussion of the collapse of dialectic in his work.

3. For a selection of images from *The Store*, see http://artnetweb.com/oldenburg/thestore1.html.

4. Brisman is right, certainly, to associate "Willowware Cup" with Yeats's "Lapis Lazuli," and to see Merrill turning against Yeats's "prewar" aestheticism to an affirmation of desire. Brisman's implication is that the historical context of the poem, the sounding of war, fades into the background as the personal human story of family and romantic love becomes the real subject. But in the fourth stanza Merrill echoes one of the most famous poems of World War I, Owen's "Dulce et Decorum Est," a lyric he would have known well, given his connection to Auden, and one that makes a sharp counterpoint to Yeatsian detachment. Although it is an "old bridge," not a soldier, that is "bent double," the line makes a bridge to war poetry.

BIBLIOGRAPHY

Adorno, Theodor. With Max Horkheimer. *Dialectic of Englightenment: Philosophical Fragments*. Trans. Edmund Jephcott. Stanford: Stanford University Press, 2002.

Aiken, Conrad, ed. *Twentieth-Century American Poetry*. New York: Modern Library, 1963.

Altieri, Charles. *Painterly Abstraction in Modernist American Poetry: The Contemporaneity of Modernism*. New York: Cambridge University Press, 1989.

Arendt, Hannah. *The Human Condition*. Chicago: University of Chicago Press, 1958.

Ariés, Phillippe, and Georges Duby, eds. *A History of Private Life*. Cambridge: Belknap Press of Harvard University Press, 1987.

Atwood, Margaret. "Against Still Life." In *Selected Poems*. New York: Simon and Schuster, 1978. 37–39.

Auden, W. H. *Collected Poems*. Ed. Edward Mendelson. New York: Random House, 1976.

——. *The Dyer's Hand*. New York: Random House, 1962.

——. "In Memory of W. B. Yeats." In *Collected Poems*. Ed. Edward Mendelson. New York: Modern Library, 2007. 246.

——. *Selected Poems*. Ed. Edward Mendelson. New York: Vintage, 1979.

Bachelard, Gaston. *The Poetics of Space*. 1958. Boston: Beacon Press, 1969.

Bahti, Timothy. *Ends of the Lyric: Direction and Consequence in Western Poetry*. Baltimore: Johns Hopkins University Press, 1996.

Bailey, Joe. "Public to Private: The Development of the Concept of "the Private." Part 1. "Public/Private: The Distinction." *Social Research* 69.1 (Spring 2002): 15–31.

Baudrillard, Jean. *Selected Writings*. Stanford: Stanford University Press, 1988.

Baudelaire, Charles. *The Painter of Modern Life and Other Essays*. Trans. and ed. Jonathan Mayne. London: Phaidon, 1965.

Beck, John. *Writing the Radical Center: William Carlos Williams, John Dewey, and American Cultural Politics*. Albany: State University of New York Press, 2001.

Benjamin, Walter. *Arcades Project*. Trans. Howard Eiland and Kevin McLaughlin. Cambridge: Harvard University Press, 1999.

——. *Berlin Childhood around 1900*. Trans. Howard Eilan. Cambridge: Belknap Press of Harvard University Press, 2006.

——. *Selected Writings*. Volume 2. *1927–1934*. Ed. Michael Jennings. Cambridge: Harvard University Press, 1999.

——. *Selected Writings*. Volume 3. *1935–1938*. Ed. Michael Jennings. Cambridge: Harvard University Press, 2002.

Berger, John. *The Sense of Sight*. New York: Pantheon, 1985.

Bishop, Elizabeth. *The Complete Poems, 1927–1979*. New York: Farrar, Straus & Giroux, 1983.

——. *The Complete Prose*. Ed. Robert Giroux. New York: Farrar, Straus & Giroux, 1984.

——. *Edgar Allan Poe & the Juke-Box*. Ed. Alice Quinn. New York: Farrar, Straus & Giroux, 2006.

——. *Exchanging Hats: Elizabeth Bishop's Paintings*. Ed. William Benton. New York: Farrar, Straus & Giroux, 1996.

——. *One Art: Letters*. Ed. Robert Giroux. New York: Farrar, Straus & Giroux, 1994.

Bloom, Harold. *Wallace Stevens: The Poems of Our Climate*. Ithaca: Cornell University Press, 1977.

Bremen, Brian A.. *William Carlos Williams and the Diagnostics of Culture*. New York: Oxford, 1993.

Breslin, Paul. *The Psycho-Political Muse: American Poetry since the Fifties*. Chicago: University of Chicago Press, 1987.

Breton, André. "Crise de l'objet." Quoted in J. H. Matthews, *The Imagery of Surrealism*. Syracuse: Syracuse University Press, 1976. 170.

Briggs, Asa. *Victorian Things*. Chicago: University of Chicago Press, 1989.

Brisman, Leslie. "Merrill's Yeats." In *James Merrill*. Ed. Harold Bloom. New York: Chelsea House Publishers, 1985. 189–195.

Brock-Broido, Lucie. *Trouble in Mind*. New York: Knopf, 2004.

Brown, Bill. *The Sense of Things: The Object Matter of American Literature*. Chicago: University of Chicago Press, 2003.

Brunner, Edward. *Cold War Poetry*. Urbana: University of Illinois Press, 2001.

Bryson, Norman. *Looking at the Overlooked: Four Essays on Still Life Painting*. Cambridge: Harvard University Press, 1990.

Cameron, Sharon. *Lyric Time: Dickinson and the Limits of Genre*. Baltimore: John Hopkins University Press, 1979.

Cantor, Jay. *The Space between Literature and Politics*. Baltimore: Johns Hopkins University Press, 1981.

Chipp, Herschel B., ed. *Theories of Modern Art*. Berkeley: University of California Press, 1968.

Clarvoe, Jennifer. *Invisible Tender*. New York: Fordham University Press, 2000.

Convergence of Birds: Original Fiction and Poetry Inspired by the Work of Joseph Cornell. Ed. Jonathan Safran Foer. New York: Distributed Art Publishers, 2001.

Cornell, Joseph. *Joseph Cornell's Theater of Mind: Selected Diaries, Letters, and Files*. Ed. Mary Ann Caws. New York: Thames and Hudson, 1993.

Costello, Bonnie. "Review of *Wallace Stevens: The Plain Sense of Things* by James Longenbach and *Wallace Stevens and the Actual World* by Alan Filreis." *New England Quarterly* 65.3 (September 1992): 485–490.

Crary, Johnathan. *Techniques of the Observer: On Vision and Modernity in the Nineteenth Century*. Cambridge: MIT Press, 1990.

Creeley, Robert. *Collected Poems, 1945–1975*. Berkeley: University of California Press, 1982.

Culler, Jonathan. *The Pursuit of Signs: Semiotics, Literature, Deconstruction*. Ithaca: Cornell University Press, 1981.

Danto, Arthur. *The Philosophical Disenfranchisement of Art*. New York: Columbia University Press, 1986.

Dauber, Antoinette. "Trahern and the Poetics of Object Relations." In *Transitional Objects and Potential Spaces*. Ed. Peter L. Rudnytsky. New York: Columbia University Press, 1993. 135–160.

Davenport, Guy. *Objects on a Table: Harmonious Disarray in Art and Literature*. Washington, D.C.: Counterpoint, 1998.

Davidson, Michael. "From Margin to Mainstream: Post-war Poetry and the Politics of Containment." *American Library History* 10.2 (Summer 1998): 266–290.

Davis, Stuart. *First American Artists' Congress, 1936*. Quoted in *Modern Art in the USA: Issues and Controversies of the 20th Century*. Ed. Patricia Hills. Upper Saddle River, N.J.: Prentice-Hall, 2001. 103.

Diehl, Lorraine B., and Marianne Hardart. *The Automat*. New York: Clarkson Potter Publishers, 2002.

Djikstra, Bram. *The Hieroglyphics of a New Speech: Cubism, Stieglitz, and the Early Poetry of William Carlos Williams*. Princeton: Princeton University Press, 1969.

Eliot, T. S. "The Metaphysical Poets." 1921. In *The Selected Prose of T. S. Eliot*. Ed. Frank Kermode. New York: Harcourt, 1975. 59–68.

Elkin, James. *The Object Stares Back: On the Nature of Seeing*. New York: Harcourt Brace, 1996.

Erikson, John. *The Fate of the Object: From Modern Object to Postmodern Sign in Performance, Art, and Poetry*. Ann Arbor: University of Michigan Press, 1995.

Evans, Walker. *Walker Evans*. New York: Museum of Modern Art, 2000.

Fearing, Kenneth. "American Rhapsody." 1934. Quoted in *Modern Art in the USA: Issues and Controversies of the 20th Century*. Ed. Patricia Hills. Upper Saddle River, N.J.: Prentice-Hall, 2001. 96–97.

Ficke, Arthur Davison. "Poetry." *Poetry: A Magazine of Verse* 1 (1912): 1.

Filreis, Alan. *Modernism from Right to Left: Wallace Stevens, the Thirties, and Literary Radicalism*. New York: Cambridge University Press, 1994.

——. "Still Life without Substance: Wallace Stevens and the Language of Agency." *Poetics Today* 10.2 (Summer 1989): 345–372.

——. *Wallace Stevens and the Actual World*. Princeton: Princeton University Press, 1991.

Gioia, Dana, ed. *Twentieth-century American Poetry*. New York: McGraw Hill, 2004.

Goehr, Lydia. "Art and Politics." In *Oxford Handbook of Aesthetics*. Ed. Jerrold Levinson. New York: Oxford University Press, 2005. 471–485.

Habermas, Jürgen. *The Structural Transformation of the Public Sphere: An Inquiry into a Category of Bourgeois Society*. Cambridge: MIT Press, 1989.

Harbison, Robert. *Eccentric Spaces: A Voyage through Real and Imaginary Worlds*. New York: Ecco Press, 1977.

Hartigan, Linda. *Shadowplay: Eterniday*. New York: Thames and Hudson, 2003.

Hauptman, Jodie. *Star-Gazing at the Cinema*. New Haven: Yale University Press, 1999.

Hegeman, Susan. *Patterns for America*. Princeton: Princeton University Press, 1999.

Hughes, Ted. *Selected Poems*. New York: Harper, 1982.

Johnson, Ellen. *Modern Art and the Object: A Century of Changing Attitudes*. New York: Harper and Row, 1976.

Joseph Cornell/Marcel Duchamp . . . in resonance. In conjunction with an exhibition organized by the Philadelphia Museum of Art and the Menil Collection, Houston. 1998. Distributed by Art Publishers, New York.

Josephson, Matthew. "The Great American Billposter." 1922. In *Modern Art in the USA: Issues and Controversies of the 20th Century*. Ed. Patricia Hills. Upper Saddle River, N.J.: Prentice-Hall, 2001. 61–63.

Kleinzahler, August. *Red Sauce, Whiskey and Snow*. New York: Farrar, Straus & Giroux, 1995.

Krauss, Rosalind. "Grids." *October* 9 (Summer 1979): 50–64.

Kurzweil, Edith, ed. *A Partisan Review Century: Political Writings of the Partisan Review*. New York: Columbia University Press, 1996.

Lasch, Christopher. *The Culture of Narcissim: American Life in an Age of Diminishing Expectations*. New York: Norton, 1978.

Lefebvre, Henri. *The Production of Space*. Oxford: Blackwell, 1991.

Leighten, Patricia. "Picasso's Collages and the Threat of War, 1912–1913." 1985. Reprinted in *Collage: Critical Views*. Ed. Katheriine Hoffman. Ann Arbor: UMI Research Press, 1989. 121–171.

Lloyd, Rosemary. *Shimmering in a Transformed Light*. Ithaca: Cornell University Press, 2005.

Longenbach, James. *Modern Poetry after Modernism*. New York: Oxford University Press, 1997.

——. *Wallace Stevens: The Plain Sense of Things*. Oxford: Oxford University Press, 1991.

Lowell Robert. *Collected Poems*. New York: Farrar, Straus & Giroux, 2003.

Lowenthal, Anne, ed. *The Object as Subject: Studies in the Interpretation of Still Life*. Princeton: Princeton University Press, 1996.

MacLeish, Archibald. "Ars Poetica." 1926. In *Modern American Poetry*. Ed. Cary Nelson. New York: Oxford University Press, 2000. 331.

MacLeod, Glen. *Wallace Stevens and Modern Art: From the Armory Show to Abstract Expressionism*. New Haven: Yale University Press, 1993.

Mao, Douglas. *Solid Objects: Modernism and the Test of Production*. Princeton: Princeton University Press, 1998.

Mariani, Paul. *William Carlos Williams: A New World Naked*. New York: McGraw Hill, 1981.

Matthews, J. H. *The Imagery of Surrealism*. Syracuse: Syracuse University Press, 1977.

McShine, Kynaston, ed. *Joseph Cornell*. New York: Museum of Modern Art, 1980.

McKeon, Michael. *The Secret History of Domesticity: Public, Private, and the Division of Knowledge*. Baltimore: Johns Hopkins University Press, 2005.

Merrill, James. *Collected Poems*. Ed. J. D. McClatchy and Stephen Yenser. New York: Knopf, 2001.

Millay, Edna St. Vincent. "I Forgot for a Moment: July 1940." 1940. In *Modern American Poetry*. Ed. Cary Nelson. New York: Oxford University Press, 2000. 330.

Millier, Brett C. *Elizabeth Bishop: Life and the Memory of It*. Berkeley: University of California Press, 1993.

Moore, Marianne. *Complete Poems*. New York: Viking, 1981.

——. *The Complete Prose of Marianne Moore*. Ed. Patricia Willis. New York: Viking, 1986.

Morell, Abelardo. *Camera Obscura*. New York: Bulfinch Press, 2004.

Morris, Daniel. *Remarkable Modernisms: Contemporary Poets on Modern Art*. Amherst: University of Massachusetts Press, 2002.

Morris, George. "Miró and the Spanish Civil War." *Partisan Review* 4.2 (1938): 32–33.

Mumford, Lewis. *Art and Technics*. New York: Columbia University Press, 1952.

——. *The Culture of Cities*. New York: Harcourt, Brace, & Co., 1938.

Nabokov, Vladimir. *Speak, Memory: An Autobiography Revisited*. New York: Putnam, 1966.

Nadel, Alan. *Containment Culture: American Narratives, Postmodernism, and the Atomic Age*. Durham: Duke University Press, 1995.

Nelson, Deborah. *Pursuing Privacy in Cold War America*. New York: Columbia University Press, 2002.

Noland, Carrie. *Poetry at Stake: Lyric Aesthetics and the Challenge of Technology*. Princeton: Princeton University Press, 1999.

Oppen, George. "Interview." *Sagatrieb* 3.3 (1984): 5–9.

——. *New Collected Poems*. Ed. Michael Davidson. Manchester: Carcanet, 2003.

Perl, Jeffrey. *New Art City: Manhattan at Mid-century*. New York: Knopf, 2005.

Perloff, Marjorie. *Poetry On and Off the Page: Essays on Emergent Occasions*. Evanston: Northwestern University Press, 1998.

Pinsky, Robert. *First Things to Hand*. New York: Sarabande Quarternote Chapbook, 2006.

——. *Gulf Music*. New York: Farrar, Straus and Giroux, 2007.

——. *Poetry and the World*. New York: Ecco, 1988.

Plath, Sylvia. *Collected Poems*. New York, 1993.

Ponge, Francis. *The Power of Language: Texts and Translations*. Intro. and trans. Serge Gavronsky. Berkeley: University of California Press, 1979.

Pope, Alexander. *Complete Poems*. Boston: Houghton Mifflin, 1903.

——. "The Rape of the Lock. 1714. In *The Norton Anthology of Poetry*. 4th ed. Ed. Margaret Ferguson, Mary Jo Salter, and Jon Stallworthy. New York: Norton, 1996. 547–564.

Putnam, Robert. *Bowling Alone: The Collapse and Revival of American Community*. New York: Simon & Schuster, 2000.

Rathbone, Eliza, and George Shakelford. *Impressionist Still Life*. New York: Abrams, 2001.

Rich, Adrienne. *Collected Early Poems*. New York: W. W. Norton, 1993.

Riggs, Sarah. *Word Sightings: Poetry and Visual Media in Stevens, Bishop, and O'Hara*. New York: Routledge, 2002.

Roman, Camille. *Elizabeth Bishop's World War II–Cold War View*. New York: Routledge, 2001.

Rose, Barbara. *Claes Oldenburg*. New York: Museum of Modern Art, 1970.

Rosner, Victoria. *Modernism and the Architecture of Private Life*. New York: Columbia University Press, 2004.

Rowell, Margit. *Objects of Desire: The Modern Still Life*. New York: Museum of Modern Art, 1997.

Rukeyser, Muriel. "Poem." 1968. In *Modern American Poetry*. Ed. Cary Nelson. New York: Oxford University Press, 2000. 690.

Sawin, Martica. *Surrealists in Exile and the Beginning of the New York School*. New York: Columbia University Press, 1995.

Scarry, Elaine. *On Beauty and Being Just*. Princeton: Princeton University Press, 1999.

Schaffner, Ingrid. *The Essential Joseph Cornell*. New York: Abrams, 2003.

Schama, Simon. *The Embarrassment of Riches: An Interpretation of Dutch Culture in the Golden Age*. New York: Knopf, 1987.

Schapiro, Meyer. *Modern Art: 19th and 20th Centuries*. New York: Braziller, 1978.

Schmidt, Peter. *William Carlos Williams, the Arts, and Literary Tradition*. Baton Rouge: Louisiana State University Press, 1988.

Sebald, W. G. *The Emigrants*. Trans. Michael Hulse. New York: New Directions, 1996.

Seitz, William. "The Realism and Poetry of Assemblage." 1961. Reprinted in *Collage: Critical Views*. Ed. Katherine Hoffman. Ann Arbor: UMI Research Press, ca. 1989. 79–90.

Sennet, Richard. *The Fall of Public Man*. 1974. London: Faber, 1986.

Simic, Charles. *Dime-Store Alchemy*. New York: Ecco, 1992.

———. *Return to a Place Lit by a Glass of Milk*. New York: Braziller, 1974.

Smithsonian Microfilm. Joseph Cornell Papers. Archives of American Art, Smithsonian. Washington, D.C.

Spender, Stephen. From *World Within World*. 1951. Reprinted in *Poets on Painters: Essays on the Art of Painting by Twentieth-Century Poets*. Ed. J. D. McClatchy. Berkeley: University of California Press, 1988. 139.

Starr, Sandra Leonard. *Joseph Cornell: Art and Metaphysics*. New York: Castelli, Feigen, Corcoran, 1982.

Stein, Gertrude. *Tender Buttons: Objects, Foods, Rooms*. New York: Haskell House Publishers, 1970.

Stein, Kevin. *Private Poets, Worldly Acts: Public and Private History in Contemporary Poetry*. Athens: Ohio University Press, ca. 1996.

Sterling, Charles. *Still-Life Painting from Antiquity to the Twentieth Century*. New York: Harper and Row, 1981.

Stevens, Wallace. *Collected Poetry and Prose*. New York: Library of America, 1997.

Stewart, Susan. *On Longing: Narratives of the Miniature, the Gigantic, the Souvenir, the Collection*. Durham: Duke University Press, 1993.

Susman, Walter. *Culture as History: The Transformation of American Society in the Twentieth Century*. New York: Pantheon, 1973.

Tamen, Miguel. *Friends of Interpretable Objects*. Cambridge: Harvard University Press, 2001.

Tashjian, Dickran. *Skyscraper Primitives: Dada and the American Avant-Garde, 1910–1925*. Middletown: Wesleyan University Press. 1975.

Taussig, Michael. *Mimesis and Alterity: A Particular History of the Senses*. New York: Routledge, 1993.

Trotsky, Leon. "Art and Politics: A Letter to the Editors of *Partisan Review*. 1938. Reprinted in *A Partisan Review Century*. Ed. Edith Kurzweil. New York: Columbia University Press, 1996. 12–19.

Vendler, Helen. *Wallace Stevens: Words Chosen Out of Desire*. Cambridge: Harvard University Press, 1986.

Von Hallberg, Robert. "The Politics of Description: William Carlos Williams in the Thirties." *ELH* 45 (1978): 131–151.

Waldman, Diane. *Joseph Cornell: Master of Dreams*. New York: Abrams, 2002.

Weintraub, Jeff. "The Theory and Politics of the Public/Private Distinction." In *Public and Private in Thought and Practice: Perspectives on a Grand Dichotomy*. Chicago: University of Chicago Press, 1997. 1–43.

Wilbur, Richard. *Collected Poems*. Orlando, Fla.: Harcourt, 2004.

———. *Conversations with Richard Wilbur*. Ed. William Butts. Jackson: University Press of Mississippi, 1990.

——. "Comment." In *Mid-century American Poets*. Ed. John Ciardi. New York: Twayne, 1950. 7.

——. "An Interview" with Joseph T. Cox. In *War, Literature, and the Arts* 10.1 (Spring–Summer 1998): 7–21.

——. *Responses: Prose Pieces, 1953–1976*. New York: Harcourt Brace Jovanovich, 1976.

Williams, William Carlos. *The Collected Poems of William Carlos Williams*. Volume 1. *1909–1939*. Ed. A. Walton Litz and Christopher MacGowan. New York: New Directions, 1986.

——. *The Collected Poems of William Carlos Williams*. Volume 2. *1939–1962*. Ed. Christopher MacGowan. New York: New Directions, 1988.

——. *Paterson*. New York: New Directions, 1992.

——. Prologue to *Kora in Hell*. 1920. In *Imaginations*. Ed. Webster Schott. New York: New Directions, 1970.

——. *Selected Essays*. New York: Random House, 1954.

——. *The Selected Letters of William Carlos Williams*. Ed. John C. Thirlwall. 1957. New York: New Directions, 1984.

Wright, Charles. *Negative Blue*. New York: Farrar, Straus & Giroux, 2000.

Yeats, W. B. *Essays and Introductions*. New York: Macmillan, 1961.

——. *Selected Poems and Four Plays of William Butler Yeats*. Ed. M. L. Rosenthal. New York: Scribner, 1996.

Zagajewski, Adam. *A Defense of Ardor: Essays*. Trans. Clare Cavanagh. New York: Farrar, Straus & Giroux, 2004.

ACKNOWLEDGMENTS

Special thanks to the Boston University Humanities Foundation for a semester's leave from teaching, which allowed me to complete this book, and for financial assistance in obtaining reproductions. Thanks also to the Liguria Study Center, which provided me with a blissful setting in which to think about poetry and still life at an early stage in the project. I am indebted to Barbara Martin of the Boston Museum of Fine Arts for initiating my thinking about this inter-art subject. My friend and colleague Julia Prewitt Brown has been an ideal reader of parts of this book, and our conversations about the bourgeois interior have influenced my thinking about the intimate worlds I describe here. Thanks also to Amanda Heller for her patient and thorough copyediting.

I gratefully acknowledge the following institutions and persons for permission to reproduce poems:

Robert Pinsky for permission to quote "First Things to Hand," which appeared in *First Things to Hand* by Robert Pinsky. Sarabande/Quarternote chapbooks, 2006.

"Sea Trout and Butterfish" and "The Sadness of the Sea" by William Carlos Williams, from *Collected Poems, 1909–1939*, volume 1, copyright 1938 by New Directions Publishing Corp. Reprinted by permission of New Directions Publishing Corp.

"Asphodel, That Greeny Flower" by William Carlos Williams, from *Collected Poems, 1939–1962*, volume 2, copyright 1944 by William Carlos Williams. Reprinted by permission of New Directions Publishing Corp.

INDEX

Page numbers in italics refer to figures.

Rich, Adrienne, 25, 88; "Aunt
Jennifer's Tigers," 169; "When We
Dead Awaken," 169
Riggs, Sarah, 29, 34–35, 184 n5, 185 n2
Rilke, Rainer Maria, 108, 115, 116
Rodriguez, Mariano, 184 n6
Roman, Camille, 81, 90–91, 98
Ronsard, Pierre de, 108
Rose, Barbara, 172–73; *Claes
Oldenburg*, 187 n2
Rosner, Victoria, 20
Rourke, Constance, 95
Roy, Pierre: *The Electrification of the
Country*, 120
Rukeyser, Muriel, 7; *Book of the Dead*,
182 n2 (Introduction), "Poem," 4–5
Ruskin, John, 140

Santayana, George, 26
Scarry, Elaine, xii
Schaffner, Ingrid, 127
Schama, Simon, 88
Schapiro, Meyer, 113
Schmidt, Peter, 48
Sebald, W. G., 11
Seitz, William, 54
Seligman, Kurt, 107
Sennet, Richard, xiv
Sexton, Anne, 170
Shahn, Ben, 2, 111
Sheeler, Charles: *Yachts and Yachting*,
66
Shelley, Percy Blythe, 60
Simic, Charles, 13, 25; *Dime-Store
Alchemy*, 109; "Eastern European
Cooking," 176; "Fork," 176;
"Mother Tongue," 176; "Return to a
Place Lit by a Glass of Milk," 175
Snyder, Gary, 162
Soupault, Phillip, 108
Soyer, Raphael, 2
Spender, Stephen: *World Within
World*, 1–2

Starr, Sandra, 129–30, 134
Stein, Gertrude: "Tender Buttons,"
183 n6
Stevens, Wallace, xi–xiii, 9–10, 13, 15,
17, 25, 26–47, 48–52, 76, 77, 79, 81,
86–88, 93, 103, 119–20, 136, 142, 147,
162, 169, 170, 176; "Anecdote of the
Jar," 14, 30–31, 45, 50, 155; "Angel
Surrounded by Paysans," 43; "An
Ordinary Evening in New Haven,"
184 n5; *The Auroras of Autumn*, 43;
"Auroras of Autumn," 43; "The
Bouquet," 45–47; *Collected Poems*,
viii–ix, 31; "Crude Foyer," 21–22,
167; "Cuisine Bourgeoise," 40–41;
"A Dish of Peaches in Russia,"
34–35; "Dry Loaf," 38–40, 46;
"Esthétique du Mal," 73, 143; "The
Figure of Youth as Virile Poet," xi;
"The Glass of Water," 35–38;
Harmonium, 14, 27, 30, 51;
"Hibiscus on the Dreaming Shore,"
50; "The Idea of Order at Key
West," xiv, 31, 66; "The Irrational
Element in Poetry," vii; "Local
Objects," 27–28, 35, 47; "Man and
Bottle," 38; "Man Carrying Thing,"
28; "The Man on the Dump," 8, 42;
"Martial Cadenza," 37–38; "Notes
toward a Supreme Fiction," 43–44;
Parts of a World, 14, 27, 28, 31–47;
"The Planet on the Table," viii–ix;
"The Poems of Our Climate," 18,
26–27; "The Relations between
Poetry and Painting," 26; "Someone
Puts a Pineapple Together," 44–46;
"Study of Two Pears," 29, 34, 35, 45;
"Sunday Morning," 30; *Transport to
Summer*, 21–22, 28; "Woman
Looking at a Vase of Flowers," 42,
46
Stewart, Susan, xv, 33, 185 n3; *On
Longing*, 10–12, 83